Photography
The Contemporary Era 1981–2013

The book has been published
thanks to the collaboration
and the contribution of

 UniCredit

Composition of the Work

Volume 1 The Origins
 1839–1890

Volume 2 A New Vision of the World
 1891–1940

Volume 3 From the Press to the Museum
 1941–1980

Volume 4 The Contemporary Era
 1981–2013

Photography
The Contemporary Era 1981–2013

edited by
Walter Guadagnini

Texts by
Charlotte Cotton
Okwui Enwezor
Walter Guadagnini
Thomas Weski
Francesco Zanot

Editorial Realization

Graphic Project
Marcello Francone

Editorial Coordination
Emma Cavazzini

Copy Editor
Andrew Ellis

Layout
Serena Parini

Translation
Paul Metcalfe, Susan Ann White,
Felicity Lutz and Oona Smyth
for *Scriptum*, Rome

Iconographic Research
Federica Borrelli

Chronology
Silvia Ferrari

Research and Glossary
Ilaria Speri

*We are grateful to the following
for their precious collaboration*
Flaminio Gualdoni, Milan
Bärbel Kopplin, Munich
Neve Mazzoleni, Milan
Franziska Nori, Frankfurt
Sandra S. Phillips, San Francisco
Johanna Singer, Munich

First published in Italy in 2013 by
Skira Editore S.p.A.
Palazzo Casati Stampa
via Torino 61
20123 Milano
Italy
www.skira.net

Printed and bound in Italy.
First edition

ISBN: 978-88-572-2054-3

Distributed in USA, Canada, Central
& South America by Rizzoli
International Publications, Inc., 300
Park Avenue South, New York,
NY 10010, USA.
Distributed elsewhere in the world by
Thames and Hudson Ltd., 181A High
Holborn, London WC1V 7QX,
United Kingdom.

Photography
The Contemporary Era 1981–2013

Reader's Guide

This history of photography is divided into four volumes, and is characterised by an innovative approach aimed at enabling the reader to follow different paths within a clearly defined structure.

Monographs

The work of a single author, Francesco Zanot, the monographs constitute the backbone of the individual volumes, tracing the historical evolution of photography through the books and exhibitions that marked its key stages. These short essays focus on the author of each of the books dealt with, or the photographers featured in the exhibitions, and place them in their historical context. The works and events discussed are therefore not considered in isolation, but become the starting points of a systematic analysis of the cultural climate within which they were born and presented. Identified and selected on the basis of their historical importance, and their capacity to exemplify particular uses of photography, the books and exhibitions included are linked to specific subjects of artistic, scientific, historical, and ethnographic character, thus pinpointing and illustrating the different aspects of the photographic medium. Fundamental importance attaches in these monographs to iconography, which makes the nature of the themes or event discussed immediately clear, while independently providing an image-based reading of the history narrated in the written text, and also making possible an essentially visual approach to the evolution of the photographic language. Each essay ends with a select bibliography for the author or authors discussed, aimed at readers interested in developing the subjects addressed in greater depth.

Essays

The essays constitute the second level of reading, with in-depth discussion of some of the primary themes of the historical period examined. Written by international specialists, they address subjects briefly discussed in the monographs, or concentrate on aspects of photographic practices that find no outlet in the official channels of exhibitions and published works. By their very nature, they cover a broad span of time, so as to constitute a history within a history, and above all to offer opportunities for reflection on some of the concepts and practices that have marked the history of photography, its functions, and its interpretations. Iconography plays a key role here too, and responds to the criterion of visual narration already noted in connection with the monographs. Attention is focused in both cases on striking a balance between the most renowned images, the icons of photography, and others that are less known but no less important for the purposes of providing the most complete overview possible.

Glossary

The history of the photography is inseparably bound up with the history of technology, the evolution of equipment for capturing and printing images all the way from the daguerreotype to digital cameras. For this reason, photography makes use of highly specific terminology regarding the succession of different processes, above all during its infancy, which is sometimes crucial to any understanding of the nature of the images before us. A basic glossary is therefore provided to help readers find their way in a world where primary importance attaches to the technical dimension.

Synoptic tables

In every history, synoptic tables supply the reader with crucial support as regards the reconstruction of the socio-cultural context within which the events recounted in the text developed. These aids become even more important in the case of photography, precisely because of its inherent propensity to engage in constant dialogue with all the manifestations of knowledge, history, and everyday life. Ever since the birth of photography, there has been no event devoid of photographic documentation, no personage not captured on film. At the same time, scientific progress has often been reflected in advances in photographic equipment, sometimes with a radical impact on the language of photography. Finally, as the relationship of photography with the so-called major arts has been one of the fundamental questions addressed ever since 1839, direct links are often to be found between artistic developments and the evolution of the photographic vocabulary.

Bibliography

Each volume has two separate types of bibliography, one accompanying each of the short monographs and essays, offering references for further exploration of the subjects and the authors addressed; and the other at the end of the volume, providing a concise but comprehensive overview of the vast literature for the entire period considered. The latter is thematically arranged to enable readers to refer to their own particular areas of interest. Specific studies regarding individual figures are not included in this general bibliography, but can be found in those accompanying the monographic texts, or those of the numerous volumes cited.

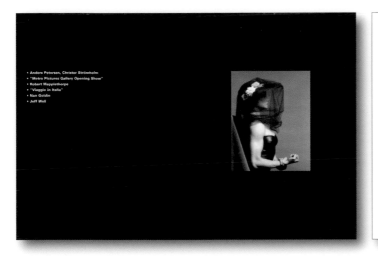
- Anders Petersen, Christer Strömholm
- "Metro Pictures Gallery Opening Show"
- Robert Mapplethorpe
- "Viaggio in Italia"
- Nan Goldin
- Jeff Wall

Monographs

Thomas Weski

Documentary Modes

Essays

Contents

10 Introduction
Walter Guadagnini

14 Documentary Modes
Thomas Weski

36 Anders Petersen, Christer Strömholm
46 "Metro Pictures Gallery Opening
Show"
56 Robert Mapplethorpe
64 "Viaggio in Italia"
72 Nan Goldin
80 Jeff Wall
Francesco Zanot

88 Photography and the Archive:
1980–2013
Okwui Enwezor

110 "Aus der Distanz"
118 Paul Graham
124 Hans-Peter Feldmann
132 Hiroshi Sugimoto
138 "1ères Rencontres de la photographie
africaine de Bamako"
146 Rineke Dijkstra
Francesco Zanot

154 Photography in the 21st century
Charlotte Cotton

172 Wolfgang Tillmans
182 Boris Mikhailov
188 "The Museum as Muse: Artists Reflect"
196 Martin Parr, Alec Soth
204 Luc Delahaye
212 "Between Past and Future:
New Photography and Video from
China"
Francesco Zanot

218 A Narrative of the Present
Walter Guadagnini

246 The Atlas Group and Walid Raad
252 "From Here On: Neo Appropriation
Strategies in Contemporary
Photography"
262 Adam Broomberg & Oliver Chanarin
Francesco Zanot

Appendix

273 Glossary
277 Timeline
287 Bibliography
295 Index of names

Walter Guadagnini

Introduction

The opening of this volume coincides with the appearance of the first digital camera on the market in 1981 and the first, celebrated operation of digital retouching in 1982, when a pyramid was moved to make it fit on the cover of *National Geographic*. The book ends with Kodak's decision to discontinue production of Kodachrome film in 2009 and the birth of the Instagram app in 2010. The course of photography developed over the thirty years between these events, three decades that saw the latest in the long line of revolutions in which photography has played a leading role since its birth. In terms of book publications over the same period, Jean Baudrillard's *Simulacra and Simulation* appeared in 1981 and Fred Ritchin's *After Photography* in 2009. Photoshop, the Web, the Internet and Flickr are now readily accepted terms of everyday use, an integral part not only of our culture but of our life as a whole. While it might almost seem as though they have been with us since time immemorial, a glance at the chronology in the closing pages of this book will suffice to show that they are actually very recent inventions, practices and commercial ventures, which have changed our relations with the world and with our fellow human beings in the very short space of a few years, or decades at most. Each of these inventions has to do with photography. From apps directly involving the camera and the capturing, processing, and printing of images, to those regarding the sharing of photographs, this technological evolution has affected every stage of the photographic process, and sometimes has even been generated by the same. The three previous volumes of this work endeavoured to recount the variety of the nature and uses of photography through different voices and from different standpoints, highlighting the plural nature of an instrument born out of a confluence of science, art, and industry, as well as its paramount role in the era of mass communications. This fourth volume now addresses the advent of what has already been described as the post-photographic era, and shows that it is paradoxically the richest in photographic images in history. A further addition to the long list of paradoxes that have marked the history of photography and make its study as fascinating as it is complex, entailing as it does a whole variety of methodological approaches and multidisciplinary knowledge, as well as skill in interpreting not only the image but also – and often above all – its context.

The period considered here is also important in historical terms, marked by epoch-making events like the collapse of the communist regimes of eastern Europe, the dramatic Yugoslav Wars fought in Europe, the terrorist attack of September 11 and the ensuing US military campaigns in various parts of the Middle East, the rise of China as a new economic power and the Arab Spring, to mention just those of greatest impact and

repercussions. It is curious to note that these events are not represented directly in the pages that follow. There are no photographs of statues of dictators being toppled, or planes crashing into the Twin Towers, even though such images do exist and have been published and seen thousands or even millions of times. It is, however, for this very reason – because overuse has dulled their edge – that we have chosen not to present them here and to focus instead on those who have considered these matters in depth through photography, using the medium in full awareness of the new context in which we all find ourselves. It is no coincidence that the volume opens and closes with two essays, one by Thomas Weski and the other by myself, focusing precisely on the new definition and the new practices of photojournalism and documentary photography. Both of these have been called into question most explicitly by the advent of the new technologies and new means of communication, first and foremost the Internet, which have focused still more attention on photo manipulation and introduced new ways of providing and using information, thus essentially prompting photographers to reflect on their role and their instruments. All this can be seen in the work of many of the photographers presented in these pages. At the same time, however, as Okwui Enwezor writes in his essay, this is also the age of archives, one characterised by the ubiquity and all-pervasiveness of the archival practices inherent in the instruments we use every day, including computers and cameras. On the basis of these reflections, Enwezor addresses a series of responses from some of the leading contemporary artists who use photography as their primary means of expression. Since it is clear that the last decades of the twentieth century and the first of the twenty-first have established the primacy of photography amongst the visual arts, thus marking definitive completion of a process that began halfway through the nineteenth century, when some photographers began to claim the right to be regarded as artists, a status that proved anything but easy to obtain. Inclusion in museums and the highest centres of artistic education – not to mention the stratospheric prices fetched by some photographs in auctions – have now ensured that at the time when the very existence of photography as previously known is being called into question, the work of some photographers, both contemporary and of the more or less recent past, has become an integral part of the artistic culture of the century as well as a possible field for financial investment. Photography is therefore more alive and kicking today than ever before both in communications and in the world of art. In this connection, Charlotte Cotton focuses fruitfully on the new generations of photographers born in the digital era, whose approach to the instrument and its potential is once again new and surprising in its capacity to combine the very latest

practices with the memory of actions and attitudes apparently linked to the past. It is precisely with this glimpse of a nascent creative world that this long publishing venture comes to an end. On its conclusion, I would like to thank all those who have been involved in different ways. First of all, the various representatives of the UniCredit banking group, who have unwaveringly supported the project in the course of these four years, even when the going got tough, presiding over its birth and following its development through to today's conclusion. All the staff of Skira, for the commitment and passion they have always shown in the by no means easy task of assembling so many heterogeneous materials. All the authors whose theoretical contributions to the series over these four years have made it an absolutely unique and extraordinary product in the Italian panorama, and unquestionably noteworthy also at the international level. The compilers of the scholarly indexes that enrich the work in an essential way. Finally, we are particularly indebted to Francesco Zanot for his extraordinary work in terms of research and writing, as well as his unflagging involvement in each and every volume, with rare insights and constant readiness to assist.

Thomas Weski

Documentary Modes

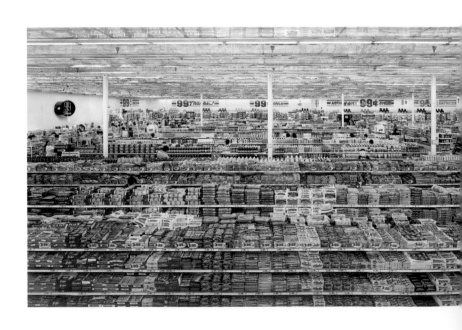

Contemporary fine-art photography is shaped by various methods of representing reality. At the same time, over the past decades the concept of documentary has changed, and now encompasses different methods of interpreting reality. The visual results were produced in direct contrast with reality or indirectly derived from it in some other way. These documentary modes no longer merely involve merely duplicating reality using the vehicle of photography.

The transformation of individual concepts may also involve minimal intervention during photography – such as the use of special photographic techniques, post-production of the subjects, or even computerised post-processing or construction. Despite the variety of different production methods and image-making strategies, the various subjective views reveal a worldliness, a close and seemingly truthful link with their subjects that can be described as a documentary moment.

The first growth phase of infrastructure for fine-art photography that took place in western industrialised countries in the 1970s was followed by the expansion and consolidation of this process. In this text I would like to present the various documentary approaches in contemporary photography through a series of different artistic positions.

Obviously, this selection is the result of a subjective process.[1] I am less concerned with meeting an encyclopaedic demand than presenting the exemplary works of photographers who have in my opinion introduced new aspects into documentary language.

In 1976 a photography class was founded in the Staatlichen Kunstakademie Düsseldorf (Düsseldorf Art Academy) under the leadership of Bernd Becher. In the late 1950s Bernd Becher, together with his wife Hilla, embarked upon a long-term project unparalleled in the history of art and photography, which involved photographing framework houses and anonymous industrial structures like mine winding-towers, blast furnaces, gasometers, factories, mines, and grain silos. They researched their subjects, which were located in the United States as well as Europe, in a scientific manner.[2] Bernd and Hilla Becher organised their black-and-white images in what they called "typologies" or ordered sets of single images. The presentation of several prints in a single large-format picture allowed viewers to observe and compare images on the basis of variation and repetition. This visual roundup of the features of a subject group represented a kind of "besten Durchschnitt" or "ideal mean".[3] When seen from a distance, the grid-like picture consisting of nine, twelve, fifteen, or more photographs would appear as a composition in its own right, which would dissolve when viewed close-up, making way for the arrangement of single pictures. Subsequently, this arrangement would also disappear into the background, and the differing subjects would induce observers to examine the single images in depth. This self-referential presentation allows the grid to be read in multiple directions, horizontally, vertically, or diagonally. The unification of the form and imagery makes this type of comparative viewing possible. The typologies, which represent a cross-section of time and space

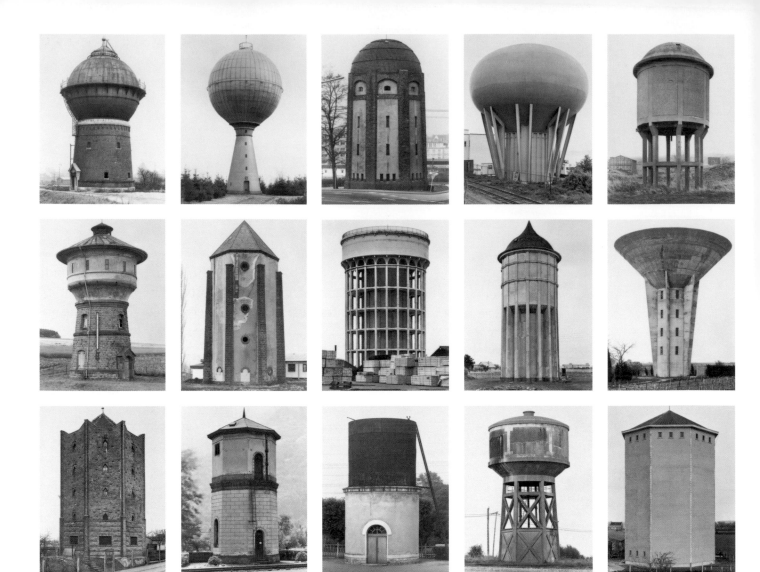

combining photographs from four decades of work and from various countries, show a world that appears to be frozen. The artistic work of the Bechers does not appear to undergo any visible development; there are no early or late works. The fact that this apparently dispassionate representation conceals a passionate interest in the subject is the paradox distinguishing their work. During the course of their development, their works have been defined as a part of the protection of historical buildings and monuments, as documentary photography, as concept art, and, lastly, as fine-art photography in the form of a document.[4]

Traditionally, the term documentary photography refers to an image that apparently reproduces objects first-hand without any obvious interpretations. This presumed neutrality causes it to be considered authentic, traceable and therefore appropriable. In an interview in 1971 the great American photographer Walker Evans touches upon these issues yet defines his own photography, which mostly dates to the 1930s, in a rather different way. "Documentary? That's a very sophisticated and misleading word. And not really clear. You have to have a sophisticated ear to receive that word. The term should be *documentary style.* An example of a literal document could be a police

photograph of a murder scene. You see, document has use, whereas art is really useless. Therefore art is never a document, though it can certainly adopt that style."[5]

This distinction between a form of photography associated with a precise field of application, and photography that develops out of it according to artistic criteria, represents the two poles and differing characters of documentary photography. While its traditional form aims to reproduce the visible world in as true a manner as possible, documentary style represents a world view in the form of a document. This is a crucial difference, with one type of photography committed to producing an accurate image, and the other invoking the tradition of the personal gaze and therefore the author of the photograph. While one type of documentary photography is concerned with using the tool of photography to attain the most accurate representation of the world, the aim of the other is to formulate a subjectively based vision of the world.

The photography course at the Kunstakademie Düsseldorf was the first course in Germany to give students the opportunity to embark upon photographic training outside the traditional system of schools, which had a predominantly professional orientation focussing on photojournalism or advertising photography.

The curriculum in art academies is closely linked to the lecturers concerned and follows in the footsteps of the master-apprentice tradition. Classroom teaching is therefore extremely individual. Among the first students to enrol in Bernd Becher's class at Düsseldorf were a number of students already attending the academy like Thomas Struth, Axel Hütte, and Candida Höfer. It was not until later that photography students like Thomas Ruff or Andreas Gursky applied for places in this special class.

They received all the benefits available to academy students like grants, publication subsidies or studies abroad, which allowed them to be recognised in the context of art and culture.

The 1977 documenta 6 held in Kassel made a vital contribution to the recognition of photography as an art form in Germany and Europe. Back in 1972, Harald Szeemann, documenta 5 curator, decided to display photographs for the first time although they were shown for the purpose of documenting performance art or Land Art, not as art in their own right. Manfred Schneckenburger, director of documenta 6, called upon a team of experts in photography to represent schools of artistic thought from the nineteenth and twentieth centuries.

This resulted in a pictorial representation of the history of photography beginning with the pioneers of the past like Niépce, Talbot, and Daguerre, and ending with the very different works of photographers of the present like Bernd and Hilla Becher, Lee Friedlander, or Stephen Shore. On the 150th anniversary of this medium, for the first time ever, photography was being shown as a means of artistic expression on equal terms with other art forms in this huge exhibition of contemporary art, thus reaching a wider public beyond the narrow scope of trade exhibitions.[6]

Massimo Vitali
Rosignano Black, 1995
Courtesy of the artist

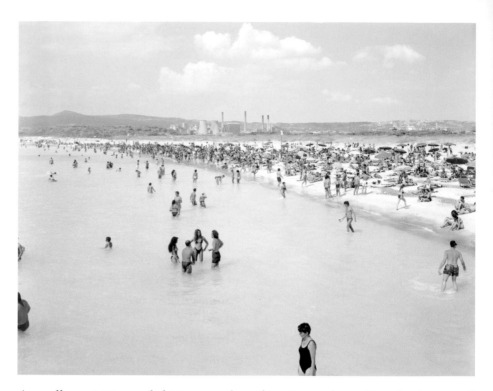

As well as visiting exhibitions and reading journals and books, lovers of photography had other opportunities to obtain and exchange information. In Berlin in 1976 photographer Michael Schmidt set up a photography workshop at the Volkshochschule Kreuzberg, an adult training college, to provide "an alternative to the traditional photographic training centre … courses are open to everyone seriously wishing to learn how to use photography as a means of expression".[7] In addition to courses on method, the programme offered criticism, exhibits, and conferences. Workshop talks were held to allow photographers to describe their own work or that of their colleagues. From 1980 onwards art photographers of the period had access to another hotbed of information in the symposia held for a period of several years under the direction of Christine Frisinghelli and Manfred Willmann as part of the Steirischer Herbst international contemporary art festival. A combination of exhibits and talks later published in the *Camera Austria* magazine represented a highly sustainable information format. The geographical proximity of southern and eastern Europe guaranteed a highly international public. Events also saw the participation of Italian photographers such as Luigi Ghirri, Olivo Barbieri, Gabriele Basilico, and Guido Guidi as both visitors and speakers.

In 1978 Luigi Ghirri self-published his first monograph *Kodachrome* in which he presented his interpretations of the contemporary Italian landscape in austere colour photographs. He also re-photographed postcards and advertisements, which in turn contained photographic subjects. He mixed these works with his own photographs in order to explore the different forms of reality: "The daily encounter with reality, the fictions, the surrogates, the ambiguous, poetic or alienating aspects, all seem to preclude any way out of the labyrinth, the walls of which are ever more illusory… to the point at which we might merge with them…

The meaning that I am trying to render through my work is a verification of how it is still possible to desire and face a path of knowledge, to be able finally to distinguish the precise identity of man, things, life, from the image of man, things, and life."[8]

The extent to which the Graz photography symposia, their speakers, and exhibits influenced the development not only of European, but Italian contemporary photography in particular, has yet to be established. Nevertheless, the Italian photographic historian Roberta Valtorta alluded to this in her 1987 Graz talk: "The presence of American influence, from Evans to Frank, from Friedlander to Meyerowitz, Eggleston, Shore, Baltz and Robert Adams, that is, generally, the interest in 'New Topography' and in colour – all this is so much alive and active in those young Italian photographers that we must of necessity speak of a state of transition, a step in the direction of a well-defined future situation."[9]

As it turned out, the contemporary fine-art photography scene growing up in Italy not only owed its reputation to the impressively comprehensive and internationally recognised works of Olivo Barbieri, Gabriele Basilico, and Guido Guidi, all mentioned above, but also to the contribution of works by photographers like Walter Niedermayr and Massimo Vitali. In his 1993 book *Die bleichen Berge* Niedermayr examined the impact of mass tourism on the Alpine landscape. He arranged his meticulous photographs with their own typical colour schemes in diptychs and triptychs whose parts were conceived as individual images, but whose documentary content and combined presentation constantly referred back to the fact that this was an interpretation of the use of a cultural landscape using the medium of photography. Massimo Vitali also used a large-format camera to take the photographs in his 2004 book *Landscape with Figures*, a series also tackling the phenomena of mass tourism besetting his homeland, Italy. He usually takes his photographs from a raised vantage point providing viewers with a privileged perspective that reveals the connections in his complex staging of beach and night-life in seaside resorts. There are also photographs taken in other countries, which generally see the artist exploring the use of public spaces. Vitali also arranges his single photographs in groups comprising single prints sometimes only separated by a short space of time and slight shifts in composition. This allows him to obtain interesting studies regarding the "decisive moment" in the photograph and the meaning of the individual in a mass society.

In 1967 the gallery Il Diaframma opened in Milan, in 1971 the independent Photographers' Gallery was founded in London, and in that same year in Paris the Bibliothèque Nationale opened its own photography gallery.[10] Twentieth-century art museums also began to open their doors to photography. Although they initially considered the medium a means to documenting ephemeral art forms, by the end of the 1970s, in Germany, the Museum Ludwig, Cologne, Museum Folkwang, Essen, and Berlinische Galerie had all opened their own photographic departments and were buying, collecting, exhibiting, and

publishing photographs. Their organisation and approach were all inspired by the Museum of Modern Art in New York, which had established its first photography collections as early as 1930 and had opened a photography department by 1940. Today in Germany there are now a dozen museums regularly displaying photographs, although only a handful do so on a continuous basis, and they are equipped with climate-controlled storage spaces suitable for photographs, or are staffed with curators with specialist expertise in this sector.

From the 1980s onwards, fine-art photography had gone from being the exclusive province of just a few specialist photography galleries to being included in the programmes of established commercial art galleries. The demand for photography was created by a younger generation of buyers who wished to acquire art despite their limited financial resources and had no prejudices against a medium that they had grown up with. The prices of photographs were still modest during the early years of this process of recognition, but in time they began to climb due to the increase in demand. Photographers followed the example of graphic artists and began to produce prints in limited editions. Although seemingly at odds with the reproduction potential of this technical medium, the practice of artificially limiting production caught on, with only a few exceptions. Despite the financial crises of recent years, instead of collapsing like the prices of other art works, the price level for photographs continued to rise. In the meantime, contemporary photographers like Cindy Sherman, Jeff Wall, and Andreas Gursky[11] formed a consistently high price segment in the international art market that was no longer called into question.

As a consequence these artists were able to make a living by selling their works, and no longer had to turn to other activities to earn their living, as generations of photographers before them were forced to do. Also making an important contribution to the acceptance and increased understanding of photography was Klaus Honnef's 1989 Bonn exhibition "In Deutschland – Aspekte gegenwärtiger Dokumentarfotografie". Honnef not only presented the leading West German photographers like Bernd and Hilla Becher, Heinrich Riebesehl, Michael Schmidt, and Wilhelm Schürmann, along with their younger colleagues like Candida Höfer, Axel Hütte and Thomas Struth from Düsseldorf, and Ulrich Görlich and Wilmar Koenig from Berlin, his catalogue also linked them historically to the like of Eugène Atget, August Sander, and Walker Evans. In addition, his programmatic

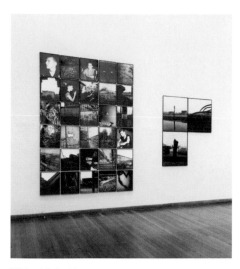

Michael Schmidt
Untitled from *Waffenruhe*, 1985–87
Gelatin silver print

catalogue text introduced the concept of auteur photographers, which he defined after auteur films. According to Honnef's description work by auteur photographers produces "a photographic reality that is authentic because of its strict adherence to the documentary principles of photography but that is nevertheless selected, filtered, processed, and compressed through a personal awareness and thereby bound to an individual vision. … When seen as a body these prints … express a clear stance with regard to reality … and, occasionally, a permanent vision of reality."[12]

The photographers selected by Klaus Honnef included Michael Schmidt who participated in the exhibition with documentary views of the urban landscape in West Berlin. Although he originally claimed "total submission to the things to be photographed"[13] he soon abandoned this approach when he published *Waffenruhe* in 1987, a book and exhibition project presenting a highly subjective and oppressive psychogram of the still-divided city of Berlin. He used a series of gloomy, atmospheric black-and-white images to describe the impact of the Cold War, linking it to the pessimist expectations for the future of the younger generation. *Waffenruhe* not only stands out for its suggestive form, but by tackling contemporary issues, presenting them metaphorically, and formulating them in pictures, it also stands for a constructive approach to existing political relationships. Schmidt continued to address topical political issues and contents in his subsequent works. In 1996 he published the *Ein-heit* series examining the process of Germany's reunification, while his latest project *Lebensmittel* takes a look at industrial food production.

Schmidt displays his works in constantly changing wall arrangements allowing him to tailor his show to the single venue involved. The single pictures in a series can be considered elements making up a grammar, elements meaningful by themselves, while the various presentations are like a frame of reference that is constantly rearranged by the artist, thus doing justice to the complexity of the theme and offering the viewers room for associative thinking, despite the documentary nature of the pictures. The work of Wolfgang Tillmans, a photographer born in 1968, obtains a very similar effect through a similar approach, and with a kind of leap through time. Tillmans is considered the chronicler of his generation, encapsulating their lifestyle in his pictures. He arranges his snapshot-like photographs evoking the techniques of keepsake photography on walls and in table display-cases to create complex display situations with highly subjective atmospheric feature stories. These arrangements are also made up of abstract pictures which, when combined with figurative photographs, act like blind spots in a story that viewers can fill with their own associations, thus becoming active participants.

The ordering and presentation of pictures in books and exhibitions, the arrangement of single pictures in a context – series, grid, sequence – are all part of authorship. A further level of observation resides in the entire body of exhibits or prints, which provides the basis for an understanding of the full formal and content meaning of the single

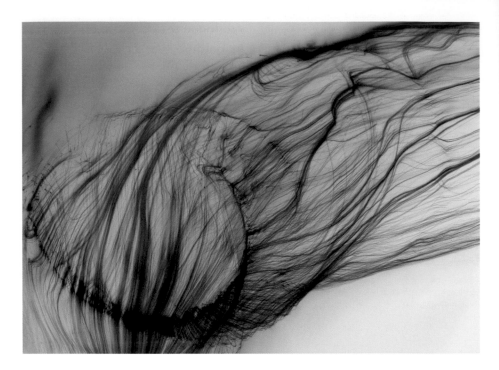

photographs. Unlike photojournalism, which comes into being through a juxtaposition of visual superlatives, this approach develops a kind of everyday drama, acknowledging apparently secondary issues and endowing them with meaning. The results of this artistic construction leave a lasting impression because they do not limit themselves to illustrating the imagination of the observer or visually enhancing visible phenomena. On the contrary, in composing their images, these photographers place these objects in an evocative dialogue that allows viewers to participate. By considering viewers as equal partners in analysing reality and leaving room for individual interpretation, they ensure that their photographs become firmly rooted in the viewers' memories, where they gradually develop their effect. Subsequently, this process may govern perception to such an extent that even in a real encounter with the objects concerned, viewers will continue to see them as the subjects of the artistic work. When this takes place, the photographer has succeeded in colonising viewers' subconscious and in preparing them for an altered understanding of the world.

The 1980s saw the rise of a series of international photographic centres that have continued to influence contemporary photography today. Rather than world metropolises, places like Düsseldorf, Boston, or Vancouver acted as poles for the development of photographic training opportunities and of communities partly defining themselves in terms of a related access to or perception of the medium of photography. With the growing commercial success of several of these artists, the art market created catchy expressions to allocate positions: for example, the so-called Becher School is one of the most persistent labels in this process of brand construction. Although the advantages inherent in such a classification led to it being initially welcomed by the members of the group of graduates from the Düsseldorfer Kunstakademie that it identified, later, as their work developed they began to perceive it as levelling and restrictive. In fact, the photographers grouped together

under the Becher School label have produced highly individual work. For the past four decades Candida Höfer has explored the meaning of public and private spaces. Although her encyclopaedic approach is in the tradition of her teacher, she adopts different approaches and forms of presentation in the formal transposition of her concepts.

Thomas Ruff enlarges passport-type portraits to create large-format portraits. His portraits of his fellow-students, who stood in for the generation of the 1980s, marked the transition from a classical format copy to a photographic picture with the same dimensions as a historical panel painting. In his work Ruff has constantly explored formal and content-related aspects of photography and other image-making techniques, continuously changing his work methods during the process. In time he made the leap from analogue to digital image-making, methodically examining genres, subjects, and techniques and focussing on human perception to combine analysis with image creation. Thomas Ruff recently described photography as the "greatest awareness-altering device to act upon humans"[14]; the technological developments of the past decade have revolutionised the presence and nature of photographs in newspapers, magazines, film and television, and possibilities for manipulation are constantly increasing.

By adopting the work method of a "scientific artist",[15] Ruff has altered our understanding of the expression "documentary", just as he has consistently pursued his individual path from reproduction to the image as a credible construction of authenticity – with the aim of "attaining pictures that we have never seen quite like that".[16]

Thomas Struth's sober black-and-white photographs of streets in Düsseldorf, Europe, and New York exploring public space in different cultural contexts were followed in the mid-1990s by his series of large-format "Museum Photographs", which allowed him to make his international breakthrough. In these colour photographs a relationship was created between the viewers and the artistic masterpieces on display. In fact, the audience of his museum photographs discovered themselves in the observers of artworks being portrayed. The prints

Thomas Ruff
Portrait 1988 – (L. Coelevy), 1990
C-print, 24 x 18 cm

Thomas Ruff
Portrait 1988 – (S. Weirauch), 1999
C-print, 24 x 18 cm
UniCredit Art Collection –
HypoVereinsbank

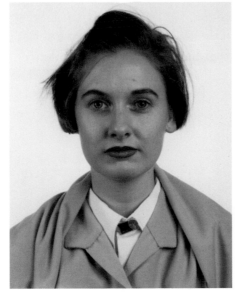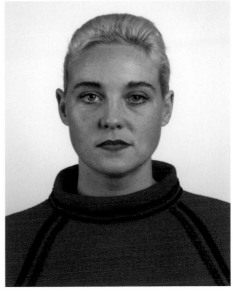

conveyed statements about various phenomena of our times, mass tourism and reception of artworks in conditions of globalisation, as well as the availability and accessibility of artworks. None of these astonishing pictures are staged. They are the result of a patient wait for the crucial moment in which the objects form a fruitful constellation corresponding to the artistic concept. Thomas Struth's work can be encapsulated in Diane Arbus's words, "Instead of arranging it, I arrange myself".[17]

The works belonging to the Becher School are usually united by the same accurate photography and the presentation of the artistic results as large-format framed prints mounted under Plexiglas. When first introduced, this presentation method represented an innovation, but it has since been taken over by numerous photographers, becoming a standard procedure. The format, which is frequently larger than the standard dimensions, makes it possible to view the photographs in a different manner, one that no longer focuses exclusively on recognising the composition and studying details, but enables a different presentation in the exhibition space concerned, and a reception that can be experienced physically. Also characterising their work was the use of colour photography, which was infrequently used in artistic contexts at that time. William Eggleston's 1976 exhibition at the New York Museum of Modern Art paved the way for the growing acceptance of colour photography as a means of artistic expression – until then it had been restricted to advertising and journalism.

Yet colour photography could give subjects an evocative charge, influence their perception by viewers, and, what is more, unlike black-and-white photography, which was always perceived as indicating a completed action in the past, it was apparently rooted in the here and now. This led to the creation of works in Germany that were

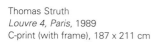

Thomas Struth
Louvre 4, Paris, 1989
C-print (with frame), 187 x 211 cm

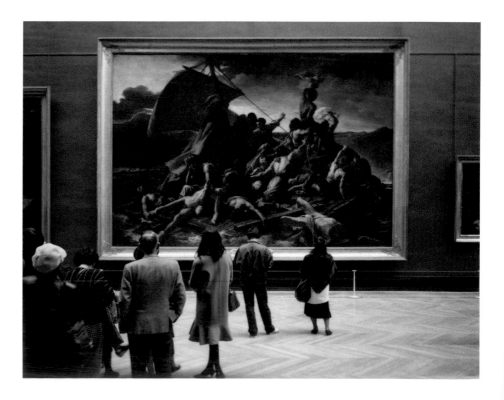

Philip-Lorca diCorcia
London, 1995
C-print, 65 x 97 cm
UniCredit Art Collection –
HypoVereinsbank
Courtesy of the artist and David
Zwirner, Spruth Magers, Berlin /
London

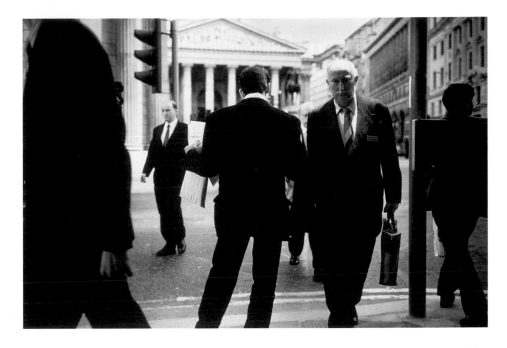

simultaneously characterised by the accessibility of their subject world, seductive form and content analysis, and which contributed to the international breakthrough of the Becher School.

The work of American photographer Nan Goldin, who studied photography in Boston in the 1970s, is characterised by a rather different documentary approach focussing on the private sphere. Her fellow students included Philip-Lorca diCorcia, David Armstrong, Mark Morrisroe, and Jack Pierson, who all worked under the heading of Boston School of Photography despite their very different approaches to their work – a further attempt by the art market to create a label along the lines of the Becher School. Philip-Lorca diCorcia became known for colour photographs that used flash lighting placed outside the camera's field of view to "freeze" people moving in public spaces in their casual constellations, thus transforming the street into a stage. These pictures, laden with the drama and narrative of a film still, represent a distillation of shared human behaviour. Goldin's approach, on the other hand, is intensely private. She documented her relationship with her then partner and her personal world revolving around the underground and alternative life-styles. Care, love, violence, sexuality, drug use, and self-discovery are the themes of this autobiographical and often intimate story in pictures and Goldin often finds a way to place her own striking self-portraits in the heart of this story. Before *The Ballad of Sexual Dependency* came out in book form in 1987, Goldin presented the series as a work in progress in the form of a slideshow accompanied by a soundtrack chosen by the artist. Evolving over a period of years, this project, which blended artistic work with real life, was not seen from the perspective of someone on the outside, but from that of an involved observer.

Until the 1980s Britain was dominated by a traditional type of social documentary photography characterised by a marked political class consciousness. Photographers defended the vulnerable and the victims of the capitalist system. They denounced social problems

in black-and-white photographs resembling the images of photojournalism, published them in the appropriate publications, and exhibited them in their traditional associations, which were linked to the workers' movement. At first glance Chris Killip's *In Flagrante* would seem to belong to this tradition. However the series abandons the conventional presentation, making its personal glance a yardstick in the context of this entirely political and enlightened work. In 1988 Killip published his black-and-white photographs in a painstakingly edited book that provided no accompanying information whatsoever. His picture essay documented the industrial decline in northern England along with the unemployment, drug use, rebellion and defiant refusal to abandon traditions. When showing them in exhibitions Killip displayed his black-and-white prints in a relatively large format for the times, which brought the pictorial element to the foreground. *In Flagrante* attracted great attention because of its vivid evocation of social conditions under the Conservative Prime Minister Margaret Thatcher, and her dismantling of the welfare state, while placing them in an artistic context.

Martin Parr photographed rural life in provincial Britain until the 1970s before turning to bad weather, probably the nation's favourite topic of conversation. Whenever there was rain, snow or storms, Martin Parr would set off with his underwater camera, which he kept ready for his expeditions to familiar locations. In order to keep taking photographs even when weather conditions were extreme and it was dark in the daytime, he started using an underwater flash light. The combination of flash light, which completely lit up and brightened the foreground, and the daylight, which the photographer captured on the film by using a slow shutter speed causing the background to become visible, gave these black-and-white pictures a curiously artificial

Martin Parr
England. New Brighton,
from *The Last Resort,* 1983–85

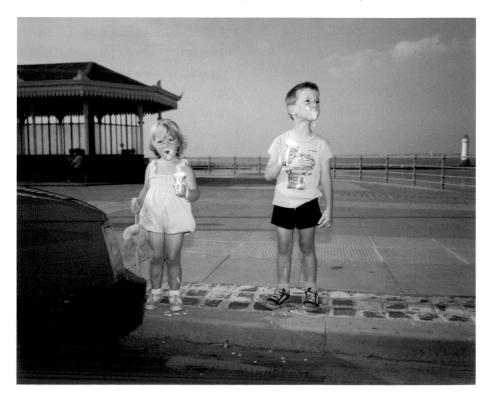

Paul Graham
Wall Street, 19 April 2010,
12.46.55 pm, from *The Present*, 2011
C-print, 101.6 x 152.4 cm
Diptych, edition of 5
Courtesy of Pace Gallery and
Pace/MacGill Gallery, New York

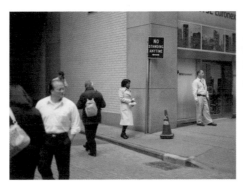 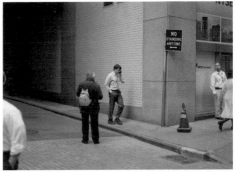

appearance. Parr continued to use this photographic technique and ironic staging of everyday dramas in his later series. He used colour photography for the first time in *The Last Resort* to explore the leisure activities of his compatriots. The book, which was self-published in 1986, contained a series of scenes set in the seaside resort of New Brighton and viewed through the photographer's typically pitiless lens. The use of the flash light with colour photography introduced the seductiveness and availability familiar to advertising to fine-art photography, a strategy that still holds true for Martin Parr's work today.

In *Beyond Caring* the British photographer Paul Graham examined the consequences of Margaret Thatcher's reform of the welfare state. He documented the depressing waiting rooms in welfare offices in a series showing the endless wait of job-seekers in a sympathetic way. The use of colour photography not only enhanced his depiction of his subjects, but also gave his pictures a suggestive charge involving viewers emotionally. The subjectivity present in several of the pictures caused these descriptions of various situations to appear particularly authentic although they were criticised by some social documentary photographers for the use of a hidden camera to portray some of the subjects, meaning that the presumed authenticity of the prints was based on a construct. The ethical conflicts inherent to this approach, sensed by traditional photographers, can be illustrated by means of a historical example. In the mid-1930s the American photographer Walker Evans visited the families of farmers in the wouthern states together with the writer James Agee in order to report on the effects of the great drought on suffering country folk. His sensitive portraits and vivid interiors have always been held to document a national crisis. Yet a number of his photographs were skilfully staged in order to enhance reality and make it appear even more credible in the pictures. In one of his pictures, Evans pushed a farmer's bed into a diagonal position in order to draw attention to the flies on the unwashed sheets. Is this contrary to the rules of documentary photography, or does it contribute to the discovery of the truth in the context of a documentary work? In his 2004–2006 *A Shimmer of Possibility*, Graham examines the message of a single picture in the context of a social theme. The photographs, all taken in the United States, his chosen homeland, dealt with the meaning of public space and the movement of the people portrayed within it. Graham published them in a book comprising

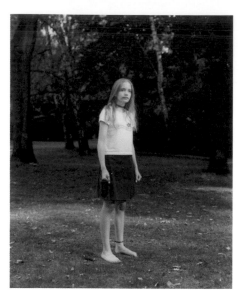

Rineke Dijkstra
Tiergarten, Berlin, 27 June, 1999
Courtesy of Marian Goodman Gallery,
New York / Paris

Although the Canadian photographer Jeff Wall makes similar claims, he uses different artistic means to express them. He began staging his photographs thirty years ago, initially inspired by historical sources and now usually based on observations and studies. The artist does not react to given situations or subjects in the way that traditional photographers do, but recreates these and then photographs them. To some extent his picture production resembles that of films, and the artist describes the photographs produced in this manner as "cinematographic".[19] Wall places performers before a camera where they carry out a series of rehearsed actions on a carefully staged set. He then chooses the shot best expressing his vision. For some time now Wall has also used digital processing techniques to produce works going beyond the compositional possibilities of traditional photography. These large-format works, initially presented exclusively in light boxes, radiate a magical luminosity. The adoption of presentation techniques used in advertising makes these works fascinating, and suggests the major issues of the modern age and the present dealt with by Wall: alienation and loneliness, the desolation of the cities, the abuses of capitalism, and the consequences of globalisation. Although Wall began by carefully staging every detail of his pictures, he now gives himself more freedom, letting chance influence his compositions.

In so doing he is following a long-established photographic tradition that views chance as a possibility for enhancement. In Wall's works what can be calculated and the unpredictable come together in synthesis of fiction and fact, creating a documentary path that leads back to reality. Seen in the context of contemporary photography, his works, which use staging to obtain their alienating effect, may be the ones coming closest to fulfilling the demand made by Bertolt Brecht in 1931, when he remarked that "The situation is complicated because the simple 'reproduction of reality' says less than ever about that reality. A photograph of the Krupp works or the AEG reveals almost nothing about these institutions. Actual reality has slipped into the functional. The reification of human relations, the factory, for example, no longer discloses these relations. So something must in fact be 'built up', something 'artificial', 'posed'. It is equally true that art is necessary to do this."[20]

The Dutch photographer Rineke Dijkstra, who has been making portraits of adolescents for several decades, can show us just how something so artificial or posed may appear when combined with a documentary approach. In some cases she developed close relationships to her models, resulting in portraits of the same people photographed over a period of time. The use of time-lapse in these photographs means that those viewing these processes of maturation, mostly transitions to adulthood, participate in comparative observation. When Dijkstra takes her photographs in public spaces, she begins by establishing how to frame her as-yet-unfinished portrait. After establishing her location and conditions, she asks potential models – she generally works with young people who are still in the phase of

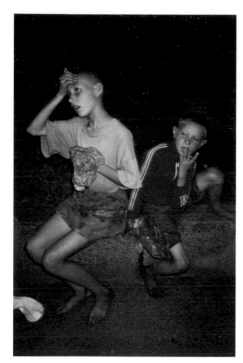

Boris Mikhailov
Untitled, from the series *Case History*,
1997–99
Courtesy of Pace/MacGill Gallery,
New York

personal development – whether she can take their photograph. Her models assume their poses – with occasional input from the photographer with regard to details – within the established frame. Simultaneously aware of the photography process yet denying it, the resulting portraits shift between spontaneousness and artifice. This is also a result of Dikjstra's technique, which combines use of daylight with artificial lighting.

These artificial moments lift her pictures from the sphere of pure documentary photography, creating an artistic interpretation of adolescents and their relationships in an in-between space within a timeless formal language.

A different kind of ambivalence characterises the work of Ukrainian photographer Boris Mikhailov, whose photography book, *Case History*, was published in 2000. This pictorial "case history" uses shockingly immediate photographs to document the consequences of the break-up of the Soviet Union in his country. The abrupt introduction of an economic system – which took the form of an early capitalism – created victims forced to live on the fringes of society by their lack of welfare support. Sometimes Mikhailov worked together with his subjects to stage pictures, whose compositions were drawn from Christian iconography. Both types of photos, his direct social documentary photographs and staged portraits, sow doubts.

The artist arranged them in an essay resembling a grotesque, whose artificial nature made it possible to illustrate social conditions in an unconventional manner, creating a disturbing and even more powerful impact.

A total different conception of documentary style distinguishes the staged works prepared by photographers like Cindy Sherman, James Casebere, and Thomas Demand. Cindy Sherman began by photographing herself in the 1970s when she was still a student, assuming different poses illustrating the clichéd models of behaviour communicated by the media. The *Film Stills* series published on the occasion of her solo show at the Museum of Modern Art in 1995 show her taking on various roles, wearing different clothing and appearing on different sets, which viewers believe they recognise from the history of films. Her works referencing Post-Modernism and gender discussion played with stereotyped representations of women in the media. If one considers mass media like newspapers, television and film as a part of reality, then these staged works contain something resembling a documentary momentum. In the case of James Casebere, who became celebrated for his photographs of architectural models that he had built himself, it is equally clear that, regardless of how it came into being, a collective memory is the key to interpreting his scaled-down but highly effective interiors.

A similar concept underpins the work of the German artist Thomas Demand, who makes paper models recreating historical situations viewed by the media and then photographs them. Afterwards he destroys these models, which were created to be seen from the perspective of the camera, and all that remains is a photographic image

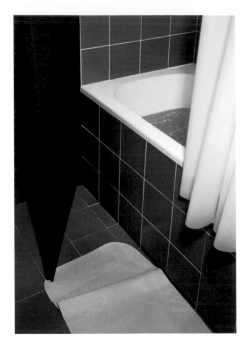

Thomas Demand
Bathroom, 1997
C-print / Diasec, 160 x 122 cm
Courtesy of Spruth Magers, Berlin /
London

referring to another photographic image. If viewed outside their cultural context, these works become mere aesthetic constructions and cannot be considered documentary pictures, given that collective memory only functions in the same social context and generation. In addition to the investigative powers of fiction, on which these photographers draw, the unifying moment of their works is the artistic exploration of the mass media, from which they take their documentary content. Moreover, they also reflect the different uses of photography in the form of imitation, thereby disclosing its structure and mechanisms.

Jean-Francois Chevrier's demand for a "construction of information" expresses itself as an element linking the different artistic strategies in the sphere of documentary photography. Contemporary fine-art photography is characterised by the diversity of these documentary concepts, which reflect also their own medium – photography and its history. The description of reality is less important in this context than an artistic representation of the world, whose realisation may involve the use of traditional media, acting or improvisation in established frameworks as well as the staging of shots. Staging, post-staging or post-processing of photographs using digital media represents another way of formulating a subjective understanding of the world, revealing it by means of a collectively rooted picture.

The construction in question may be expressed as the sum of single parts in a photographic series or a composition of different shots forming a single picture, as a deliberate statement or as intended artificiality, but whatever form this conception of reality takes it always incorporates belief and doubt in the photographic image.[21] Regardless of whether we consider this stylistic instrument a "distancing effect" similar to the device employed by Bertolt Brecht in his Epic Theatre "to make the audience assume a critical perspective with regard to the events being staged"[22] or a fundamental element of contemporary descriptions of reality using photographic means, the end result is a changed, broader understanding, and new perception of the documentary mode.

Annette Kelm
Anna #1, 2011
C-print, two parts, 52 x 42 cm;
69.8 x 60.3 cm
5 + 2 AP
Courtesy of the artist and Johanna
Konig, Berlin

1 In this text I intend to focus on a select number of key positions in fine-art photography, representing a further evolution of the documentary mode. In non-western cultural circles documentary work is often carried out for different purposes, which will introduce new aspects into the debate about the meaning of the documentary mode in photography.

2 Although Bernd Becher died in 2007, Hilla Becher has continued to work on their joint project.

3 Hilla Becher in a conversation with the author, Kaiserswerth, 23.6.2003, quoted in T. Weski, *Der beste Durchschnitt*, in B. und H. Becher, *Typologien*, Schirmer/Mosel, Munich 2003, p. 46.

4 The varied reception of their work over the years also led to the Bechers being awarded the Golden Lion at the 1990 Venice Biennale in the category of sculpture.

5 Walker Evans talking to Leslie George Katz, "Art in America", March/April 1971, reprinted in *Walker Evans, Incognito*, Eakins Press Foundation, New York, 1995, p. 18.

6 Cf. K. Honnef, *150 Jahre Fotografie*, Kunstforum, Mainz 1977.

7 M. Schmidt, *Gedanken zu meiner Arbeitsweise*, in *Camera*, March 1979, p. 11.

8 Luigi Ghirri, http://www.mackbooks.co.uk/books/44-Kodachrome.html

9 R. Valtorta, *Amerika – Europa good bye – hallo II*, in *Camera Austria*, No. 22, 1987, p. 41.

10 *Photogalerien in Europa – Bilanz einer Umfrage*, Spectrum Photogalerie Hannover, Hannover 1975. The 1974 survey lists a total of 28 exhibition venues for photography in Europe. A number of institutions, like for example, The Museum of Modern Art in Oxford, were included even though they do not exclusively host photography shows. The infrastructure for showing photographs was therefore still rather limited in the mid-1970s. The extent to which this situation has changed emerges clearly from the magazine *Photonews*, which lists 246 photography exhibitions taking place in German museums, cultural associations and galleries in November 2005. *Photonews*, No. 11, November 2005, pp. 25-27.

11 In 2011 *Rhein II* by Andreas Gursky sold for $4.3m at Christie's, setting what is still the record for most expensive photograph ever sold.

12 K. Honnef, *Es kommt der Autorenfotograf*, in *In Deutschland – Aspekte gegenwärtiger Dokumentarfotografie*, Bonn 1979, p. 24.

13 M. Schmidt, *Gedanken zu meiner Arbeitsweise*, in *Camera*, March 1979, p. 4.

14 Thomas Ruff in the film by Ralph Goertz, Institut für Kunstdokumentation und Szenografie (IKS), Düsseldorf, 2011.

15 G. Jappe, *Industrie – Aschenputtel der Kultur? Die Architektur der Förder- und Wassertürme*, in L. Derenthal, *Die Dokumentation der Zeche Zollern 2 – Arbeiten an der Grenze zur Typologie*, in B. und H. Becher, *Typologien industrieller Bauten*, Schirmer/Mosel, Munich 2003, p. 260.

16 Thomas Ruff in conversation with the author, 13.7.2011, quoted in: *Thomas Ruff, Works 1979-2011*, Schirmer/Mosel, Munich 2012, p. 36.

17 D. Arbus, in *Diane Arbus*, Aperture, New York 1972, p. 12.

18 J-F Chevrier, *Das Tableau und das Dokument der Erfindung*, in *Click DoubleClick – das dokumentarische Moment*, König, Cologne 2006, p. 57.

19 Cf. *Interview between Jeff Wall and Jean-Francois Chevrier*, in J. Wall, *Selected Essays and Interviews*, The Museum of Modern Art, New York 2007, p. 318.

20 B. Brecht, *Gesammelte Werke in 20 Bänden*, Suhrkamp Verlag, Frankfurt/Main 1967, Vol. 18, p. 161.

21 I believe that artistic works of the younger generation of photographers like Annette Kelm, Roc Ethridge or Christian Patterson have various elements in this enumeration in common.

22 B. Brecht, *Kurze Beschreibung einer neuen Technik der Schauspielkunst, die einen Verfremdungseffekt hervorbringt*, in B. Brecht, *Gesammelte Werke*, B. 15, Suhrkamp Verlag, Frankfurt/Main 1967, p. 341.

- Anders Petersen, Christer Strömholm
- "Metro Pictures Gallery Opening Show"
- Robert Mapplethorpe
- "Viaggio in Italia"
- Nan Goldin
- Jeff Wall

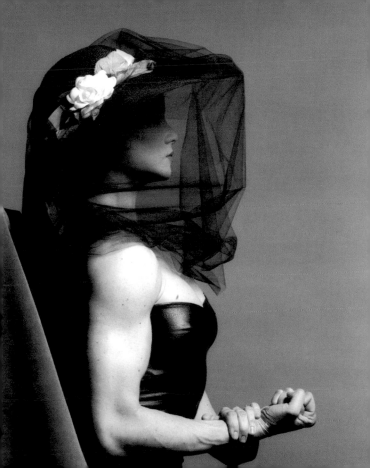

Anders Petersen
Christer Strömholm

Café Lehmitz

Schirmer/Mosel: Munich, 1978

Christer Strömholm was born in Stockholm in 1918, and prepared for his artistic career by studying painting, first at the Academy of Fine Arts in Dresden and then in Sweden under Otte Sköld and Isaac Grünewald. He enlisted in the army as a volunteer during World War II, and later joined the resistance movement in his home town. He discovered photography in 1946 when he moved to Paris, and then went back to studying at the academy. From the outset he refused to specialise in a particular genre and photographed the most disparate subjects, from the faces of artists (André Breton, Fernand Léger, Man Ray, Le Corbusier) to graffiti, from nocturnes to objects he came across in the street, and in the houses and shops he frequented. The thread linking all this was his invariable gaze, which enabled him to blend irony and disquiet in pale black-and-white photographs. In 1949 he became a member of the German group Fotoforum, founded that same year by Otto Steinert, and two years later he took part (under the pseudonym of Christer Christian) in the first edition of the group exhibition "Subjektive Fotografie" in Saarbrücken. These were pivotal experiences that determined his poetics, which combined the documentary function of photography with the vibrant expression of his own individuality. Every photo he took possessed all the power of the encounter/conflict between the subject and the photographer, and the camera accentuates its consequences. Immersed in the energetic, restless atmosphere of Paris, where the foreign photographers passing through included William Klein and Ed van der Elsken, in 1956 Strömholm began a lengthy project on the transsexuals who lived in the area of Place Blanche, where the famous Moulin Rouge was located. This work lasted until 1962, when the Swedish photographer returned to Stockholm, and was not published by Förlag until 1983, with the title Les Amies de Place Blanche and texts by Johan Ehrenberg and Strömholm himself. A quotation from the latter is sufficient to set in perspective the content and spirit of the project: "This is a book on insecurity. It is a portrait of those who live a different life in the big city of Paris, people who have endured the hard life on the streets. This is a book on humiliation, on the smell of prostitutes and night life in the cafés. This is a book on seeking one's identity, on the right to live, on the right to own and control one's own body. This is also a book on friendship, an account of the moments we shared in the area of Place Blanche and Place Pigalle."

Some photographs show the streets and buildings in the area, the actual setting for this daily show, while most of them are devoted to the faces and bodies of the protagonists, though they are hardly ever seen completely in the nude, so there is always a constant tension between male and female, past and present, attraction and detachment. As the title indicates, these are images taken within a group that also includes the photographer. Nana introduced Strömholm to the many members of that rowdy and close-knit community, and he shared the dark apartments, the hotel rooms, the hectic night life, the café au lait at two in the afternoon. At the same time he put together an in-depth account of a dark side of the French metropolis (prostitution, often associated with drug addiction and do-it-yourself hormone therapies, the cause of many suicides, was the only answer to the institutions' total lack of concern) that is a real 'family' album. Strömholm continues: "Every night I took my pipe, my old Leica, some rolls of Tri-X and the little French I knew, and went

Les Amies de Place Blanche

ETC Förlag: Stockholm, 1983

down to the brasseries in Place Blanche. Everyone knew what I was doing. I've never taken stolen photos." After this series the photographer developed a working method based on taking part in his subjects' activities, quite the opposite of voyeuristic, pivoting on the use of ambient light, a diary-like structure, and the acceptance of full personal responsibility for the choices regarding the content and circulation of the images. This is the approach he suggested to his students when he was teaching at Stockholm University between 1962 and 1974, where he and Tor-Ivan Odulf introduced a three-year degree course in photography. Many of the leading lights of the future generation of Scandinavian photographers attended this course including Gunnar Smoliansky, Walter Hirsch, Björn Dawidsson, Agneta Ekman, Lasse Svanberg, Bille August and Ulla Lemberg. A strong friendship grew up between Strömholm and one student in particular, Anders Petersen; they also enjoyed a close professional relationship which led to the latter inheriting a whole visual and cultural legacy.

Born in 1944 in Solna, Sweden, initially Petersen was interested in painting and writing, until 1966 when he was impressed by an old photograph taken by Strömholm in Montmartre cemetery, with a line of footprints hinting at the unseen movement of the dead, and decided to enrol in his course (much later, in 2005, he took a similar photograph as a tribute to his recently deceased teacher). It was a revelation: at the time *Les Amies de Place Blanche* had not yet come out, but the shots had been taken and many of Strömholm's lectures were about this series and the spirit in which it was produced. They had such an impact on Petersen that, using the same logic of total immersion, in 1967 he began an extensive investigation of the clients of a famous bar in the red light district of Hamburg, where a weird and wonderful crowd of people including sailors, stokers, dockers, taxi drivers, strippers, drug addicts, prostitutes, poets, and delinquents from the four corners of the earth gathered every night. He spent his days there between the bar and the dance floor for the next three years, and in 1970 he exhibited a selection of around 350 images for the first time, attaching the prints to the wall with drawing pins and allowing the viewers to take away those photos in which they recognised themselves. Subsequently, the German publishing

house Schirmer/Mosel brought *Café Lehmitz* out as a book in 1978. It contains eighty-eight images taken with an easy-to-handle camera, which he often let the clients or owners of the bar use, in order to mingle with them freely without any filters. Moreover, reducing the distance between subject and observer is a crucial element in this work, which is an extraordinary exercise in photographic proximity. The distorted hands, noses, mouths, teeth and behinds, all taken a few centimetres from the lens, are not only the result of life's misfortunes, but are created by a saving and consoling optical effect. Getting so close means overturning the rules that govern the relationship of most of these individuals with society: *Café Lehmitz* results from their accepting the photographer's presence, and that of all of us who view these images.

Bibliography
Caujolle, C. *The Imprints by Christer Strömholm*. Göteborg: Hasselblad Center, 1998.
Petersen, A. *Close Distance*. Stockholm: Journal, 2002.
Tellgren, A. *Arbus, Model, Strömholm*. Gottingen: Steidl, 2005.
VV.AA. *Da Capo: Sweden with the Times, 1997–2007*. Stockholm: Journal, 2007.

Anders Petersen
Zigeuner Uschi and Her Man,
Café Lehmitz, Hamburg, 1967–70
Gelatin silver print

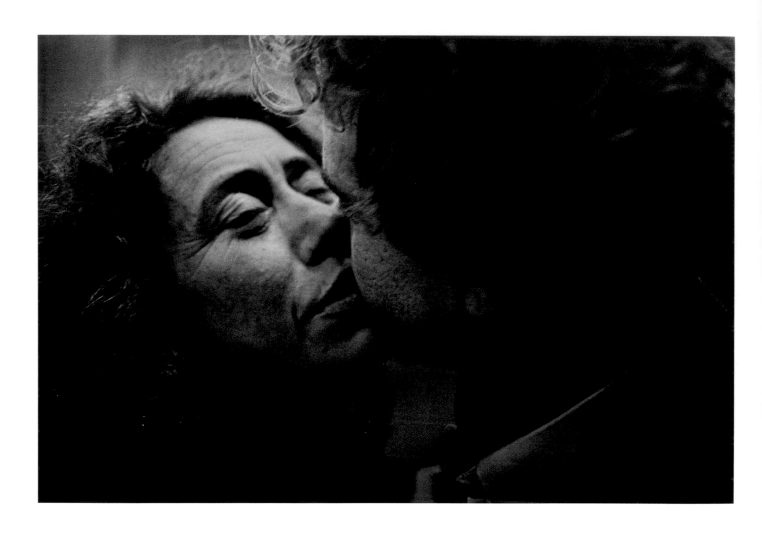

Anders Petersen
Schrunkelmadame, Café Lehmitz,
Hamburg, 1967–70
Gelatin silver print

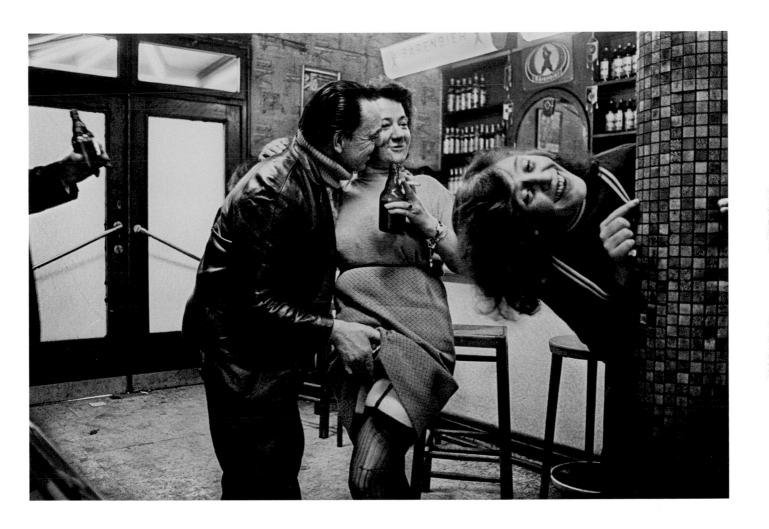

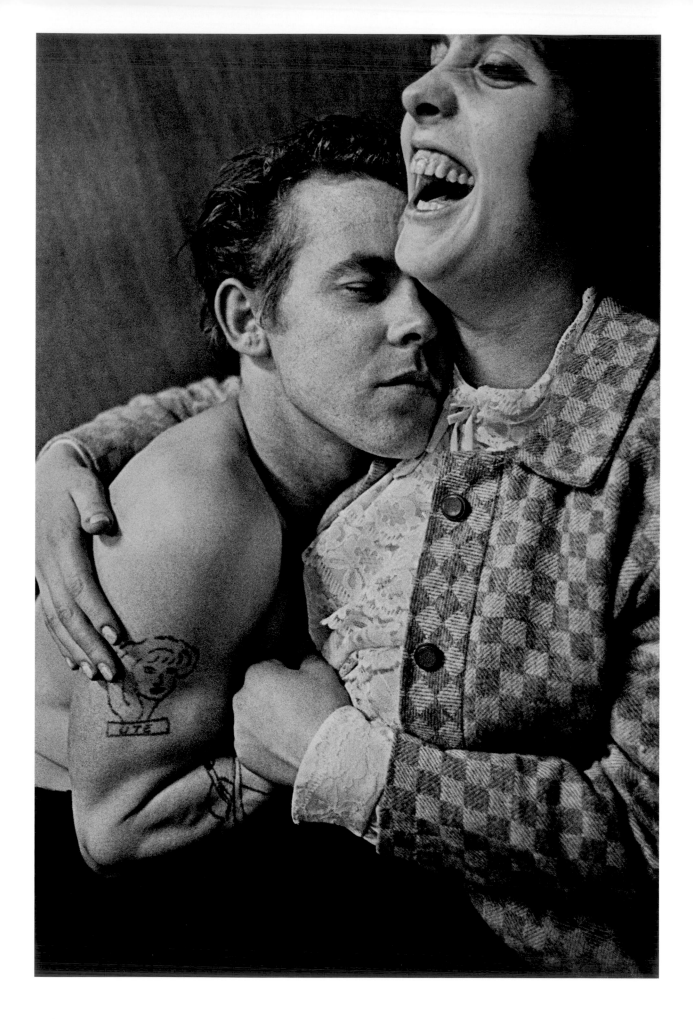

Anders Petersen
Lilly and Rose, Café Lehmitz,
Hamburg, 1967–70
Gelatin silver print

Christer Strömholm
Gina and Nana, Place Blanche,
1960
Gelatin silver print

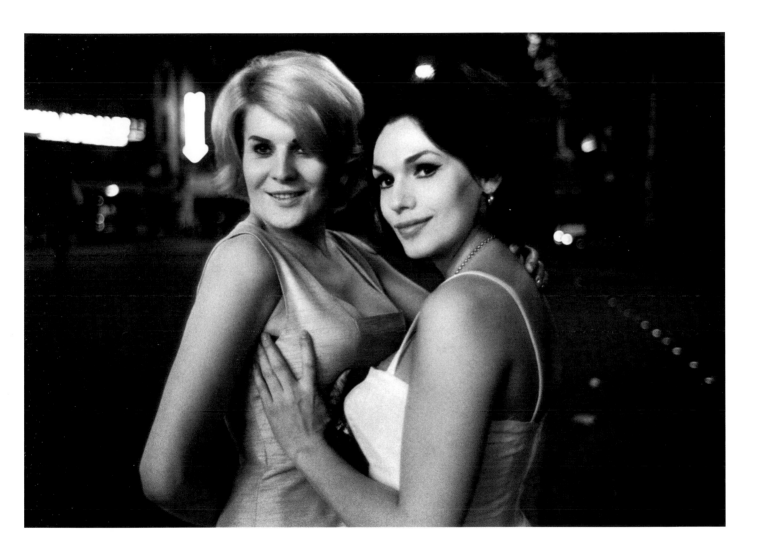

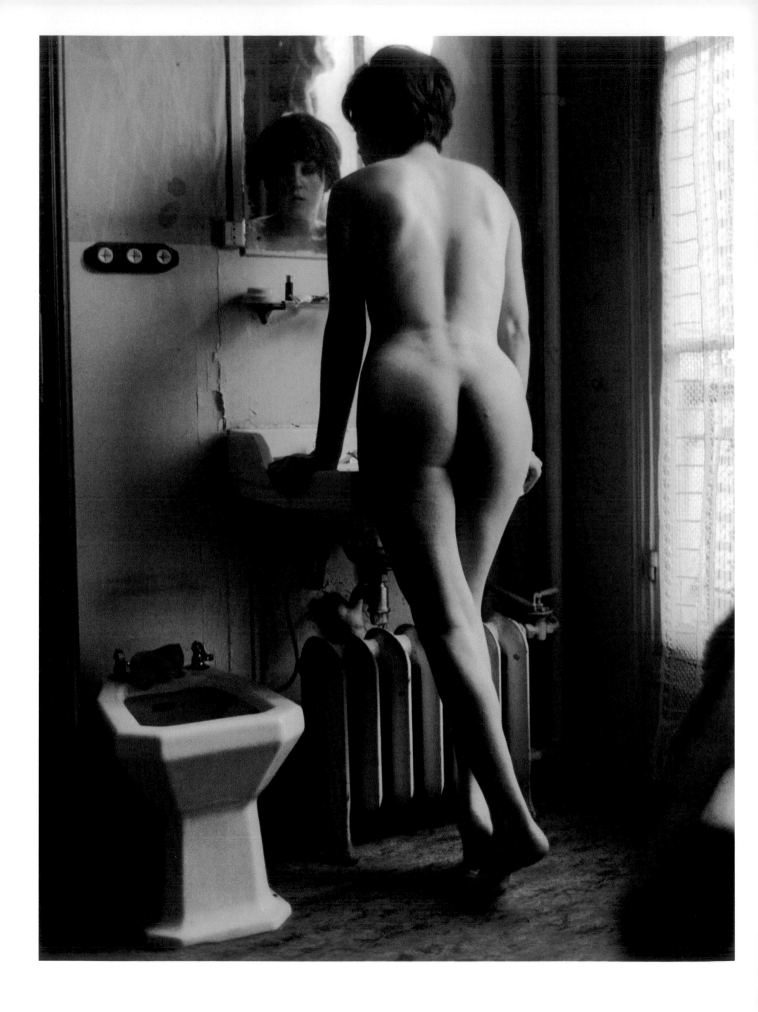

Christer Strömholm
Hotel Ideal, 1966
Gelatin silver print

Christer Strömholm
Moulin Rouge
Gelatin silver print

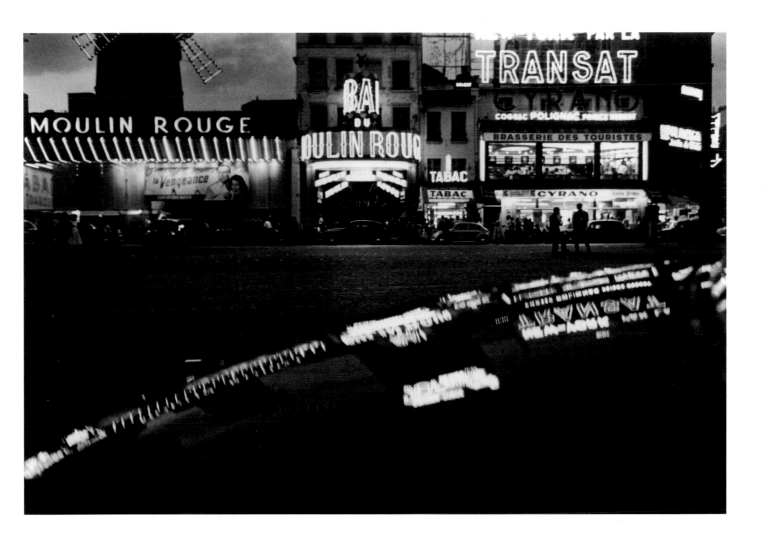

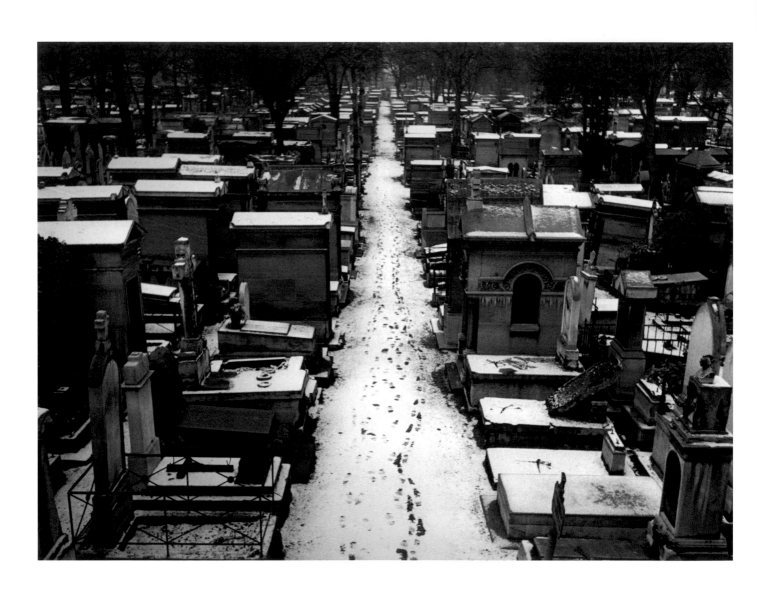

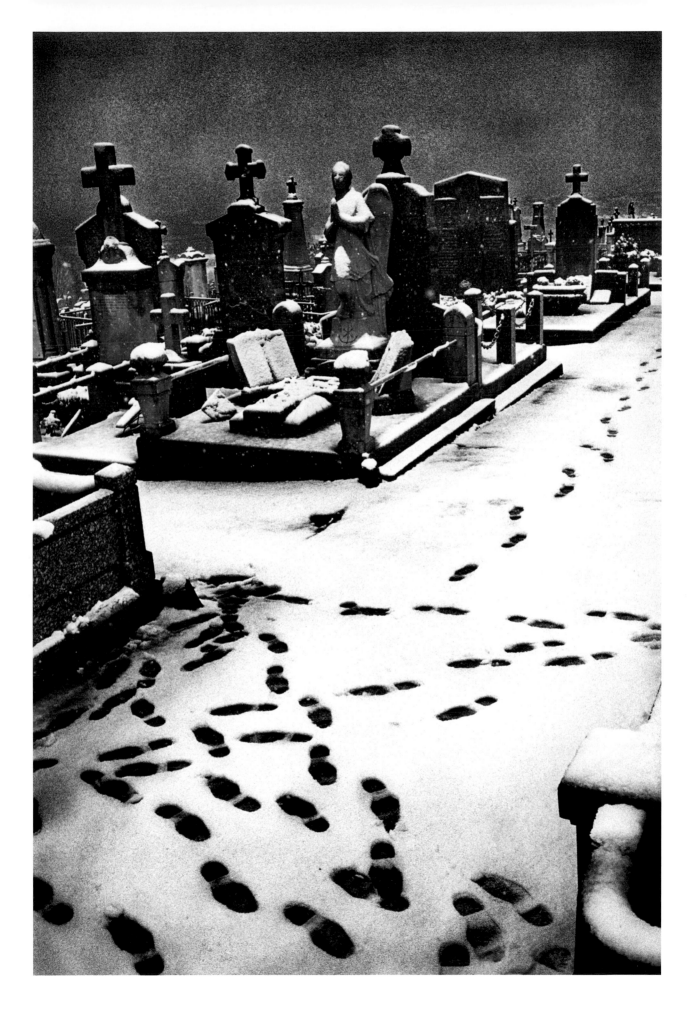

"Metro Pictures Gallery Opening Show"

Metro Pictures Gallery, New York, 15 November – 3 December 1980

It was in the autumn of 1977 that the Artists Space in New York, whose mission is to support emerging art, held an exhibition entitled "Pictures" organised by Douglas Crimp, who became editor-in-chief of the illustrious magazine *October* the same year. Featuring the work of five young Americans, Troy Brauntuch, Jack Goldstein, Sherrie Levine, Robert Longo, and Philip Smith, the show was based on a shared interest in images from the worlds of the mass media and advertising capable of forming an authentic parallel universe.

The ontological structure of this was investigated as along with its relations with individuals and the collectivity in an approach strongly influenced by views put forwards in the same period within the general area of the social sciences and by philosophers, psychologists, semiologists and linguists. Its inevitable points of reference include Guy Debord's *La Société du spectacle* (Buchet et Chastel, Paris 1967) and the studies of Roland Barthes, Michel Foucault and Julia Kristeva. The rationale and fulcrum of this work are aptly summed up by Crimp in the accompanying catalogue: "our experience is governed by pictures, pictures in newspapers and magazines, on television and in the cinema. Next to these pictures firsthand experience begins to retreat, to seem more and more trivial. While it once seemed that pictures had the function of interpreting reality, it now seems that they have usurped it. It therefore becomes imperative to understand the picture itself, not in order to uncover a lost reality, but to determine how a picture becomes a signifying structure of its own accord" (Committee for the Visual Arts, New York 1977, p. 3). The initial nucleus of artists thus identified was joined over the next few years by other figures, thus giving rise to a never formally established group known as the "Pictures Generation" from the names of this first show and of the gallery that began to handle their work shortly afterwards. It was on 15 November 1980, at 150 Greene Street in the SoHo district of New York, that the Metro Pictures Gallery was opened by Helene Winer, formerly director of the Artists Space, and Janelle Reiring, previously of the Leo Castelli Gallery. The inaugural show provided the first opportunity to gather together the leading figures of this new tendency, and the above-mentioned Troy Brauntuch, Jack Goldstein, Sherrie Levine, and Robert Longo (Philip Smith was the only one

of the initial group missing) were joined by Michael Harvey, Thomas Lawson, William Leavitt, Richard Prince, Cindy Sherman, Laurie Simmons, and James Welling. While several of them had studied either at the California Institute of Arts under John Baldessari or at the Hallwalls Arts Center in Buffalo, their strongest link was the fact of growing up in the years of Watergate and the closing stages of the Vietnam War, and thus developing a critical attitude with respect to mass communications and information. Photographs, on which these systems largely rely for their penetrative capacity, therefore constitute a starting point for these artists, who often transpose them, altered or otherwise, into works created in different media such as painting, sculpture, performance, installation, video and photography itself.

Among the leading figures in appropriation art, regarded as one of the practices peculiar to Postmodernism, Sherrie Levine carried out her first experiments at the end of the 1970s. Her *Presidents* series consists of silhouettes of the best-known presidents of the United States (George Washington, Abraham Lincoln, and John F. Kennedy) cut from pages of magazines showing images of women, and her *Fashion Collage* of small cut-out photographs of models on the catwalk isolated against a white background. In their exploitation of common images, these works pinpoint one of the major themes associated with the Pictures Generation, namely gender identity. (The others include consumerism, political power, the race issue, and history.) In the first case, Levine develops a series of subtle symbols of the male abuse of power over women and transformation of them into commodities (the profiles of the presidents reproduced being the ones that appear on American coins). In the second, she carries out close analysis of a common way of representing women in the mass media, altered so that the body used simply to show garments becomes a heroine to be looked up to. With the eighty-four images of the *Untitled Film Stills* series created between 1977 and 1980, Cindy Sherman also reflects on female iconography. The frame of reference in this case is provided by movies of the 1950s and 1960s, the source of settings in which she invariably plays the leading role, changing costumes and make-up for quick photo sessions halfway between performance and an operation of cultural guerrilla warfare. There are no sets, actors or technicians, just a small case from which she takes what is needed to transform herself into a whole variety of different characters. Sherman thus uses the dynamics of ambiguity to examine some crucial issues: the role of women in society, defined here through a sort of inventory of stereotypes (the housewife, the *femme fatale*, the diva, the matron, the business woman and so on); the question of identity, shown not as an innate factor but as an unstable and provisional cultural construct; and the relationship between reality and photography, which is inevitably impaired by the protagonist's disguises and adoption of the typical codes of cinematic genres. These images were presented on the walls of the Metro Pictures Gallery as simple and devoid of value. Printed on glossy paper in the 8 x 10-inch format, they reproduce the standards of promotional photography and thus cause further uncertainty in those who observe them as works of art.

Among the participants of the inaugural show in 1980, Laurie Simmons also introduced some notes of feminist critique into her work, but focused in more general terms on the investigation of American domestic

imagery, photographing dolls and puppets inside houses and other miniature settings. The primary model for her simple reproductions corresponds to what is laid down in the collective memory by the content of TV programmes, films and glossy magazines. The result is recognition of a particular blend of irony and anxiety that accompanies experience of the family context, as well as a marked underscoring of the constructed nature of its image for whoever is not part of it. James Welling also addresses the combination of family and memories. In 1977, using a view camera for 4 x 5-inch plates bought on the advice of Matt Mullican, he embarked on the *Diary Landscapes* series, where close-up details of the diaries of his great-grandparents for 1840–41 are juxtaposed with views of the Connecticut landscape. The words of his ancestors thus take on completely new meaning, both because they are cut out and transformed into images and because of the new photographs with which they are combined so as to become unusual captions. To give just one last example, Richard Prince is a key figure among those who investigate the more hidden aspects of the American civilisation, including male chauvinism, sexual perversions

and drug abuse. Since the beginning of his career in the second half of the 1970s, he has extracted fragments of images from advertisements and newspaper articles, separating them entirely from their context, writing included, and allowing the viewer to reinterpret them freely. While this initially involved cutting out the original images, he began to photograph them again in 1980, disproportionately magnifying details that thus take on great importance and combine with the texture of the paper and the typographical marks to assert their nature as reproductions. As he stated in an interview with Barbara Kruger published in the magazine *Bomb*, "At first it was pretty reckless. Re-photographing someone else's photograph, making a new picture effortlessly. Making the exposure, looking through the lens and clicking, felt like an unwelling [*sic*] … a whole new history without the old one. It absolutely destroyed any associations I had experienced with putting things together. And of course the whole thing about the naturalness of the film's ability to appropriate. I always thought it had a lot to do with having a chip on your shoulder" ("All Tomorrow's Parties", *Bomb*, no. 3, New York 1982). A photograph

is therefore both in front of and behind the lens. Together with the other members of the Pictures Generation, by calling into question his own authoriality and the originality of the works he produces, Prince prepares himself to face the latest stage in the unstoppable proliferation of images with the advent of digital technologies.

Bibliography
Crimp, D. *Pictures*. New York: Committee for the Visual Arts, 1977.
Eklund, D. *The Pictures Generation, 1974–84*. New York: Metropolitan Museum of Art, 2009.
Evans, D. *Appropriation*. Cambridge, MA: MIT Press, 2009.
Galassi, P. *Cindy Sherman: The Complete Untitled Film Stills*. New York: The Museum of Modern Art, 2003.
McKenna, K. *Richard Prince: Collected Writings*. Santa Monica: Foggy Notion Books, 2011.
Prince, R. *Robert Longo: Men in the Cities*. New York: Harry N. Abrams, 1986.
Respini, E. *Cindy Sherman*. New York: The Museum of Modern Art, 2012.
Schor, G. *Cindy Sherman: The Early Works. Catalogue Raisonné*. Ostfildern: Hatje Cantz, 2012.
Schorr, C. *Laurie Simmons: Photographs 1978/79*. New York: Skarstedt Fine Art, 2003.
Singerman, H. *Art History, after Sherrie Levine*. Berkeley: University of California Press, 2011.
Spector, N. *Richard Prince*. New York: Guggenheim Museum, 2007.

Laurie Simmons
Blond/Red Dress/Kitchen, from
the series *Interiors*, 1978
Silver dye bleach print,
8.3 x 12.7 cm
New York, The Museum
of Modern Art
Courtesy of Laurie Simmons
Studio

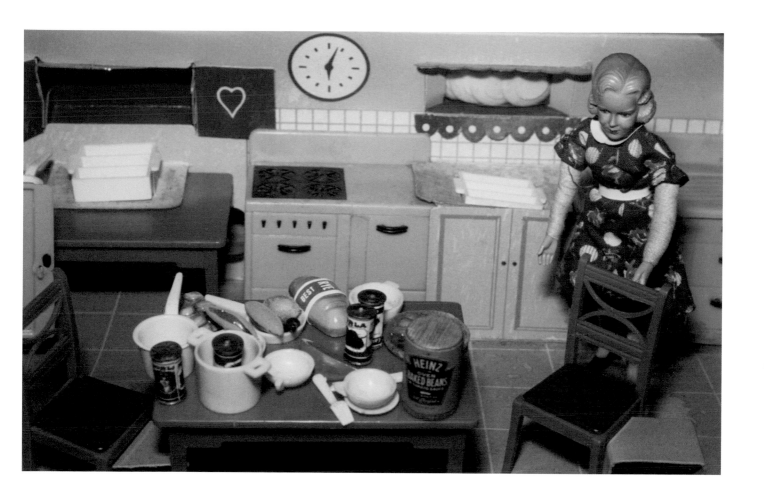

James Welling
Lock, 1976
C-print from original Polaroid,
9.52 x 7.3 cm
Courtesy of James Welling
and David Zwirner, New York

Cindy Sherman
Untitled Film Still, #9, 1978
Gelatin silver print, 18.9 x 24 cm
New York, The Museum
of Modern Art
Courtesy of Cindy Sherman
and Metro Pictures

Richard Prince
Untitled (Three Women with Their Heads Cast Down), 1980
C-print, 50.8 x 61 cm each
New York, The Metropolitan Museum of Art, Purchase, The Horace W. Goldsmith Foundation; Gift, through Joyce and Robert Menschel, 2000 (2000.264a-c)

Page 54
Sherrie Levine
President Collage: 1, 1979
Cut-and-pasted printed paper on paper, 61 x 45.7 cm
New York, The Museum of Modern Art, Gift, The Judith Rothschild Foundation Contemporary Drawings Collection, inv. TR12112.1161

Page 55
Sherrie Levine
Fashion Collage: 11, 1979
Cut-and-pasted printed paper and pencil on paper, 61 x 45.7 cm
New York, The Museum of Modern Art, Gift, The Judith Rothschild Foundation Contemporary Drawings Collection, inv. 2203.2005.5

54 | "Metro Pictures Gallery Opening Show"

Robert Mapplethorpe

Lady Lisa Lyon

Viking Press: New York, 1983

Robert Mapplethorpe met Lisa Lyon in 1980 during a party at a loft in SoHo, New York. The famous pioneer of female bodybuilding had just made a name for herself by winning the first professional world championship devoted to her discipline, while Mapplethorpe was a photographer with ten years' experience who had already achieved important recognition, such as his first solo exhibition at the Light Gallery in 1973, the invitation to participate in the contemporary art event Documenta 6 in 1977, and his entering the Robert Miller Gallery stable the following year.

Born in 1946 at Floral Park, Queens, New York into an American middle-class Catholic family, Mapplethorpe had moved to Brooklyn in the early 1960s to study art at the Pratt Institute, where he had experimented with collage while mastering the more traditional disciplines. He did not take up photography until 1970, when he bought a Polaroid camera (he would later upgrade to a medium-format Hasselblad) to take snapshots that he incorporated into his collages. He immediately found photography a medium congenial to his intentions, since it enabled him to combine his preference for realism with a process that was certainly simpler and quicker than other artistic techniques. It was "a sort of lazy man's approach to sculpture", Mapplethorpe himself confessed in an interview with Janet Kardon. During that period, in fact, he embarked on research dominated by an unmistakable formal rigour and the use of light as a modelling element, which enabled him to "carve" the volume of the subjects out of the surface of the film. His subjects ranged from portraits (of himself or others) to flowers, from scenes depicting sex to works of art, but the human body was undoubtedly the main focus of his interest. The early nudes of Patti Smith, his partner until 1974, and of his friends on the New York underground scene, were characterised by an approach that was both direct and sensual, but which would gradually become more composed in the years to come, moving closer to the ideals of Greek statuary. Thus the distinctive elements of Mapplethorpe's work, namely physical perfection and well-defined muscles, emerged with increasing clarity while, after realising that he was bisexual, he legitimised the expressive possibilities of the

male nude, which until then had been underestimated (despite the important photographic work of Wilhelm von Gloeden, Fred Holland Day, Thomas Eakins, and George Platt Lynes, among others) because it was socially unacceptable.

It therefore comes as no surprise that when Mapplethorpe happened to meet Lisa Lyon at that party in 1980 he immediately knew she was his ideal model, a unique figure and "a new animal species", as she was described by Bruce Chatwin in his essay for the book that set the seal on their collaboration three years later. Titled *Lady Lisa Lyon* and published by Viking Press, the volume features 115 images selected from the countless portraits that the New York artist took of his unusual model, thus composing a revolutionary visual essay on the theme of sexual identity. At the time they met, in fact, both Mapplethorpe and Lisa Lyon displayed a keen interest in androgyny and the elastic gap between male and female gender. They both explored the main aspects of this through different media: Mapplethorpe via photography; Lyon, her own body. Each found their equal in the other, in the opposite sex, according to the symmetry of logic that was for both of them an essential step towards achieving the perfection to which they aspired (symmetry is one of the physical qualities assessed in bodybuilding competitions, while Mapplethorpe saw it as a further link to Greek classicism). The two of them were immediately united by an overwhelming chemistry, and together they investigated the manifold variations on the man-woman dichotomy.

They were driven not only by their joint obsession with the body, but also a shared sense of method and discipline.

This enabled Lisa Lyon to allow herself to be directed by the photographer. He did this without altering her personality and by maintaining a balanced relationship between director and actor. In the series featured in this book, the most clichéd stereotypes of both sexes are overturned through Mapplethorpe's visionary capacity and Lisa Lyon's chameleonic transformations: this diminutive woman (she is only 1.60 m tall and weighs about 45 kg) is seen alternately as a bride and lover, a doll and gymnast, a flamenco dancer and circus performer, finally posing as a crucified figure, as provocative as it is familiar.

Lady Lisa Lyon is a profound analysis of the concept of the "double", a monograph on the most renowned female bodybuilder of all time and an autobiographical work by Mapplethorpe, rolled into one. Aside from the double portrait on the frontispiece, in which they look identical with their sunglasses and arms folded, Lisa Lyon's constant presence is offset by the many elements that sum up the photographer's experiences and intellectual baggage through a mix of high art and popular culture. This is the only way that the Michelangelesque qualities of certain poses, a Deco decorativism in the style of George Hoyningen-Huene and certain beach settings borrowed from Edward Weston's nudes, can appear alongside a diver's wet suit complete with mask and flippers, which is worn with an explicit nod to the rubber gear typical of fetishist and sadomasochistic imagery. The result is a complex exercise in balancing reality and fiction, which Mapplethorpe found useful in questioning himself, his subject and the photographic language he used to

represent it. Bruce Chatwin writes in his essay: "This book does not simply document Lisa Lyon: it is a work of the imagination – the visual counterpart of a novel, which, like all good novels, mixes fact and fantasy to reveal a greater truth. The photographer and his model have conspired to tell a story of their overlapping obsessions. Their glorification of the body is an act of will, a defiance of nihilism and abstraction, a story of the Modern Movement in reverse. Obscurely, in images brassy and bizarre, they are signalling a message. Perhaps the owner of this book will read into its pages an allegory for the final years of a winded century?"

Bibliography
Blessing, J., G. Celant, and A. Ippolitov. *Robert Mapplethorpe and the Classical Tradition.* New York: Guggenheim Museum, 2004.
Danto, A. *Mapplethorpe.* New York: Random House, 1992.
Morrisroe, P. *Mapplethorpe: A Biography.* Cambridge: Da Capo Press, 1997.

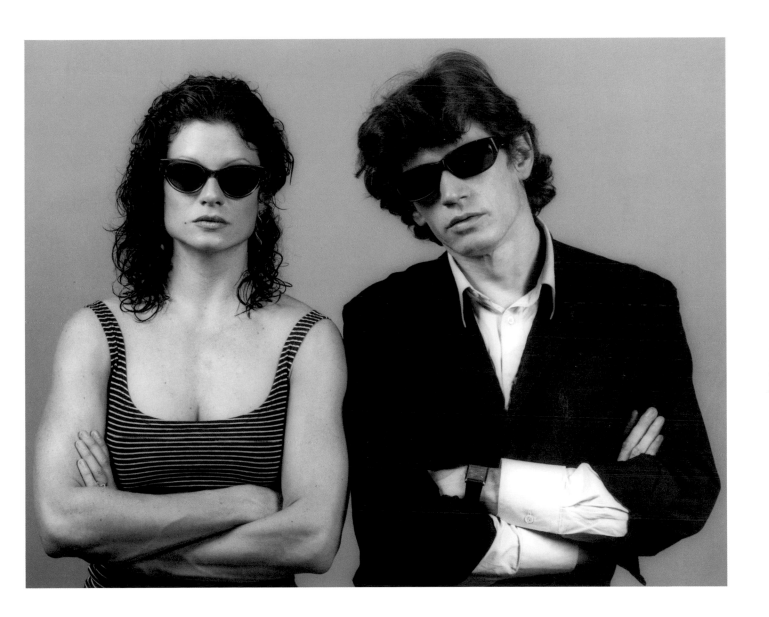

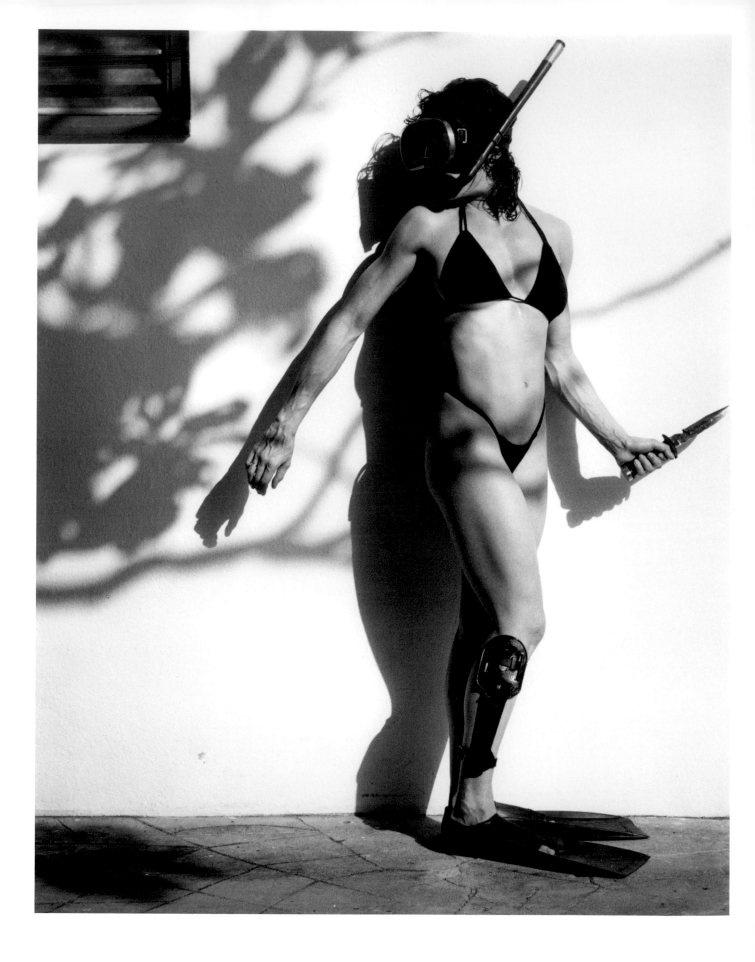

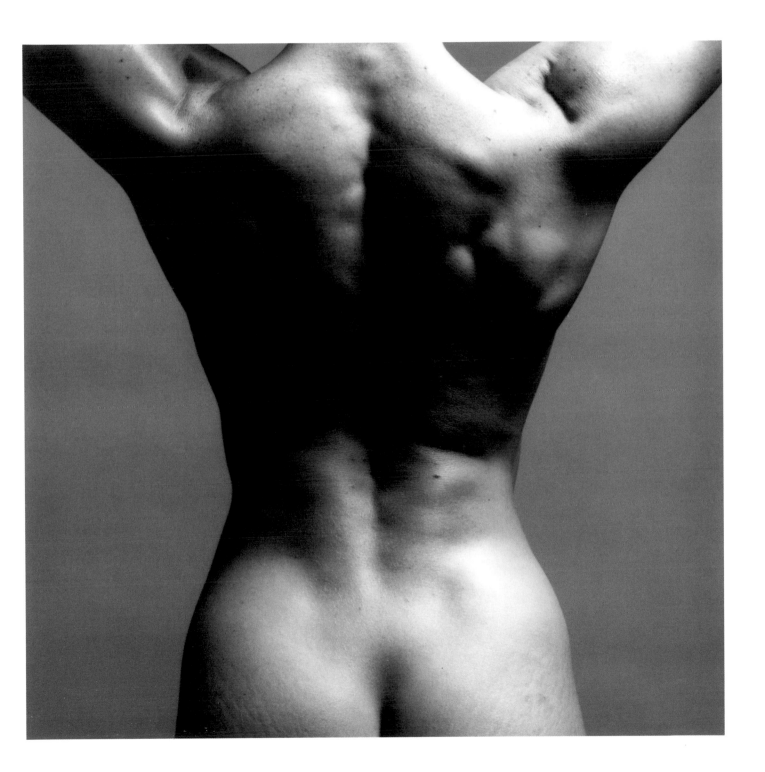

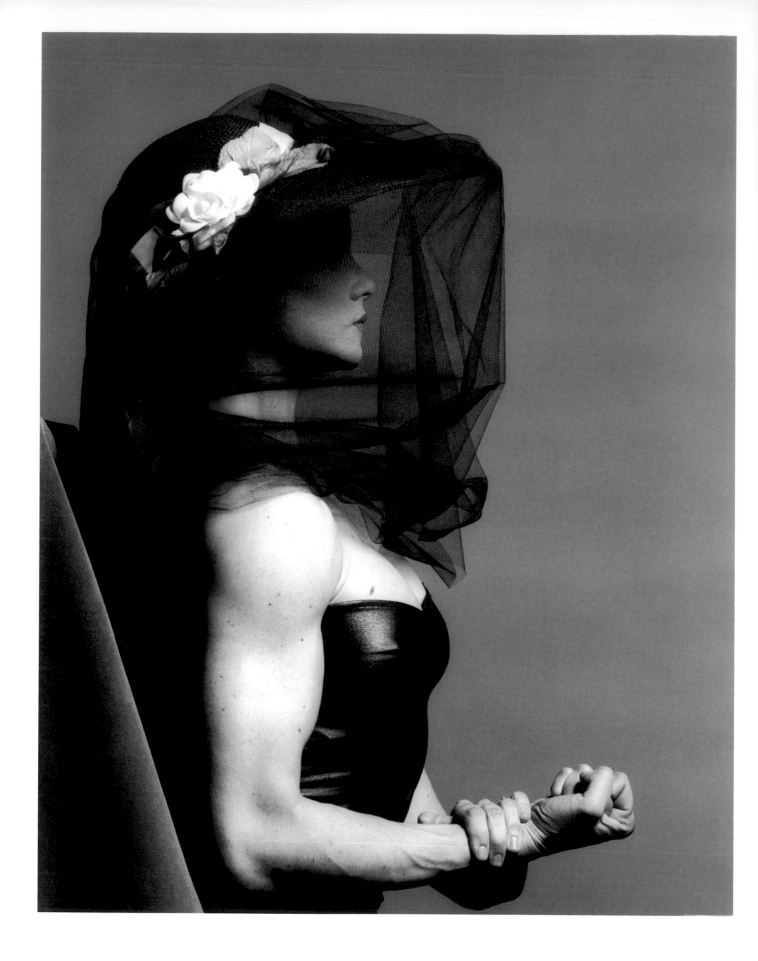

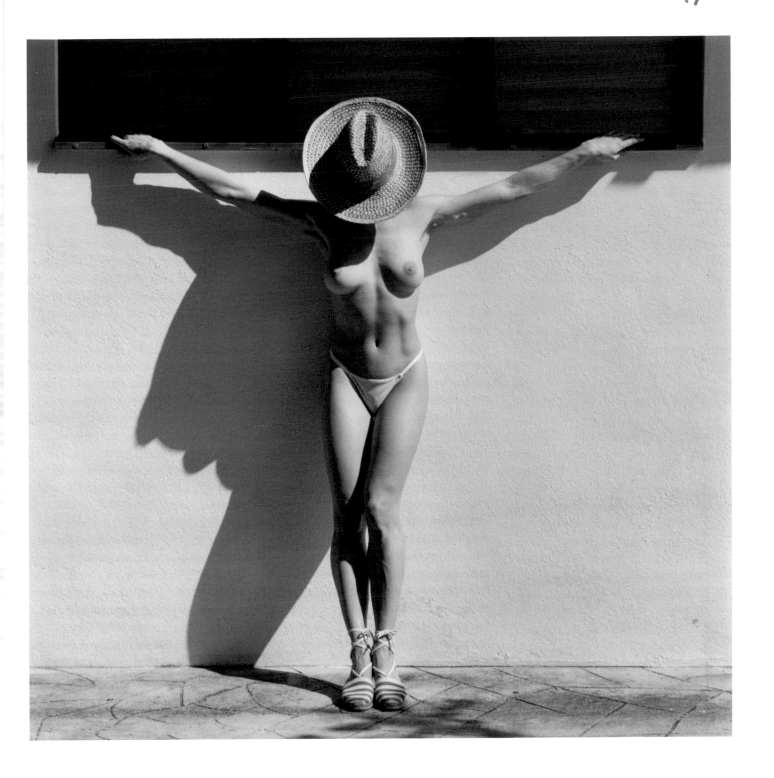

in-depth knowledge of the subjects. Photographing becomes synonymous with inhabiting, the opposite of the tourist-type, folksy and consumer images promoted by the mass media. Finally, these new works eschew a narrative reading, since they are offered as fragments of a sample collection rather than a story. On the other hand, they give a structure to the exhibition and the book, which are divided into a series of sections that indicate different paths of exploration according to criteria that mix scientific order (the cover shows a physical map of Italy) and poetry: *A perdita d'occhio*, *Lungomare*, *Margini*, *Del Luogo*, *Capolinea*, *Centrocittà*, *Sulla soglia*, *Nessuno in particolare*, *Si chiude al tramonto*, *L'O di Giotto* ("As Far as the Eye Can See", "Sea-Front", "Margins", "Of Place", "Terminus", "City Centre", "On the Threshold", "No One in Particular", "It Closes at Sunset", "Giotto's O"). After Bari, the exhibition travelled to Genoa, Ancona, Rome, Naples, and Reggio Emilia, and was acclaimed in each city by critics and public alike. It had a decisive influence on Italian photography, by stressing the importance of landscape as the area of reference in national research and by drawing other photographers to this subject.

This did not mean, however, that it led to the photographers invited to take part in this venture becoming a cohesive group. In fact, after "Viaggio in Italia", the prints were donated to the Centro Studi e Archivio della Comunicazione at Parma University, and the photographers went back to working individually and with the same independence typical of their earlier output.

Bibliography
Chiaramonte, G., and P. Costantini. *Luigi Ghirri: niente di antico sotto il sole*. Turin: SEI, 1997.
Ghirri, L. *Paesaggio italiano*. Milan: Electa, 1979.
Ghirri, L. *Kodachrome*. Modena: Punto e Virgola, 1978 (reprinted with a F. Zanot text, London: MACK, 2012).
Pellizzari, M.A. *Percorsi della fotografia in Italia*. Rome: Contrasto, 2011.
Quintavalle, A.C. *Luigi Ghirri*. Milan: Feltrinelli, 1979.
Russo, A. *Storia culturale della fotografia italiana. Dal Neorealismo al Postmoderno*. Turin: Einaudi, 2011.
Valtorta, R. *Racconti dal paesaggio 1984–2004*.
A vent'anni da Viaggio in Italia. Milan: Lupetti, 2004.

Luigi Ghirri
Modena, from *Colazione
sull'erba*, 1972
C-print, 12 x 17 cm
UniCredit Art Collection

Vincenzo Castella
Monte San Giacomo, Salerno,
1982
Cinisello Balsamo, Fondo Viaggio
in Italia / Museo di Fotografia
Contemporanea

connecting emotionally with the subjects. The colours, which are often heightened by her use of a flash, reproduce the faded tints of old New York interiors, while the framing is tilted so that any impression of stability disappears. The photographer herself writes: "These pictures come out of relationships, not observation". Although they depict violence, they lack precisely the predatory attitude typical of most photography. Far from victims of the lens, the people who inhabit Nan Goldin's images are her closet accomplices.

Bibliography
Armstrong, D., E. Sussman, and H. Werner. *Nan Goldin: I'll Be Your Mirror.* New York: Whitney Museum of American Art, 1996.
Goldin, N. *The Other Side.* Zurich: Scalo, 1993.
VV.AA. *Emotions & Relations.* Cologne: Taschen, 1998.
VV.AA. *Nan Goldin.* London: Phaidon, 2008.

Trixie on the Cot, New York City,
1979
Silver dye bleach print,
printed 2008, 39.4 x 58.7 cm
New York, The Museum
of Modern Art,
Purchase, inv. 39.2006

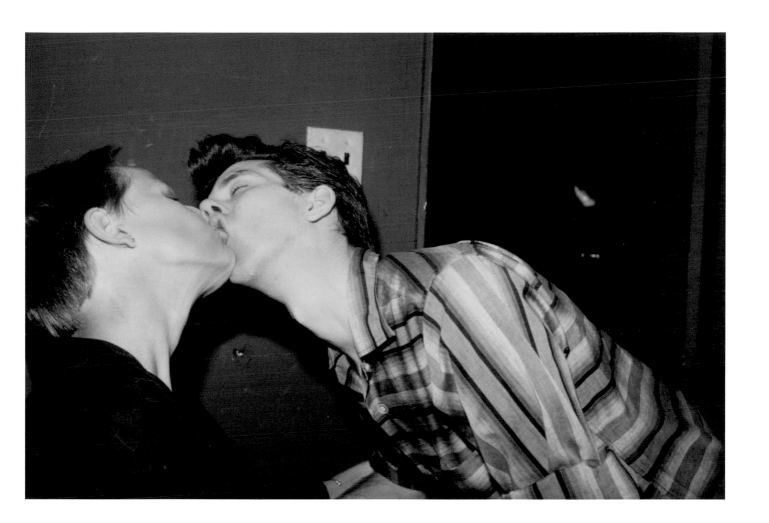

Nan and Brian in Bed, New York City, 1983
Silver dye bleach print,
printed 2006, 39.4 x 58.9 cm
New York, The Museum
of Modern Art,
Acquired through the generosity
of John L. Stryker, inv. 47.2006

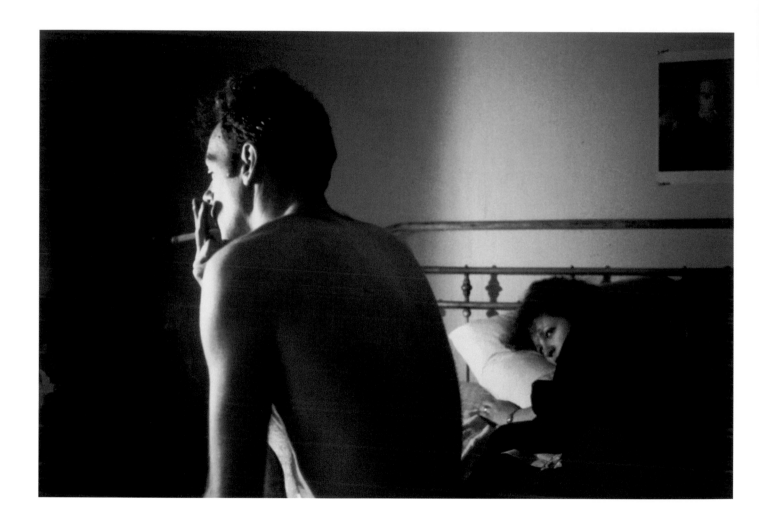

Nan One Month After Being Battered, 1984
Silver dye bleach print,
printed 2008, 39.4 x 58.7 cm
New York, The Museum
of Modern Art,
Purchase, inv. 48.2006

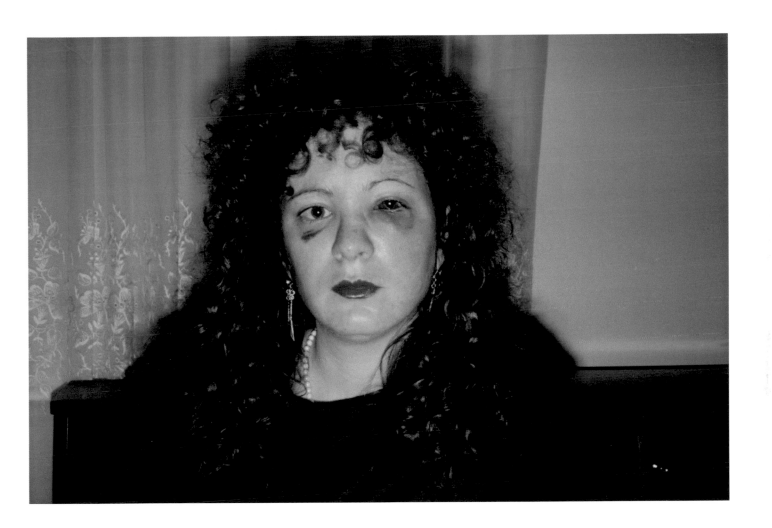

Transparencies

Schirmer/Mosel: Munich, 1986

Transparencies, published in 1986 by the German publishing house Schirmer/Mosel, is the first substantial monograph devoted to the work of the Canadian photographer Jeff Wall, who was born in Vancouver in 1946. In addition to a selection of twenty colour photographs, it contains an in-depth conversation with the Dutch curator Els Barents that took place when Wall held his solo exhibition at the Stedelijk Museum in Amsterdam in September 1985, in which the photographer – who was already teaching visual arts at the Simon Fraser University – recounts in detail the origins, rationale, and consequences of his works. After studying art history at the University of British Columbia, from which he graduated with a thesis entitled "Berlin Dada and the Notion of Context" in 1970, and subsequently at the Courtauld Institute of Art in London, where he attended the courses of T. J. Clark – an expert on Manet with a Marxist approach – in 1978 Wall began to devote himself to photography, borrowing from various disciplines. The combination of so-called "high" culture and the practices of the mass media is the most macroscopic aspect of this amalgam, in fact, he draws on painting and the cinema, politics and philosophy. In opposition to the subjective and psychological line of research that dominated the art system at the end of the 1970s, Wall's approach is more similar to the logics of Conceptual Art (among other things, in 1982 he wrote a long essay on the poetics of the American Dan Graham: "Dan Graham's Kammerspiel", in *Dan Graham*, Art Gallery of Western Australia, Perth 1985), in which he sets an in-depth investigation of his medium alongside that of the society he lives in. In his project he reprises the great art of the past, whether individual works or whole genres and pictorial typologies, on which he bases his view of the present. The first photograph in this book, *The Destroyed Room*, for example, is inspired by Eugène Delacroix's *La Mort de Sardanapale*, of 1827: there are the same predominant colours, blood red and dull green, mixed with grey, the same object, a mattress in the centre of the picture, and the same sense of a carefully calibrated disorder (the composition is firmly anchored to a diagonal axis). Then Wall mixes this reference to the past with the styles of window dressing in the most state-of-the-art shops of the time, which were generally inspired by punk and underground culture,

exploiting this novel combination to give an image of a burning topical issue: domestic violence. The starting point for *Picture for Women*, which draws on Édouard Manet's famous Impressionist masterpiece *Un bar aux Folies-Bergères*, questions similar issues, mainly women's social position (the male-female relationship) and the idea that all representation is deceptive, without, however, supplying answers or solutions. Is there someone opposite the protagonist? Does her gaze meet that of the man to one side (in this case a self-portrait of Wall, in the first painting the artist Gaston La Touche, a friend of Manet's)? What is she doing in the place where we see her? Is there a mirror behind her? As in the original, which Wall had often admired in the Courtauld Gallery, the artist gives the viewer several things to reflect on, and at the same time removes all certainty. The result is a rush of thoughts and visions in rapid succession, advancing and retreating, so that, after reaching a certain level of depth in this work, you end up looking at yourself in the act of studying it.

While Jeff Wall reprises images from past painting, by contrast the cinema is his main reference regarding the execution of his photographs and the dynamics of their interpretation by the public. First and foremost, most of the photographs published in *Transparencies* are mise-en-scènes and the way they are produced resembles shooting a film. In fact, Wall acts as a director who coordinates various professionals, from set designers to make-up artists, directs the actors (initially they were also friends and family members, though he prefers strangers) and carefully chooses clothes, locations and every single object in the shot, which rather than being merely functional acquires a symbolic meaning. Secondly, viewers appreciate his images after a willing "suspension of disbelief", which in photography acquires a very particular connotation. When watching a film we decide to believe everything we see in order to enjoy it fully, but in the case of a photographic image we are particularly reluctant to doubt its authenticity. This is a cultural fact: cinema's role is to help us escape from our world (the assumption is: it can't be true) and photography's role is to describe it (the assumption is: it can't be false), thus even when faced with the image of an unlikely situation – perhaps because it is too similar to a picture by Manet or Delacroix – we give in to the temptation to believe that it really happened (apart from its mise-en-scène), thus triggering a violent conflict. Wall states in this book: "The spontaneous is the most beautiful thing that can appear in a picture, but nothing in art appears less spontaneously than that."

Moreover Wall borrows from painting something that is also a characteristic of the cinema a preference for large formats, which is an absolute exception in the field of photography. Like the canvases of paintings, these do not have a standard size, but change each time depending on what the photographs represent (in the case of the above-mentioned examples, *The Destroyed Room* is 159 x 229 cm and *Picture for Women* is 142.5 x 204.5 cm). He writes in an article published in the journal *Artforum* in 2003: "Even while I loved photography, I often didn't love looking at photographs, particularly when they were hung on walls. I felt they were too small for that format and looked better when seen in books or as leafed through in albums. I did love looking at paintings, though, particularly ones done on a scale large enough to be seen easily in a room. That sense of scale is something I believe is one of the most precious gifts given to us by Western painting." ("Frames of Reference", in *Artforum*,

Vol. 42, No.1, New York 2003). The full enjoyment of the works and their relationship with the surrounding space are such crucial elements for Jeff Wall that he published a life-size detail of each photograph and a series of images of the lay-outs of some of his exhibitions in *Transparencies*.

The size of the prints facilitates the viewer's examination of the tiniest detail and gives the subjects a certain physical presence, but this is not the only novel material aspect of these works. In fact, most of them are mounted in light-boxes like the advertisements on station platforms. Thus the images undergo a kind of dematerialisation process, losing the link with their source as happens in the case of a projection (also cinematographic). The result is reminiscent of the alienating experience of modern life, where the seats of power and control are mostly inaccessible.

On the other hand, Jeff Wall showed a particularly lively interest in politics in his early research (this was subsequently to diminish from the 1990s on), in which he investigated the logics of the capitalist system and class conflict, both through the content of his images and through his modus operandi. As the director of everything that appears in the shot, he plays a dominant role with regard to his subjects, who yet continue to possess their own unmistakable identity through their person and attitudes. In the photograph *Mimic,* which as the title tells us focuses on non-verbal expression, the protagonist gives a dirty look to a passerby of oriental origin indicating in a typical racist gesture that he is screwy.

This is a re-enactment of a real situation that Wall had seen on the streets of Vancouver, combined with an echo of *Rue de Paris, temps de pluie* by Gustave Caillebotte. But while the protagonist plays his part, he also reveals something of himself, the way his mouth is imperceptibly open and he is holding the hand of his companion, whose eyes are half closed because she is dazzled by the sun. Wall's disillusionment, therefore, does not become the total negation of a perspective, but evidences the need to constantly resist. When Els Barents, in the closing interview in *Transparencies*, asks him how his photographs, so peremptory with regard to present-day lack of freedom, can express a promise of happiness, his answer is also peremptory: "I always try to make beautiful pictures."

Bibliography
Campany, D. *Jeff Wall: Picture for Women*. London: Afterall, 2011.
Chevrier, J.F., H. Naef, and T. Vischer. *Jeff Wall: Catalogue Raisonné 1978–2004*. Gottingen: Steidl, 2005.
De Wolf, H. *Jeff Wall: The Crooked Path*. Antwerp: Ludion, 2011.
Fried, M. *Why Photography Matters as Art as Never Before*. New Haven: Yale University Press, 2008.
Galassi, P. *Jeff Wall*. New York: The Museum of Modern Art, 2007.
Fried, M. *Jeff Wall: Selected Essays and Interviews*. New York: The Museum of Modern Art, 2007.
Graziani, S. *Jeff Wall: Gestus. Scritti sull'arte e la fotografia*. Macerata: Quodlibet, 2013.
VV.AA. *Jeff Wall: Complete Edition*. London: Phaidon, 2010.

Jeff Wall
The Destroyed Room, 1978
Transparency in light-box,
159 x 229 cm
Courtesy of the artist

Eugène Delacroix
La Mort de Sardanapale, 1827
Oil on canvas, 392 x 496 cm
Paris, Musée du Louvre

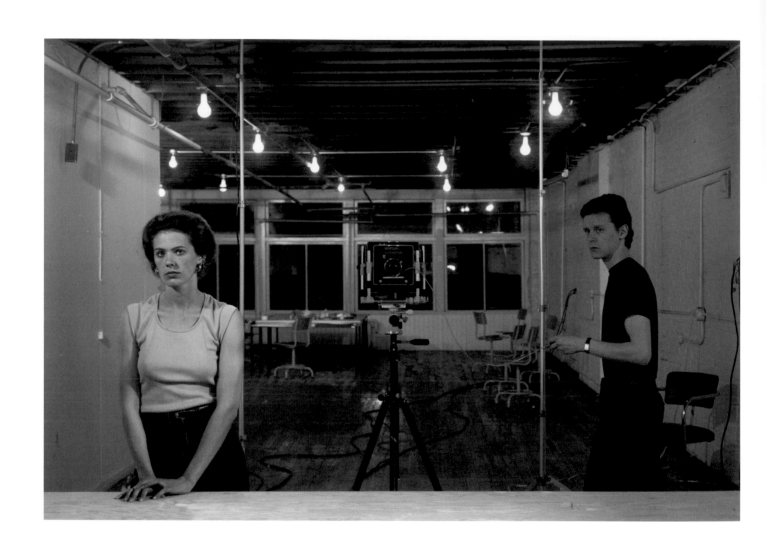

Jeff Wall
Picture for Women, 1979
Transparency in light-box,
142.5 x 204.5 cm
Courtesy of the artist

Édouard Manet
Un bar aux Folies-Bergère, 1882
Oil on canvas, 96 x 130 cm
London, Courtauld Institute
Galleries

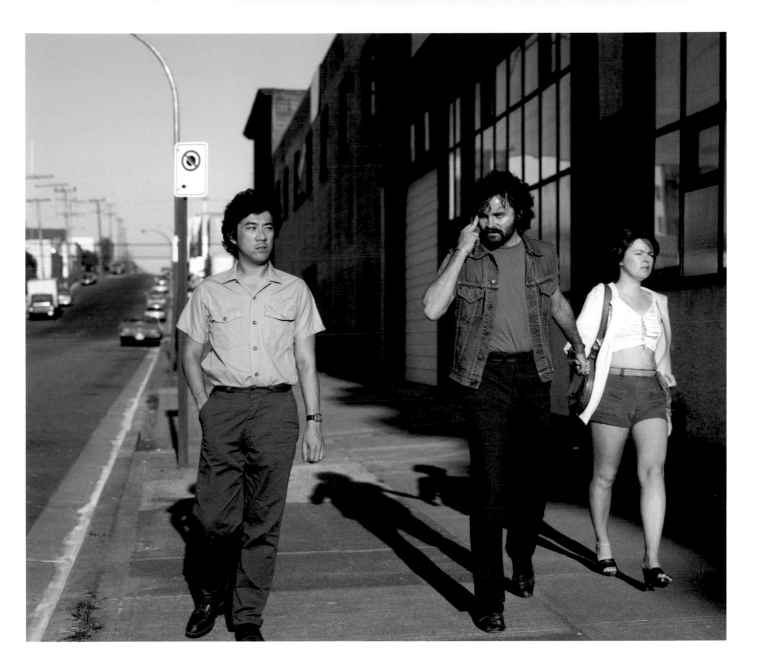

Jeff Wall
Mimic, 1982
Transparency in light-box,
198 x 228.6 cm
Courtesy of the artist

Jeff Wall
The Thinker, 1986
Transparency in light-box,
221 x 229 cm
Courtesy of the artist

Jeff Wall
The Storyteller, 1986
Transparency in light-box,
229 x 437 cm
Courtesy of the artist

knowledge, is today rising from the depths of historical sedimentation onto the surface of backlit digital screens.

While emerging from the deep wells of archival recension, the current empire of data is still structurally disposed towards the activities of collecting, conserving, consecrating, interpreting, translating, and coordinating all manners of knowledge and information. However, it does so not in the name of a superintending knowledge, but in the technological arcana of data and metadata. The advent of new digital technologies, communication networks, and software systems driven by fast and powerful servers have furthered the migration of the archive from its traditional institutional structures into an all-encompassing electronic data mine and media ecology; liberating it from the tethers of regulative supervision; at once democratising and demystifying the powerful control formerly held by institutional systems over human knowledge.

Today the classical archive is challenged by, and perhaps even threatened by the encroachment of a form of ubiquitous and dematerialised data that is on the verge of reducing the archival artefact into algorithms; in other words, into computer codes.

The overwhelming presence of digital technology across all areas in which we conduct daily life and configure everyday practices (finance, healthcare, news, shopping, education, etc.) elucidates this situation even more: that is the implication that life as such is now completely structured by, and bound up in the archival. All that is required to retrieve information, call up some data, or upload a photograph, video, or recorded music to a social media site is a password. The password is the currency of access to vast archives. The archival then is the relation to existence in which past events serve not merely as referents to be conjured back to life, or as evidence of historical importance (in the form of conservation of documents, objects, artefacts, texts, images, etc.), rather today it serves as a reference to a structure of simultaneous co-existence, as well as historical and contemporary co-dependence that constantly updates the past and infuses it with significance as part of daily practice.

As a matter of common example, the internet represents the archival technology par excellence. It is an auto-archiving instrument that surmounts and supersedes the actions of all users. Everything deposited on the web, all that it receives: gestures, texts, images, sounds, videos become instantaneously encoded in the domain of the archival to be distributed, shared, retrieved, borrowed, sampled, translated, transformed, commented on, and reused ad nauseam.

Let us think of Twitter, Instagram, YouTube, Flickr, iTunes, Google as obvious examples. Their capacity to link disparate, deterritorialised constituencies across time zones, spaces, and networks around the globe adds to the complex relations of data and archives as systems of the greatest contemporary importance in organising and liberating knowledge, information, images, and so forth. Perhaps, this situation describes more precisely Jacques Derrida's concept of *mal d'archive* or archive fever.[3] This casts the entire relationship between the domain

Walid Raad / The Atlas Group
*Let's Be Honest, The Weather Helped
Israel*, 1998/2006
Archival colour inkjet print, one of
series of 17 prints, 46.4 x 71.8 cm
Courtesy of Paula Cooper Gallery,
New York

of information and database, document and archive into a zone of ambiguity. In this sense, given the current conditions of what might be called archival presentness, the archive is no longer that which directs us to the past, nor does it constantly attend to the recursive system that governs the appearance of statements as unique events.[4] A re-tweeted image or text degenerates the moment it ceases to be a unique event. Therein lies the fate of the archive in the archival age.

The more we explore and examine the different domains of data, and the systems that collect, collate, and organise them into searchable and retrievable pieces of information, the more evident it becomes how much the architecture of contemporary information systems have annulled the structures of the classical archive. Previously, the archival artefact retained a certain idea of uniqueness and authenticity, namely the document's historical, cultural, or epistemological value.

The legibility or value of such an archival document (be it an artefact, object, or written text) depends on its level of historical, cultural, or epistemological communicability. This means that it not only generates and communicates, but also signifies a degree of historical importance and social significance; and carries the weight of interpretive power when retrieved or consulted. It is inside the classical archive, not its contemporary corollary of databases, that we encounter what Michel Foucault described as "the system that governs the appearance of statements as unique events".

With this shift, archival knowledge is no longer embedded in hushed, dark, dusty subterranean rooms (though they still certainly exist everywhere) that come to light only with the clanking of rusty keys or flooding of dim rooms with the illumination of expert insight. Rather, today the migration of archival information (music, films, photography, books, and other genres connected to classical modernity) to digital platforms, linked by gigantic data networks promises to make all these

Stan Douglas
Overture, 1986
16mm film installation, black and
white; sound, 7 minutes (loop)
Courtesy of the artist and David
Zwirner, New York / London

gathered materials – accumulated over centuries – instantaneously available, searchable, retrievable, and deployable by millions of users across the world. Documents, photographs, videos, text, speech, and so on swim in the efflorescence of this new archival condition. While old technologies of archiving storage remain (paper, vinyl records, printed photographs, films, video tapes, compact discs, floppy discs, DVDs, etc.), their rapid obsolescence as tactile artefacts on which concrete information is registered represents the overthrow of archival materiality by the hegemonic logic of software codes and data algorithms. While these transformations do not necessarily represent the demise of the physical archive, they do demand a new understanding of the registers of the archival. It is with this in mind that any assessment of the relationship between photography and the archive must also examine photographic and archival production in the context of this digital upheaval.

Archival Permeability

To think the archive today is to evoke its endless permeability, its temporal contingency. The archive's relationship to representation across photographic, filmic, and textual systems demands a wholly new conceptualisation of the terms of understanding of current archival logics, for the archive is no longer that which beckons us from the depths of time and the past. As Michel Foucault so succinctly described it, the archive "is *the general system of the formation and transformation of statements*." Which means that it is that which coordinates every relationship between past and present. According to Foucault, "the archive is first the law of what can be said, the system that governs the appearance of statements as unique events."[5] However, recent treatments of the archive give pause to the view that "the archive is first the law of what can be said". Rather, today, the archive is that which cannot be said. Given the degree of suppression of certain images and documents by a massive imperium of secrecy, it can be argued that the archive is that which cannot be permitted to make an appearance in public. This struggle over control and ownership of data and information is furthermore subtended by other networks, archival manipulation, and the deliberate opacity of data. To that extent, the archive is no longer the system that governs the appearance of statements. Fraught with doubts governing the

current conditions of archival systems and their ideological susceptibility to government agencies and economic exploitation by digital empires and multinational business, and the struggle on the part of users across networks to retain control over their information, we are in the midst of an archival crisis.

The crisis I described owes partially to the accelerating processes of technological innovation and their erosion and displacement of the authority previously vested in the systems of classifications, taxonomies, and other forms of classical knowledge. While in the past the archive wielded an overwhelming interpretive function as the arbiter of the obscure and the rare, the technical and esoteric, overseeing the collecting, classifying, systematising, preserving, and conserving of vast quantities of knowledge, it appears that in recent times technology has sought not so much to order the dispersed sites of knowledge as to organise, liberate, and democratise their availability, as WikiLeaks and the renegade "intelligence" analysts have done. Every facet of our common experience today as contemporary subjects is organised by the ineradicable proximity that technology provides in linking every facet of our lives to a new archival imperium that is so dematerialised that it exists literally in the "cloud".[6]

To propose therefore, that the archival supersedes every dimension of contemporary existence is to acknowledge the extent to which we live in an archival age. Discussions about data (a concept which deals with the immediacy of a specific type of information or forms of knowledge embedded within it), and metadata (which defines the underlying, but not immediately evident structure of data which then establishes a trail of deeper relationships between information and knowledge) call further attention to this reality. All analysis of the archive, the photographic image, and contemporary art must therefore, by critical necessity loose its innocence in the face of this empire in the "cloud", in order to produce an understanding of archival practice as it stands on the juncture of the classical archive and contemporary techniques of archivisation.

Photography and the Archive

From its inception, the photographic record has manifested "the appearance of a statement as a unique event". Every photographic image has been endowed with this principle of uniqueness. Within that principle lies the kernel of the idea of the photograph as an archival record, as an analogue of a substantiated real or putative fact present in nature. The capacity for mechanical inscription and the order of direct reference that links the photograph with the indisputable fact of its subject's existence are the bedrock of photography as a recording act; an act that transform an event into an imprint of time; and an imprint of time that is arrested into the cargo cult of an archival artefact. Photography's capacity for accurate description, its ability to establish distinct relations of time and event, image and statement, have come to define the terms of archival production proper to the language of those

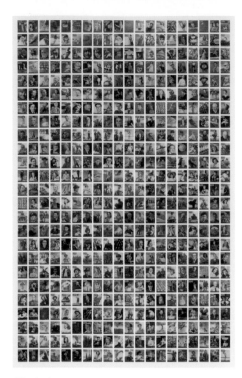

Alfredo Jaar
Searching for Africa from *LIFE*, 1996
Courtesy of the artist and Galleria Lia
Rumma, Milan / Naples

mechanical and digital mediums, each of which give new phenomenological account of the world as image. Photography is simultaneously the documentary evidence and the archival record of such transactions. Because the camera is literally an archiving machine, every photograph, every film is *a priori* an archival object. This is the fundamental reason why photography and film are often archival records, documents and pictorial testimonies of the existence of a recorded fact. The infinitely reproducible, duplicable image, whether a still picture or a moving image, derived from a negative or digital camera, becomes, in the realm of its mechanical reproduction or digital distribution or multiple projection, a truly archival image. Accordingly, over time, the photographic image has become an object of complex fascination and thus appropriated for myriad institutional, industrial, and cultural purposes – governmental propaganda, advertising, fashion, entertainment, personal commemoration, art. These uses make photography and its related discipline, film, critical instruments of archival modernity.

When Walter Benjamin published his essay on mechanical reproduction[7] in the 1930s, modern photography had been in use for a century. In the essay he was concerned with how the shift from the hand-fashioned unique image – for example painting – to the mechanically produced and infinitely reproducible image manifests a wholly new mode of pictorial distribution, a shift that was not only indexical but temporal. Because eye/hand coordination organised by the camera gave reality a different look, the liberation of the hand from image-making had a deep impact on questions of cognition and action. This change of artistic and pictorial parameters became a specific phenomenon of modernity. The advent of mechanical reproduction initiated an archival formation that would overtake all relations to the photographic record: the systems of production and distribution and, more recently, the processes of permanent digital archivisation and inscription. Since Kodak's invention of commercial processing at the end of the nineteenth century, the photographic analogue derived from the negative has not only generated an endless stream of faithful reproductions it also set the entire world of users into a feverish pace of pictorial generation and accumulation. The desire to take a photograph, to document an event, to compose statements as unique events, is directly related to the aspiration to produce an archive. The character of this archive is captured in W. J. T. Mitchell's notion of "the surplus value of images",[8] in which the photograph also enters the world of the commodity. The traffic in the photographic archive rests on the assumption of the surplus value that an image can generate.

In recent years the entanglement between the photographic image as archival document and contemporary artistic practice has renewed the consideration of types of visual knowledge this relationship generates. In the last one hundred years there has been committed analysis of the archival document in artistic practice. From Cubist collages to photomontages; Pop art to conceptual art; post-conceptual practices to the appropriation strategies of the "Pictures generation",[9] artists have

been exploring and developing artistic practices that derive from and generate new conditions that are explicitly embedded within the logic and conditions of the archival. Since the 1960s artists have drawn from, referenced, and deployed archival images to ends that attach both to art's fascination with mechanical reproduction, but also to a critical proclivity on which to contest the ideological conditions of a bourgeoning media ecology. This kind of work, especially in the context of photography, emerged at a historical moment when the photographic image had become an important tool of communicative ideologies. To that end, the turn towards the archival by artists served to underscore the degree to which the presence of the photographic image in public, institutional, and cultural systems was neither neutral nor free of political, economic, and social manipulation. From the earliest inception of what may be referred to, according to Foster, as the "archival impulse" is the development of forms of general critique of the archival object or image through strategies of degeneration of the stable structures of archival information, and the *detournement* of its historical and social meaning.

Disturbing, Perturbing, and Producing the Archive

How have artists responded to the complex conditions that currently define the status of the archive? Might archival practice today prove merely exemplary of a moment when the archive functioned within a limited and circumscribed relationship to its classical structure as a repository of knowledge to be consulted, appropriated, used, transmuted, interpreted, or degenerated? It is inside this debate in which the archive is submitted to critical interrogation that artists seek to operate. In fact, as Foster made clear, the current uses of the archive by artists are based on the desire to act upon it, to critique, prod and transform it, to disturb and stage an operation of countermemory upon the archive's accounts of public knowledge and memory. Between an earlier generation of artists such as Christian Boltanski, Hans-Peter Feldmann, Gerhard Richter, Marcel Broodthaers, Andy Warhol, and the generation from the 1980s onwards such as Richard Prince, Cindy Sherman, Alfredo Jaar, Carrie Mae Weems, Lorna Simpson, Stan Douglas, Thomas Hirschhorn, Thomas Ruff, Gabriel Orozco, Steve McQueen, Walid Raad, Dayanita Singh, Lamia Joreige, and many others, a range of practices have proved exemplary of a certain discursive representation of the archive in artistic practice. In their work these artists respond to the archive across various conceptual and aesthetic registers. Some address the archive as historical artefacts to draw insights from. Some such as Richter, Boltanski, and Feldmann work on a more fundamental interpretation of archival legacies by treating the archive as a medium through which new artworks emerge. However, it is not necessary to address every example and artist in order to demonstrate the degree to which processes of archivisation in response to the emergence of a massive, deterritorialised archive have

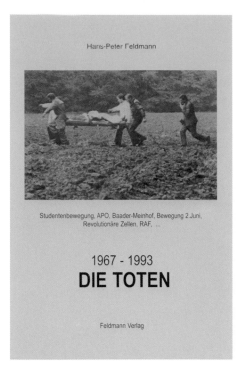

Cover of the book of Hans-Peter
Feldmann, *Die Toten, 1967–1993*
(Feldmann Verlag 1998)

developed. The critical point to keep in mind is the extent to which existing collection of images and archives have induced an archive fever, staging a permanent and perpetual photographic and historiographic depictions of past and present in new interpretive and interventional modes. The archive fascinates because it provides an open-ended platform for recursive and discursive performance.

In response to this need to re-perform the archive a range of artistic works and activities have been generated.

Artist and filmmaker Steve McQueen in a recent work, *End Credits* (2012) used the American Freedom of Information Act to gain access into the massive declassified files kept by the FBI and CIA on Paul Robeson the American actor, singer, and political activist. The files and the redacted texts drawn from them are placed in field of visualisation and animated by the reading techniques of a male and a female voice reading out passages from the documents in a scroll of narrativisation feel as if secrets were being spilled out of their boxes of incarceration. McQueen's intervention into the archive of Robeson's file calls attention not only to information lost to public knowledge through the clandestine work of American intelligence agencies, but also the overarching control wielded over information and knowledge by a vast bureaucracy of secrets.

In Hans-Peter Feldmann's *9/12 (Front Page)* (2001), an installation which exactingly documents the media response to the attacks of 11 September 2001 in the United States, the artist gathered a collection (an archive) of more than 100 front pages of newspapers published around the world on 12 September 2001, a day after the horrors unfolded. In this work Feldmann develops a vocabulary of public memory that is at once detached and impersonal as it is historical and archival. Feldmann developed this strategy of detachment when he abandoned painting in the late 1960s to focus exclusively on the photographic record drawn only from existing image ecology.

His fundamental concern is with photography's social and political meaning in the context of public culture, and with the disjuncture between the ubiquity of the photographic image as it developed a private cult of commemoration, and the evacuation of meaning that ensued as photographic images became empty signs in the media. Mixing the high and low, private and public, the artful and kitsch, Feldmann's seemingly offhanded, anti-aesthetic, "anti-photographic"[10] approach is undermined by the gravity of the subjects he engages.

In *Die Toten, 1967–1993* (1998), he addresses images of terrorism in Germany, employing a systematic, regulated format in which he collects images of the dead – mixing victims and perpetrators – as he recalibrates and dissolves the distinction between his collected or produced photographic images into new structures of interpretation. *9/12 (Front Page)*, like *Die Toten*, compels a different register of ethical and political disclosures. Do the fluttering sheets of newspaper illuminate the dark events of 11 September, or do they banalise and ultimately diminish their projected impact? Is 11 September or German terrorism principally media events? With no accompanying

Hans-Peter Feldmann
9/12 (Front Page), 2001
151 newspapers, 64 x 46.5 cm
Courtesy of Fondazione Sandretto Re
Rebaudengo, Turin

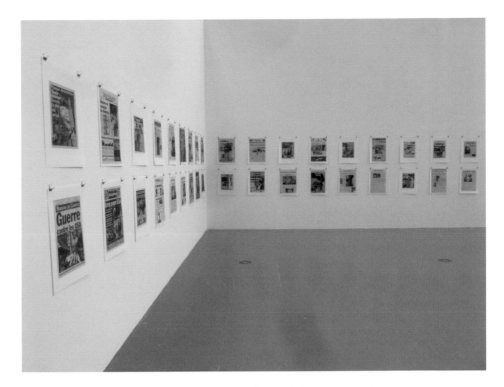

commentary, the material collected from different media sources, in different nations, cities, and languages, encode a new understanding of a public archive that at once serves a commemorative function and induce an iconographic ambivalence.

This aspect of Feldmann's practice, in which images and their contexts are constantly shuffled and represented in new forms of reception – in book works, newsprint editions, bound photocopied files, and so forth – is developed from the understanding, as Benjamin Buchloh has concisely articulated it, that far from the experience of anomie, "the photographic image in general was now defined as dynamic, contextual, and contingent, and the serial structuring of visual information implicit within it emphasised open form and a potential infinity, not only of photographic subjects eligible in a new social collective but, equally, of contingent, photographically recordable details and facets that would constitute each individual subject within perpetually changing altered activities, social relationships, and object relationships."[11]

The example of Gerhard Richter's massive and immersive project *Atlas* (1964–present), represents one of the most formidable examples of the archive as medium. It marks an important artistic watershed and already demonstrates the will to subvert the archive and render a new open account of the public media heritage and private individual memories. The entire work is composed of archives and is itself an archive. *Atlas* is an open-ended compendium of photographic panels and tableaux initiated by the artist as a reflection on the relationship between the photographic and historiographic, Each panel and tableau convenes histories and typologies of images. Richter has also organised the endless accumulation of images into structural taxonomies from images clipped from newspapers, magazines, books, to postcards, photographs from private albums, and snapshots taken on holidays, or of private

Gerhard Richter
From *Atlas*, 1964
4 b/w clippings, 1 b/w photograph
(mounted on 4 sheets, 3 with grids
and hand-written annotation),
66.7 x 51.7 cm

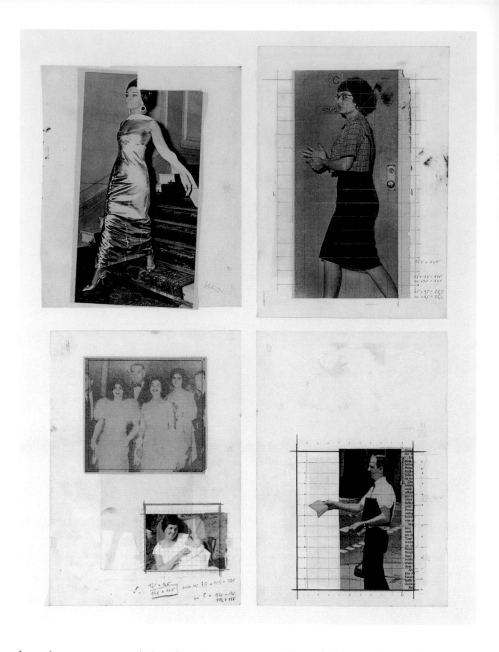

banal moments with his family, portraits of his children, his works, etc. Writing about this key work Benjamin Buchloh implicitly recognises that the principle of collectivisation – an important function of museums and archives – was integral to photography's disciplinary method from its inception. Projects such as *Atlas*, he notes, have "taken as the principles of a given work's formal organisation photography's innate structural order (its condition as archive) in conjunction with its seemingly infinite multiplicity, capacity for serialisation, and aspiration toward comprehensive totality."[12] Buchloh argues that Richter's *Atlas* inherited the conditions of this archival condition:

Yet, at the same time, the descriptive terms and genres from the more specialised history of photography – all of them operative in one way or another in Richter's *Atlas* – appear equally inadequate to classify these image accumulations. Despite the first impression that the *Atlas* might give, the discursive order of this photographic collection cannot be identified either with the private album of the amateur or with the cumulative projects of documentary photography.[13]

Inasmuch as any sensibility may wish to impose a restrictive order on the archive, then, the ability to do so is often superseded by concerns governing the disjunction between systems and methods. According to Lynne Cooke, the logic of *Atlas* is impeded by the impossibility of assigning a singular rationality to its existence as a unity: "*Atlas* hovers … between the promise of taxonomic order as divulged in the archive and the total devastation of that promise."[14]

But as the nature of the archival ecology oscillates between analogue products with their tactile materiality and digital systems and their virtual immateriality how are we to develop a relationship to works like *Atlas*? What is the archival artwork's relationship to what Jacques Derrida defines as the "science of the archive," which "must include the theory of [its] institutionalisation, that is to say, the theory both of the law which begins by inscribing itself there and of the right which authorises it?"[15]

The fascination with the archive as a facet of public memory – shared both by Feldmann's specific projects and Richter's comprehensive mapping – has retained its power over a wide range of artists who continue to deploy archival images of media as reflexive and documentary responses to events. Christian Boltanski, a pioneer of the archive as medium deploys the mnemonic as a form of meditation on mourning and loss. In his work the powers of the archive as a fundamental site through which we remember remain undiminished, even if the images he deploys and the narratives that he constitutes are more allusive and evocative of an archive than they represent an actual existing archive. For over forty years, Boltanski has posed conceptual and philosophical questions about the stability of the archive as a means by which we come to know and understand the past, not so much as a way to enter the logic of remembering but to explore and expose how photographic images trouble remembering, and in their inconsistency perforate the membrane of private and public memory. In the diverse arrangements to which their assemblage is subjected, Boltanski often treats photographic documents in contradictory ways: sometimes they are collected in a linear structure forming a seemingly coherent narrative, or they may be transformed into fetishised, individuated units such as in *Les archives de C.B. 1965–1988* (1989) composed on stacks of 646 rectangular biscuit tins inside which are stored 1,200 photographs and over 800 documents related to the artist's life. Boltanksi had gathered these materials during a process of emptying his studio. And in collating this massive number of archival images and documents, then sealing them in the biscuit tin, he not only cuts off access to the material by shielding them from the spectator's view, the dim spotlights he fixed on the expansive wall of rusted tin boxes lend them an almost devotional character, in a panoply of sentimental configurations that, remarkably, are designed to evoke shrines.

Boltanski's work oscillates between inert collections and arrangements of conservation, sometimes pushing his concerns to perverse extremes, blurring the line between the fictive and the historical. In a series of

works titled *Détective*, he draws from a popular French magazine of the same name that details a world of infamy in which crime is vicariously experienced through the spectacle of media excess. *Détective* appropriates the norms of the photographic montage, a mode in which devices such as juxtaposition and decontextualisation interrupt the regularised flow of pictorial narrative but which also privilege a democracy of relationships over the specificity of the sign. Here, the collectivised arrangements take precedence over the singular and unique. The sequence of images, collated from a variety of sources (sometimes the same images are reused in other ways, thus calling attention to issues of their authenticity as historical documents), suggests such relationships, but while the "Spectators of the work know that these photographs are images of individuals involved in crime and murder, [they] have no way of distinguishing between criminals and victims."[16] In *Leçon de ténèbres: Réserves: Ceux de détective* (Lessons of Darkness: Archives: Detective [1987]), dealing with crime, or *Les Suisses morts* (The Swiss Dead, 1990), which alludes to the Holocaust, the configuration of the images and their dilated, soft-focus pictorialism produce an unsettling ambiguity. Again, the general takes precedence over the specific.[17] The darkness of the Holocaust, for instance, is treated through the structural mechanism by which we come to experience the transformation of private images – snapshots of men, women, children hovering between disappearance and recall – into powerful, monumental, linear arrangements that become meditations on public memory.

The collectivised archive becomes a mnemonic reflection on history, building on the anonymity of individual lives to illuminate a kind of generalised singularity, but one nonetheless subordinated to the discourse of a group, a community. Given Boltanski's propensity to mix the fictional and the documentary, however, it is impossible

Christian Boltanski
Réserve: Détective, 1988
Black and white photographs, cardboxes, metal lamps, wood shelves, magazine clippings
Dimension variable
Installation, Kunsthalle Hamburg
Courtesy of the artist and Marian Goodman Gallery, Paris / New York

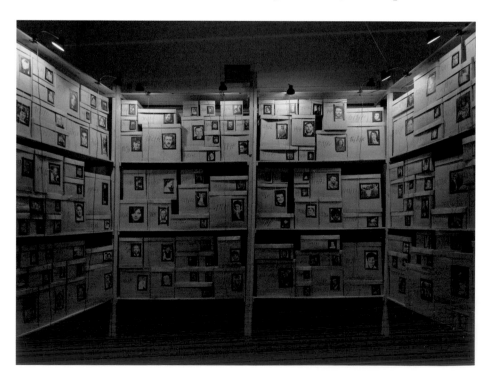

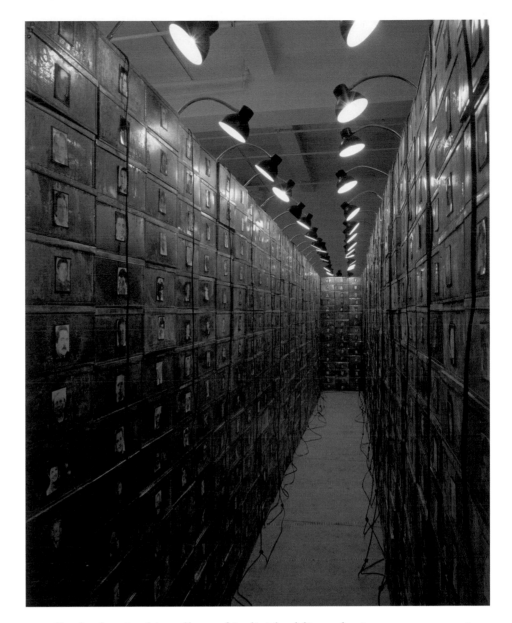

to tell whether in this gallery of individual lives the images are genuine historical documents or merely images that stand in for such individuals. This is the essence of Boltanski's archival ambivalence, for one never knows what is properly historical or semantically archival.

The Hell of Images

One enters a large darkened chamber illuminated only by the ambient brightness of a projection thrown across a white wall opposite where the spectator stands. The large image projected on the wall shows a hand holding a tablet device – an iPad to be specific – while the fingers from a second hand slide across the glass screen of the tablet. What is immediately clear with the iPad and the disembodied hand holding it, is the explicit relationship between that device and archivisation in the digital age. With long rapid motions, the fingers sweep across the screen, and each time an image appears.
The projected image lingers momentarily, dissolves and is replaced by

another image. In succession, more images like the one before appear across the wide white blankness, filling it with suffocating close-ups of traumatised, brutalised, and blown apart bodies. The larger the image looms, its claustrophobic closeness magnifies its spectatorial abnormality. And the more it becomes ever clear that this gallery of images has been organised and presented according to a certain logic of the archive on display. It is a form of display that simultaneously calls into question the relationship between the intimacy solicited by the screen and the distancing, alienating effect viewing the images produces.

As you are thinking these thoughts the fingers continue to do their work, swiping across the screen, or are brought together, and with a pinching gesture of thumb and index finger zooms into a particular area of the image, usually a grotesque wound. We are watching Thomas Hirschhorn's harrowing and mesmerising single-channel video: *Touching Reality* (2012), a film constructed wholly out of archival images. It is composed of still documentary photographs assembled from multiple media and individual sources on the internet. As the fingers work rapidly, sliding back and forth across the illuminated surface of the iPad, each swipe of the finger, each pinch of fingers, calls up scenes of car bombings, suicide operations, shootings. As the individual images begin to translate a body count of blown apart bodies, and bloated, gangrened corpses each float into view, on the white wall, it begins to dawn on us that we are descending into an archival pit, into the hell of images. The images show not merely scenes of carnage and abject brutality, which they are. More importantly, it is their underlying logic as part of the archival jetsam and flotsam that endlessly deposit ever-fresh annotations of global violence in the democratic, but anaesthetised distance of remote transmission. The scenes are challenging and at the same time fascinating. The spectacle of death fascinates, perhaps even enthrals,

Thomas Hirschhorn
Touching Reality, 2012
Video, no sound, endless loop, 4'45
Courtesy of the artist and Chantal
Crousel Gallery

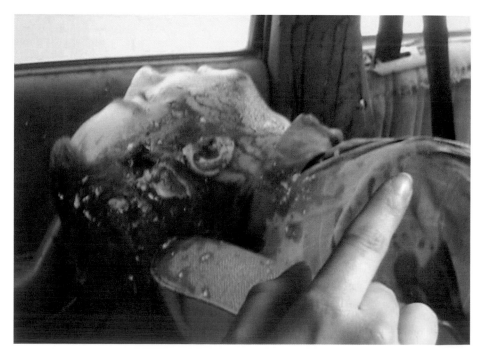

while ultimately numbing the mind and cauterising the senses. We are watching the remnants of the global war on terror, preserved in crystalline form as a screen saver, a reminder of the power and perhaps, the banality of the archive.

From Lens to Data Files: Spectres of the Archive in Fractals and Blurs

The increasing demise of film as support for the production of photographic images has manifested a crisis in old archival technologies. In the digital era the economic collapse of pioneering companies such as Kodak, Polaroid, and the ending of manufacturing of certain techniques such as Cibachrome and C-print, have each precipitated a reassessment of the technical conditions that first made mass-produced photography available to the public. With the replacement of film by digital files, and as more people document and store photographic data on mobile phones and tablets, an entire era of archival reproducibility is being eclipsed and a new one is emerging in its place. This important development in photographic practice bears directly on the conception of new ideas in which the camera lens plays little on no role in the shaping and production of archival work.

Of the artists who have addressed these changes in both a technical and conceptual fashion, the group of German artists who first emerged out of the photographic seminars of Bernd and Hilla Becher at Kunst Akademie Dusseldorf have been prominent practitioners whose works seek to meld the most exacting, sophisticated, and advanced technical means with a classical understanding of pictorial production. Amongst these artists are Andreas Gursky, Thomas Struth, Candida Höfer, and Thomas Ruff. These artists are known for producing large-scale photographic artworks, whose pictorial presence in a given space addresses itself to the history of Western painting and conditions of spectatorship. However, what is often not concretely connected to their work is their development of an understanding of pictorial art that is closely connected to archival production. Their detailed use of digital technologies to enhance and realise a completely new level of image manifests the way in which traditional modes of pictorial production deploy the technological possibilities of archival production.

In Thomas Ruff's case, much of his photographic works of the last decade have been developed and composed from existing images or derived from technologies that have recorded and archived the images. During this period his work has been less frequently based on advancing the merely technical perfectibility which a sophisticated lens-based picture can produce. Or on the kind of seamless pictorial composites that another influential and pioneering artist Jeff Wall does through his digital montages. Wall is known for images that both evolve from traditional photographic means of pictorial production and in digital post-production that seem to obscure the reality of the medium that generates them.

Thomas Ruff
Nudes (1999–2006): wr 28, 2000
C-print / Diasec, 103 x 102 cm
Private collection

Ruff's work, in terms of its format, on the one hand admits to this principle of post-production, yet on the other – especially in much of his recent work, in which he draws from existing digital files of documentary images found on the internet – departs markedly from that principle. Conceptually, Ruff's pictures operate within, and unite two inseparable but often inadmissible products of the photographic image, namely the way in which the photograph is structured by conditions of archivisation that transform images into jpeg and tiff files[18] and stored as such, rather than as a physical, analogue referent. The increasing recourse of the photographic image to being stored as digital files conveys a quality of spectrality on the photograph. The haunted quality of the archive and the recent advent of digitalisation in his work has advanced this notion of the spectral form even more, and it manifests in Ruff's work through his use of the blurred and fractal image in a language naturalised, so to speak, as a by-product of the photograph, as it migrates from a small digital file to a scaled-up image meant specifically to disintegrate, shifting from haptic stability to optical instability.

Increasingly, the camera plays a limited role in the development of Ruff's images, or has become secondary to their conception. Since the late 1990s Ruff has elaborated a number of pictorial approaches that are directly embedded in the pictorial structure of found archival images. For example, the *Nudes (1999–2006)* series represents a particular strain in Ruff's image archaeology. In this body of work, Ruff has focused mostly on the painterly values which the digital blurring of the files produces. At the same time, the careful curatorial selection of colour values in the images very much evokes and enacts an approach to the aesthetic of the classical nude. The chosen pictures contain a preponderance of pink flesh tones and flaxen blond hair. Sometimes, they are sprinkled with Richter-like grisaille blurs, and sepia-toned prints displaying bodies writhing in various poses of coitus. The disembodied structure of the images is partly intended, and partly derives both from the disintegrating resolution as they are enlarged, and from their manipulation on the computer by means of imaging software.

By fusing the archival image and computer software, Ruff his able to examine the compositional particularities of the digital file as found document, rather than the typically precise clarity and hyper flawlessness that is an idealised feature of digital photography.

Over the years Ruff has committed his conceptual resources to exploring the murky nature of the digital database and its archival possibilities of pictorial production. As his work has moved further into the territory of culturally and collectively generated photographic images, such as in the *Jpeg (2004–2008)* series drawn from documentary pictures that litter the Internet, so has the idea of the studio environment, which seemed to relentlessly embrace the post-production[19] ethos of the digital era, hold sway in his work. In fact, as his work increasingly appeared to have been freed entirely from the cumbersome cinematographic apparatus of the photographic studio,

with its large-view cameras and rigged-up lighting armatures, so did the traditional optical structure of film recede into the realm of digitalisation. The manner in which his images are made elucidates some approaches to photography, but departs from it through its anchoring in the destructuring of the picture file. In this way his heterogeneous formats are keyed to advancing complex issues of representation that cover the panoply of processes in the development of photography and the emergent pictorial forms that are constantly generated from them.

The treatment of the archive, the photograph as a found object, the use of the fragment, the contradictory aspects of the pictorial regime of object-image, are each procedures that are emblematic of some of the key ideas advanced by postmodernism,[20] but not in terms of the anti-originality pictorial codes of appropriation to be found, for instance, in Sherrie Levine's re-photographed Walker Evans pictures. For more than two decades, Ruff's photographic work has been engaged in, and reflects the possibilities of, a photographic production that is no longer dependent on the gradient values of printing techniques. Instead, from the earliest inception of his work Ruff has been recasting the surplus productivity of photography by exploring its remainders.

Annelie Pohlen underscores the importance of the structures of archivisation in his work, writing:

Ruff deals with the photograph as an aesthetic and artificial reality in itself. Basic to his work is the idea of the sample, of choosing freely from a pre-existing field of inherited structures, a series of classical motifs: the human portrait, a central artistic genre since the Renaissance; architecture, another time-honoured subject; the stars, symbols of the cosmos, and an ancient leitmotiv in all sorts of human reflection on our place in the world; and now the newspaper photo, a treasury of whatever is on people's minds, from military matters

Thomas Ruff
Jpeg (2004–2008): bi01, 2007
C-print, 238 x 320 cm
Budapest, Műcsarnok

to tourism, from politics to culture, from the economy to the entertainment industry. Ruff approaches each of these genres as a kind of found object.[21]

The remainders, far from being residues, refer to the remarkable and prolific nature of photography today and its afterlives in archives, on the Internet, in disused studios, product catalogues, and other digital databases. From this deep archival sediment artists make decisions on the specific archaeology of the image they will explore and which pictorial format the image would assume. This can take the form of a portrait, a landscape, a nude, an abstraction, a document, or a dematerialised and disintegrated picture. In this sense, the photograph always appears first as data before it is transformed and transposed into the regime of the image and finally into an object to be seen and looked at in the frame of pictorial art or merely as an agglomeration of collectivised mnemonic products.

[1] Hal Foster, "An Archival Impulse," *October 110,* Autumn 2004, p. 4.

[2] Ibid., p. 4.

[3] See, Jacques Derrida, *Archive Fever: A Freudian Impression* (Chicago: University of Chicago Press, 1998).

[4] Michel Foucault, *The Archaeology of Knowledge and the Discourse of Language*, translated by A.M. Sheridan Smith (New York: Pantheon Books, 1972), p. 130.

[5] Ibid., p. 129.

[6] According to an entry in Wikipedia, "cloud computing is a *colloquial* expression used to describe a variety of different types of computing concepts that involve a large number of computers connected through a real-time communication network…The phrase is also, more commonly used to refer to network-based services which appear to be provided by real server hardware, which in fact are served up by virtual hardware, simulated by software running on one or more real machines. Such virtual servers do not physically exist and can therefore be moved around and scaled up (or down) on the fly without affecting the end user – arguably, rather like a cloud." See http://en.wikipedia.org/wiki/Cloud_computing

[7] Walter Benjamin, "The Work of Art in the Age of Mechanical Reproduction", in *Illuminations: Essays and Reflections* (New York: Schocken Books, 1968).

[8] See the chapter, "The Surplus Value of Images," in W. J. T. Mitchell, *What Do Pictures Want? The Lives and Loves of Images* (Chicago: University of Chicago Press, 2005), pp. 76–106.

[9] The term "Pictures Generation" is used to identify a group of American artists who emerged in the mid-1970s during a period in which postmodern theory and the critique of originality produced an approach to using images based on appropriation of existing images from diverse sources. The critic Douglas Crimp is credited with identifying this tendency amongst a loose affiliation of mostly New York-based artists in his seminal exhibition "Pictures" in 1977 at the alternative art gallery Artists Space, New York. In 2008 Metropolitan Museum of Art, New York organised a retrospective of exhibition that focused on this generation of artists.

[10] Feldmann's work has been framed as issuing from an "anti-aesthetic" context based on the low character of the images he employs and the lack of fetishistic regard he accords them. Yet it is possible to observe that works like *Die Toten* – a reflection on media images, especially in newspapers and magazines, documenting the terror, murders, assassinations, and suicides in Germany initiated by radical leftist groups such as the Baader-Meinhof in the 1970s and early 1980s – in its detailed collection of the documentation reported in the media, does not take a neutral, disinterested stance. The charged context of the events lends the images the quality of political commentary, even if Feldmann deliberately sought not to distinguish between victims and perpetrators in his arrangement of the images. The oft-stated claim that photography has lost its special character of appeal because we have become inured to the bombardment of images in the media is an oversimplification of the power of images as signs of collective public discourse. Though Feldmann's work operates within this field of skepticism, it is important to note that his interests extend

from the banal and kitsch to the profoundly ethical. This is certainly the issue that must be confronted in *9/12 (Front Page)*.

[11] Ibid., p. 131.

[12] Benjamin H. D. Buchloh, "Gerhard Richter's *Atlas*: The Anomic Archive," *October* 88 (Spring 1999), p. 118.

[13] Ibid., p. 118.

[14] Lynne Cooke, *Gerhard Richter: Atlas*, exhibition brochure, Dia Center of Contemporary Art, New York, 1995, unpaginated.

[15] Jacques Derrida, *Archive Fever: A Freudian Impression* (Chicago: University of Chicago Press, 1998), p. 5.

[16] Richard Hobbs, "Boltanski's Visual Archives," *History of the Human Sciences* 11, no. 4 (1998), p. 127.

[17] For a detailed treatment of Boltanski's oeuvre, see Lynn Gumpert, *Christian Boltanski* (Paris: Flammarion, 1994).

[18] According to Wikipedia, JPEG, which is an acronym for Joint Photographic Expert Group, which created the standard, "is a commonly used method of compression for digital photography (i.e., images). The degree of compression can be adjusted, allowing a selectable tradeoff between storage size and image quality. JPEG typically achieves 10:1 compression with little perceptible loss in image quality, and is the file type most often produced in digital photography or computer screenshots. The file type also is prone to pixelating when an image is shrunk." See Wikipedia, http://en.wikipedia.org/wiki/JPEG. TIFF (originally standing for Tagged Image File Format) is a file format for storing images, popular among graphic artists, the publishing industry, [1] and both amateur and professional photographers in general. See http:// en.wikipedia.org/wiki/Tagged_Image_File_Format

[19] For a discussion of this tendency in contemporary art, a process generated in and engendered by the finishing and refining processes of post-production, see Nicolas Bourriaud, *Post-Production: Culture as Screenplay, How Art Reprograms the World*, translated by Jeanine Hermann (New York: Lukas and Sternberg Press, 2002).

[20] For an important essay in this direction, see "Notes on the Index, Part 2," in Rosalind E. Krauss, *Originality of the Avant-Garde and Other Modernist Myths* (Cambridge, MA: MIT Press, 1985), pp. 210–19.

[21] Annelie Pohlen, "Deep Surface," *Artforum*, April 1991, p. 114.

- "Aus der Distanz"
- Paul Graham
- Hans-Peter Feldmann
- Hiroshi Sugimoto
- "1$^{\text{ères}}$ Rencontres de la photographie africaine de Bamako"
- Rineke Dijkstra

"Aus der Distanz"

Kunstsammlung Nordrhein-Westfalen, Düsseldorf, 22 June – 4 August 1991

Bernd Becher started teaching photography at the Düsseldorf Kunstakademie in 1976, when the work produced entirely in collaboration with his wife Hilla had already attained international renown. It featured in the fifth edition of Documenta in 1972 and the German couple were the only foreigners to take part three years later in "New Topographics: Photographs of a Man-altered Landscape" at the International Museum of Photography, Rochester, which was crucial among other things for definitively introducing the "documentary style" into the art system. For the Bechers, these years saw recognition of an oeuvre that had already taken on its definitive characteristics as a survey of disused industrial plants in accordance with a rigorous typological criterion. Above and beyond the more obvious external aspects, from a predilection for the "anonymous sculptures" of the modern era to the modular structure within which short series of images were organised, their work was underpinned by a general thrust corresponding to the sense attributable to their artistic operation, which they passed on to their students over the years. This can be described as a sort of combination of the historical tenets of Neue Sachlichkeit movement and its more recent conceptual counterparts, which took concrete shape in the production of works with a specific thematic horizon and recurrent methodological input. The theme in question is representation itself, examined in relation to the act of looking and encompassing the vast range of associated philosophical, aesthetic, social and political questions. The method instead involved building up a critical mass whereby quantity regains a qualitative value. Hence the presence of numerous objects of the same type in a single photograph, the insistence on series, and the interest in archives, to mention only the principal developments of this logic. Even though for administrative reasons Hilla was not allowed to teach officially together with her husband, she was intensely involved in the courses, which indeed often ended up being held in their home. The power of their teaching, which ran parallel to the fundamental painting course taught by Gerhard Richter at the academy from 1971 to 1993, led to the training of a large number of photographers who never formed an actual group but were generically referred to as the Düsseldorf School, and gave birth to one of the most important "trends" in

contemporary photography at the world level. The first major recognition of this development, where signs of its autonomy with respect to other approaches are identified, came in 1991 with the exhibition "Aus der Distanz / From a Distance", organised by Bernd Finkeldey and Maria Müller. (Some of the photographers had already featured in 1979 in "In Deutschland – Aspekte gegenwärtiger Dokumentarfotografie / In Germany – Aspects of Contemporary Documentary Photography" at the Rheinisches Landesmuseum, Bonn, a key response to "New Topographics" held, however, when it was still too early to recognise the specific character of the developments in Düsseldorf.) Held at the Kunstsammlung Nordrhein-Westfalen in Düsseldorf from 22 June to 4 August, it presented some of the Bechers' typologies together with a selection of works of the leading figures in the first generation of their students: Andreas Gursky, Candida Höfer, Axel Hütte, Thomas Ruff, Thomas Struth, and Petra Wunderlich. (Laurenz Berges, Elger Esser, Simone Nieweg, and Jörg Sasse were also to attend the Kunstakademie in later years.)

With the exception of the Bechers, everyone involved presented work produced primarily in the period just before the show, thus offering a key overview of the major characteristics of the Düsseldorf School at the moment when it took off in the sphere of museums and the art market. Andreas Gursky showed the first photographs taken from an elevated viewpoint in which the dimension of space – internal or external, natural or artificial – overwhelms that of the human beings present in it. Photographed unawares, normally at work and occasionally during their free time, the latter lose their identity and appear like tiny parts of collective activities, while the viewer instead has the impression of occupying a dominant position. Candida Höfer concentrates on the documentation of places devoted to the preservation of culture and knowledge, from museums and universities to libraries and castles, with such order and precision as to highlight even the slightest irregularity, as though it were a side effect of her approach, thus raising doubts as to the ability of the instrument she uses to record and preserve. Axel Hütte observes the interaction between the signs of mankind (especially buildings) and the surrounding natural environment with an excess of detachment, taking advantage of the impassive eye of the camera to place them on the same level. Working from the outset on independent series differing greatly from one another, at least as regards subjects and visual organisation, Thomas Ruff presented *Sterne / Stars*, produced by enlarging some details of negatives belonging to a colossal programme of mapping the stars carried out between 1974 and 1987 by an international astronomical organisation at the Silla observatory in Chile. In this, the only project of appropriation to appear in the show, Ruff not only cited the taxonomic rigour of his masters but also highlighted the instability of the meaning of images in relation to their setting. Thomas Struth also concentrated on the mechanisms of viewing but with reference to imagery of a very different kind. Taken in museums all over the world, his photographs show the relationship established between some great works of art of the past (which are consequently reproduced by him) and the people who contemplate them, placing the viewers in a situation where they observe their own behaviour and feel observed in turn. Finally, Petra Wunderlich shows a vast range of quarries and historical buildings in photographs (the only

ones in black and white other than those of the Bechers) that emphasise the texture of their surfaces by capturing the smallest details, thus highlighting the gap between the material of reality and the material of its image.

The works shown by these six photographers were in every case much larger than those of the Bechers, ranging from the 36 x 52 cm prints of Candida Höfer to the monumental 188 x 260 cm prints of Thomas Ruff. Introduced in the second half of the 1980s (the pioneer was Ruff with the first experiments in 1986, followed by Gursky, Hütte and Struth at the end of the decade), this crucial attribute of their work had a series of significant consequences. First, rejection of the miniaturisation typical of photographic representation places the works in direct relation to the history of the painting. Second, a marked difference is established between the experience of the original (that is to say, *an* original) and of any reproduction thereof in a magazine or a book, thus countering another misapprehension normally associated with photography. Experience of the photograph thus takes on an immersive character and the peak of the discipline's illusionistic aspirations

is attained. The distance referred to in the title of the exhibition thus takes two forms. On the one hand, it regards the relationship between the photographer and the subject, which is kept far enough away to avoid any emotional involvement whatsoever and described in its context, discarding the excessive partiality of the close-up. On the other, it corresponds to the space required by the viewer to appreciate a large-sized image in overall terms. The resulting detachment is one of the hallmarks of the work of these photographers and evidently underlies the definition of the artistic approach that Charlotte Cotton describes as "deadpan photography", which began with them and spread throughout the world at the turn of the millennium: "The adoption of a deadpan aesthetic moves art photography outside the hyperbolic, sentimental and subjective. These pictures may engage us with emotive subjects, but our sense of what the photographers' emotions might be is not the obvious guide to understanding the meaning of the images. The emphasis, then, is on photography as a way of seeing beyond the limitations of individual perspective, a way of mapping the extent of the forces, invisible from a single human

standpoint, that govern the man-made and natural world. Deadpan photography may be highly specific in its description of its subjects, but its seeming neutrality and totality of vision is of epic proportions" (Charlotte Cotton, *The Photograph as Contemporary Art*, Thames and Hudson, London 2004, p. 81).

Bibliography
Belting, H. *Thomas Struth: Museum Photographs*. Munich: Schirmer/Mosel, 2001.
Chevrier, J.F., and J. Lingwood. *Another Objectivity*. Milan: Idea Books, 1989.
Christov-Bakargiev, C. *Thomas Ruff*. Milan: Skira, 2009.
Cotton, C. *The Photograph as Contemporary Art*. London: Thames and Hudson, 2004.
Galassi, P., and G. Lowry. *Andreas Gursky*. New York: The Museum of Modern Art, 2002.
Gronert, S. *The Düsseldorf School of Photography*. London: Thames and Hudson, 2009.
Honnef, K., and W. Schürmann. *In Deutschland – Aspekte gegenwärtiger Dokumentarfotografie*. Cologne: Rheinland Verlag, 1979.
Honnef, K. *Axel Hütte: Landschaft*. Munich: Schirmer/Mosel, 1995.
Kruger, M. *Candida Höfer: A Monograph*. Munich: Schirmer/Mosel, 2002.
VV.AA. *Thomas Struth, 1977–2002*. New Haven: Yale University Press, 2002.

Andreas Gursky
Karlsruhe, Siemens, 1991
C-print, 175 x 205 x 5 cm
Courtesy of Spruth Magers,
Berlin / London

Axel Hütte
Balford Tower, 1990
C-print, 214 x 152 cm

Axel Hütte
Trellic Tower, 1990
C-print, 214 x 152 cm

Thomas Struth
Kunsthistorisches Museum II,
Wien 1989, 1989
C-print, 151 x 196 cm
UniCredit Art Collection –
HypoVereinsbank

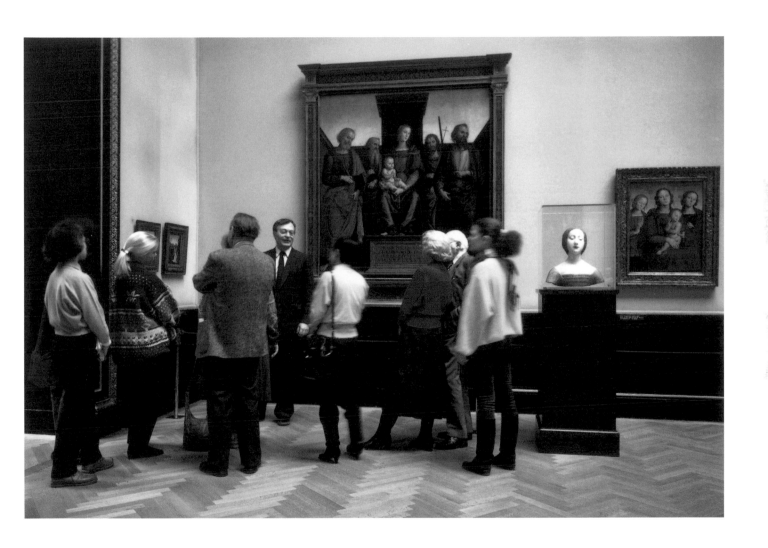

Thomas Ruff
Stars, 05h, 08m/-45 degrees,
1990
C-print
New York, The Metropolitan
Museum of Art, Purchase,
The Horace W. Goldsmith
Foundation Gift, through Joyce
and Robert Menschel, 1991
(1991.1057)

Candida Höfer
Universität Utrecht I, 1990
C-print, 35 x 52 cm
UniCredit Art Collection –
HypoVereinsbank

Paul Graham

New Europe

Cornerhouse Publications: Manchester, 1993

Paul Graham, born in England in 1956, studied microbiology at Bristol University before dropping out in 1976 to concentrate on photography. This was a period when numerous British photographers took an interest in the social problems caused by the policies of the Thatcher government, thus giving rise to a sort of spontaneous and informal movement. Graham was involved in this with work that took up the tradition of documentary photography and constantly called into question its poetic and formal precepts. (The most initial successful attempts to take stock of this particular phase in British photography include "Britain in 1984", held at the Photographers' Gallery in London and "British Photography from the Thatcher Years", held at the MoMA, New York, in 1991, both including some of Graham's photographs.)
A self-taught photographer, he started out with rigorous black-and-white but switched to colour in the early 1980s, becoming a pioneer of its use in the United Kingdom alongside Martin Parr, whose work is distinguished by saturated colour and contrasts from 1984 on. Graham made his debut the year before with the book *A1 – The Great North Road* (Grey Editions, London 1983), which addresses the theme of the journey, combining personal memories and social investigation in addressing what was a broad tradition, especially in the United States, enriched in the same period by cornerstones of colour photography like Stephen Shore's *Uncommon Places* (Aperture, New York 1982) and Joel Sternfeld's *American Prospects* (Times Books/Museum of Fine Arts, New York/Houston 1984).
Having taken the shots for this first publication, Graham devoted his energies to the simultaneous investigation of two specific issues. For *Beyond Caring* (Grey Editions, London 1986), he addressed the problem of unemployment in the United Kingdom, visiting Social Security offices to photograph their bleak interiors and the long queues of depressed and jobless people, victims of the crisis in the manufacturing sector. The use of colour here has a shattering twofold effect. On the one hand, it endows situations of everyday desperation with a pictorial quality; on the other, it makes them unpleasantly and uncompromisingly concrete.
Troubled Land (Grey Edtions, London 1987) is instead a report on the endemic conflict in Northern Ireland consisting exclusively of a series of huge landscapes, calling a

Page 120
Untitled, Germany, 1989
Courtesy of Pace Gallery and
Pace/MacGill Gallery, New York

Page 121
Untitled, Belfast, 1988
Courtesy of Pace Gallery and
Pace/MacGill Gallery, New York

consolidated canon into question with images that appear detached, ambiguous and densely laden with symbols all at once. These attributes came together in the next project, for which Graham expanded his range of analysis from a circumscribed situation to a broader, multifaceted context on the verge of incomprehensibility. *New Europe* is the result of work carried out from 1988 to 1993 with the aim of capturing the complex transition of a number of western European countries towards the creation of a supranational union. Exhibited for the first time at the Anthony Reynolds Gallery, London, in March 1990 (with the large-sized prints mounted apparently at random on aluminium panels with no frames or other forms of protection) and published in complete form in 1993 by Cornerhouse Publications, it marks a crucial turning point of fundamental in the sphere of contemporary photography as a whole. In addressing an issue of great topical interest, it not only rejected the approach of linear narrative, stereotype, and the typical elements of reportage, but also converted the detachment maintained with respect to the subjects from the result of an ethical choice to an authentic existential condition.

Made up of forty-five photographs and an accompanying text by Urs Stahel, the book develops within the constant dialectic of past and future, generating irresolvable tension between spectres of what has been and the utopia predicted. We see images of the great dictatorships, the Iron Curtain and the revolutions and counter-revolutions that have marked the history of the period since World War II together with those of the capitalist system in whose name the unification of the new Europe is taking place, capable only of drawing a flimsy veil over wounds that are still open, thus allowing disillusionment and growing moral torpor to show through. This is perfectly encapsulated in the opening image of a war veteran looking towards the horizon with his wounds clearly visible as he observes the fruits of victory from afar: a squalid agglomeration of blocks of flats in pale colours glowing in the sun. In the same way, this photograph pinpoints the primary theme of the entire series, namely *absence*: the lack of any deep ties between the individual nations of the community being created, or of long-term prospects for their citizens, and indeed a lack of clarity and straightforwardness in Paul Graham's images, which employ a series of

visual strategies, including frequent close-ups and the darkness of night clubs, to express a sense of opacity. The hand of an unseen man resting on the arm of a woman smoking a cigarette, the two individuals looking upwards, the faint reflection of lamps in a shop window, the erased part of the reproduction of a photograph from the Nazi era, these are all signs referring to what cannot be seen, frustrating our habit of looking for exhaustive answers in photographs and opening up the possibility of countless interpretations. *New Europe* made its appearance on the art circuit in the same year as the founding of the European Union with the Treaty of Maastricht, suggesting a possible parallel between the unstable and temporary character of its images and the structure of its subject.

Bibliography
Almereyda, M., D. Chandler, and R. Ferguson. *Paul Graham*. Gottingen: SteidlMACK, 2009.
Badger, G. *The Pleasures of Good Photographs*. New York: Aperture, 2010.
VV.AA. *British Photography: Towards a Bigger Picture*. New York: Aperture, 1988.
Wilson, A. *Paul Graham*. London: Phaidon, 1996.

Hans-Peter Feldmann

Voyeur

OFAC Art Contemporain: La Flèche, 1994

Born in Düsseldorf in 1941, Hans-Peter Feldmann studied painting in Austria at the Kunstuniversität Linz. The context of his formative years was rich in different stimuli that he was to rework and combine in those to come. Having grown up in the difficult period of national reconstruction in both physical and spiritual terms, Feldmann was simultaneously exposed in the 1960s to the tail end of the movements of socialist and nationalist realism, with their strong graphic and political impact, and the emerging ideas of Conceptual Art and Pop Art. His primary points of reference included the Belgian Marcel Broodthaers (who began his career as a visual artist in 1964 by pouring plaster over forty-four unsold copies of a book of his poems), as well as Bruno Goller and Konrad Klapheck, both resident in Düsseldorf, the former a member of the Neue Sachlichkeit movement and the latter the author of large paintings of everyday objects. The result is a wholly unprecedented and unclassifiable mélange.

Feldmann started out in 1968 on three years of work to craft a series of ten books of found photographs, each devoted to a single subject and entitled simply with the number of pictures contained, from *1 Bild* to *45 Bilder*. The generally commonplace nature of the subjects, including mountain peaks, family portraits, aeroplanes, and the legs of seated women, makes the work at least apparently similar to the taxonomic operations typical of the German photographic tradition (e.g., the monumental projects of Blossfeldt and Sander as well their more recent colleagues Bernd and Hilla Becher and Gerhard Richter, again active in Düsseldorf), as well as the French photographer Christian Boltanski and the American Ed Ruscha. While the points of contact are many, in particular with the last-mentioned and more or less contemporary authors (Ruscha published his first book in 1962, Richter began work on his *Atlas* in the mid-1960s, and Boltanski's *Inventaire des objets ayant appartneu à une femme des Bois-Colombes* appeared in 1974), a substantial difference distinguishes Feldmann's approach, where the focus is shifted from the subject to the viewer and there is no attempt whatsoever at cataloguing. In practical terms, what matters in his images is not so much what is seen,

but above all how it can be interpreted by every individual according to his or her characteristics (nationality, sex, age, religion, etc.) and personal inclinations. They thus become neutral fields serving to trigger countless meanings.

In 1994, over twenty years later, Feldmann developed similar reflections in a very different way by publishing just one book with a vast number of extremely heterogeneous subjects. Many things had happened in the meantime, including participation in the 1972 and 1977 editions of Documenta, various solo and groups shows in Europe's major museums, the creation of numerous books, and not least his withdrawal from the art scene from 1979 to 1989, during which period he continued his work privately while running a toy shop. This notwithstanding, when it appeared *Voyeur* offered the perfect complement to the early *Bilder* works. Published by the French company OFAC Art Contemporain, it develops a complex investigation of the very language in which it is written, namely photography, and on the modalities of its reception and decoding. In physical terms,

it is a book of 256 pages measuring 11 x 16.5 cm and containing 800 black-and-white photographs. Despite its ordinary appearance, each of these characteristics is closely connected with the questions raised. The small size not only keeps the price of the publication down, but also makes the images less spectacular so as to facilitate comparison. In the same way, the exclusive use of black-and-white, with colour having been eliminated from photographs in which it appears, produces an amalgamating effect. Finally, the ratio of pages to pictures means that the latter are presented with very high density and inevitably enter into relations with one another according to the dynamics of the individual's viewing experience. It is therefore the apotheosis of the viewer's process of reading, reworking and personalisation, which can express itself in complete freedom due to the absence of any captions providing information on the images themselves (author, date, place, etc.) and their content. The photography neither informs nor documents here: above all, it overwhelms.

The primary sources from which

Feldmann obtained the photographs for *Voyeur* are books, newspapers, and magazines. There were no restrictions of genre but instead a resolute insistence on the inclusion of the most varied subjects, from fashion, sport, news and advertising to war, science, tourism and pornography as well as amateur snapshots and sporadic shots by known photographers, including Edgerton, Giacomelli, and Salgado. An impression of familiarity is thus created with images already seen or in any case corresponding to our everyday experience of photography, which is, however, immediately disturbed by the frenzied mixing of completely different and apparently irreconcilable subjects. To give just a few examples of the logic that guides the book's entire sequence, one page can juxtapose an aeroplane crash and the Queen Mother, the Empire State Building and a group of elephants, a sexual act and a scene of armed combat. This is the opposite of *The Family of Man*, an authentic triumph of order and ethics. There is instead nothing hierarchical or epic about *Voyeur*, just a particular mixture of public and private, the new and the already

seen, generating a sense of excitement and anxiety. The safety of cataloguing is completely absent in this work, which stops at the prior stage of accumulation in a gesture that takes on strong political significance: power is in the hands of the people.

Bibliography
Enwezor, O. *Archive Fever. Uses of the Document in Contemporary Art.* New York / Göttingen: International Center of Photography / Steidl, 2008.
Feldmann, H.P. *Album.* Cologne: Walther König, 2009.
Obrist, H.U., and H.P. Feldmann. *Interview.* Cologne: Walther König, 2010.
Szeemann, H. *documenta 5.* Kassel: Bertelsmann, 1972.
Tatay, H. *Hans-Peter Feldmann: Catalogue.* Cologne: Walther König, 2012.

From the book *Voyeur*, 1994
Courtesy of the artist / Courtesy
Galleria Massimo Minini

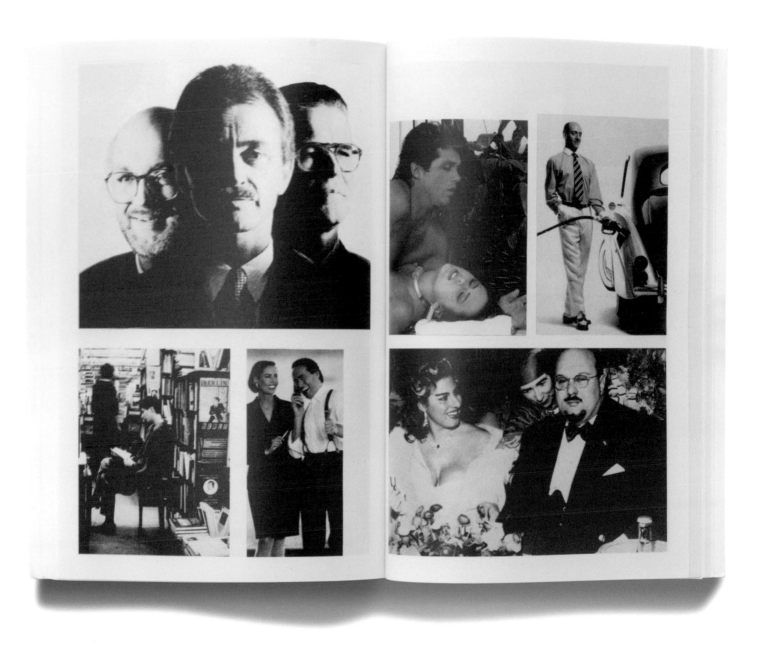

From the book *Voyeur*, 1994
Courtesy of the artist / Courtesy
Galleria Massimo Minini

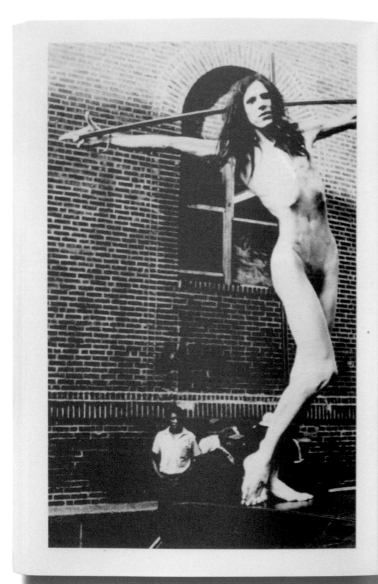

From the book *Voyeur*, 1994
Courtesy of the artist / Courtesy
Galleria Massimo Minini

Hiroshi Sugimoto

"Time Exposed"

Kunsthalle, Basel, 21 January – 5 March 1995

Hiroshi Sugimoto was born in Tokyo in 1948. After studying politics and sociology at Rikkyo University he moved to the United States, where he obtained his diploma from the Art Center College of Design in Los Angeles in 1974, before settling in New York. Here he began his complex research in the field of photography, which, however, is not exclusively rooted in the specifics of this discipline, but draws abundantly on the experiments of the avant-gardes at the beginning of the twentieth century and of the most advanced artistic movements, particularly Minimalism and Conceptualism, using an approach that is both analytical and philosophical. The result is a slow build-up of series (Sugimoto's work exclusively takes the concrete form of distinct and self-sufficient projects), which since the 1990s have been shown in the Japanese artist's first retrospectives. The one organised by the Kunsthalle in Basel in 1995, "Time Exposed", accompanied by a catalogue with the same title (containing seventy-three images, an interview with the artist and an essay by Thomas Kellein), published by the German publishing house Hansjörg Mayer, gives a broad panorama of Sugimoto's career to date. It focuses on the two main lines of research running through his production: on the one hand time as the decisive element in defining actuality and history, and on the other the complicated process of transformation that any object undergoes every time it is observed (first) and represented (later). In its own particular way, each of the series exhibited contributes towards developing both these themes, by launching a linear trajectory that it is possible to follow by exploring them in the same order in which they were executed: *Dioramas* (begun in 1976), *Wax Museums* (also conceived in 1976), *Theaters* (from 1978), and *Seascapes* (from 1980).

Dioramas is the first series Hiroshi Sugimoto worked on when he arrived in New York, inspired by the three-dimensional reproductions of natural scenery on a 1:1 scale that he found in one of the main tourist attractions in the Big Apple: the American Museum of Natural History. These large installations, photographed here as in other similar museums, became the sole subject of his shots, which were precisely framed so as to exclude any external element, from

the lights that illuminated them to the explanatory panels. What results is a paradox: in fact, thanks to the photographic images, the situations shown in the dioramas become animated and confused with the reality they represent. The stuffed animals, ranging from African antelopes to polar bears, from vultures to big cats, come back to life thanks to the opacity of any photographic image that shows only a part of what is in front of the camera, and to the viewer's faith in the reliability of this medium. The culmination was reached when Sugimoto photographed some prehistoric scenes with dinosaurs and Neanderthal men. Reproductions of reproductions as in a double negative, linguistic-mathematical operation these images are the opposite of a photograph: they turn the past into the present and the dead into the living. The *Wax Museums* series is similarly structured. Taken mainly inside the Madame Tussaud's wax museums in New York, London, and Amsterdam, it is a collection of portraits of many celebrities that excludes the actual context in which they are found. In this case there are even more stages of representation: the craftsman who executed the wax statue, in fact,

based himself on a previous image in order to shape the wax figure subsequently photographed by Sugimoto. But the effect does not change, since initially the viewer is in doubt as to whether this is a portrait of a person in the flesh. The power of the work lies in this moment of hesitation. The effect created involves both time (some of the subjects died before the invention of photography), and, more obviously than before, space, because none of the people featured in these images ever posed for the photographer.

The *Theaters* series tackles the theme of representation in a different way. The subject is the big screens of cinemas and drive-ins, which Sugimoto photographed using an exposure time that corresponded to the duration of the film projected, by opening the shutter at the beginning of the first scene and closing it after the end of the last scene. Unlike what you would expect, however, what appears in his photographs is not a confusion of overlapping images, but simply a blank screen. The lengthy exposure, characteristic of Sugimoto's whole working method as the title of the exhibition underlines, erased all the images of the film. In other words,

the build-up of an unknown quantity of images (photographic images since cinema is the projection of stills in rapid succession) resulted in an empty space, no image, no possibility of reading or interpretation. But this is not all, by going beyond the limits of the screen, Sugimoto's photos show the details of the context, whether interiors or spaces in the open air, which are rendered visible solely by the light reflected on the screen. By being eliminated, the images enable one to see what lies outside their confines.

Seascapes is a series characterised by the same compositional scheme, with the line of the horizon right in the centre of the shot that divides the space into equal sections devoted to only two subjects: water and sky. The slightly blurred surface of the sea and the movement of the stars in the nocturnes suggest that here, too, a lengthy exposure has been used. This was not the only way that Sugimoto introduced a reflection on time, since he made a long journey into the past through the simple content of his images. The reason he photographed only a portion of the sea and sky was because he wanted to reproduce a scene that resembled, as

closely as possible, the view of the world that our ancestors had, in the thousands of years that it took the human species to evolve, and he excluded the earth because it had undergone so many changes. Starting from the present that his camera reproduced, Sugimoto sought to photograph the past. Man's only action that it is possible to perceive lies outside the shot, in the title of each image, which refers to the need to give a name to everything, including what one cannot physically circumscribe and possess. Thus, over the years, this Tokyo artist has been travelling the world setting his R. H. Phillips & Sons camera, loaded with 8 x 10-inch black-and-white plates (this is the only camera he uses, also for his earlier works) before seas that evoke remote eras and entire civilizations, from the Atlantic Ocean to the Pacific, from the Sea of Marmara to the Tyrrhenian Sea, capturing in a single shot the grandeur of nature and culture.

Bibliography
Brougher, K. *Hiroshi Sugimoto: Seascapes*. Los Angeles: Museum of Contemporary Art, 1993.
Brougher, K., and P. Muller-Tamm. *Hiroshi Sugimoto*. Ostfildern: Hatje Cantz, 2010.
Kellein, T., and E. Schneider. *Hiroshi Sugimoto: Architecture of Time*. Bregenz: Kunsthaus Bregenz, 2002.
Morris Hambourg, M., D. Riis-Hansen, and A. Yasuda. *Sugimoto*. Houston / Tokyo: Contemporary Arts Museum / Hara Museum, 1996.

Earliest Human Relatives, 1994
Gelatin silver print
Courtesy of Fraenkel Gallery,
San Francisco

Mandrill, 1980
Gelatin silver print
Courtesy of Fraenkel Gallery,
San Francisco

Marmara Sea Silivli, 1991
Gelatin silver print
Courtesy of Fraenkel Gallery,
San Francisco

"1ères Rencontres de la photographie africaine de Bamako"

Musée National du Mali / Bibliothèque Nationale du Mali,
Bamako, 5–11 December 1994

"African photographers did not wait for the Bamako Rencontres exhibition, indeed the majority worked, and continue to do so, albeit in complete isolation … We hope this first edition will instil in these photographers, and also their countries, the will to create the common heritage that photography represents." With these words, Françoise Huguier and Bernard Descamps presented the first edition of the "Rencontres de la photographie africaine de Bamako" in a supplement of *Photographie Magazine*, the only publication that documented the event. It was 1994: experts and the international public had only recently begun to show a specific interest in the production of contemporary African artists that went beyond the folkloric and ethnographic. This new interest was reflected in the opening of the Biennale de l'Art Africain Contemporain at Dakar in 1990 (the first edition was devoted to literature, the second and those that followed to the visual arts) and the launch in 1991 of *Revue Noire*, a quarterly whose aim, stated in the editorial of the first issue, was to show that "there is art in Africa". Along with the pioneering Festival Panafricain du Cinéma in Ouagadougou, founded in the capital of Burkina Faso in 1969, these

initiatives provided African painters, sculptors, film directors, writers and musicians with suitable platforms for visibility and confrontation. Already featured to some extent in *Revue Noire*, African photographers now found their own space at the Bamako Rencontres, whose institution was certainly facilitated by the curator André Magnin's purchase of some of Seydou Keïta's photographs for Jean Pigozzi's Contemporary African Art Collection, one of the largest of its kind in the world.

The first Rencontres exhibition was held from 5 to 11 December 1994 at various venues in the Mali capital, including the Musée National du Mali and the Bibliothèque Nationale du Mali. The programme included a series of theoretical and technical workshops and lectures, as well as around twenty exhibitions that brought together the works of about fifty photographers. The leading light was Seydou Keïta himself, a fundamental point of reference both for foreigners, who had already heard his name in art circles (Magnin had discovered him at the exhibition "Africa Explores: 20th Century African Art" at the Center of African Art, New York, in 1991), and at home, where he developed a collection of images that was destined

to constitute the first independent African contribution to international photographic research. Keïta was actually born at Bamako in 1921, and had worked as a studio portraitist from 1948 to 1962, mixing a keen perception of his fellow citizens' individuality with the depiction of his country's transition from the colonial to the postcolonial period. Thus the signs of local tradition, from the arabesque motifs of the drapery in the background to the women's headgear (or their hairstyles), are juxtaposed with typically Western objects like radios, watches, cigarette-holders, and court shoes to convey the complexity of an identity issue and social situation that are not simply rendered through the dichotomy between Africa and Europe, but a combination of the two. Okwui Enwezor writes: "It is important to underscore that Keïta is by no means the pioneer of the style of 'studio photography' for which he is well known and acknowledged today. What sets his work apart from the workaday processes of the other commercial epigones was his transformation of the studio genre to the level of great art" (Okwui Enwezor, *Contemporary African Photography from The Walther Collection. Events of the Self.*

Portraiture and Social Identity, Steidl, Göttingen 2010, p. 33).

However, Keïta did not have an exclusive on the studio portrait at the first edition of Rencontres; on the contrary, the exhibition featured many images of this genre, making it the main ground for comparison at a continental level. Among the most important photographers who displayed such images were Malick Sidibé and Samuel Fosso, both of whom belonged to the generation after Keïta. Sidibé, the first photographer to receive a Golden Lion at the Venice Biennale (2007), was also from Mali. From the 1960s on he investigated the relationship between Africa and the West, past and present, focusing on the sensuality of bodies (always clothed) and going beyond the conventions of the genre by introducing unorthodox points of view (he even shot his subjects from behind) and dynamic poses reminiscent of the style of fashion photography. Instead of allowing the models to express their own personality through the positions they adopt in front of the camera, the photographer actually directs their movements to achieve perfect aesthetic rendition. On the other hand, Samuel Fosso, born in Cameroon in

1962, puts himself centre stage, using disguise to explore his own identity (over time he has dressed up as a tribal chief, a marine, a boxer, an odalisque, and many other characters) and the countless upheavals that have marked his country's history. Hence his self-portraits, which he began to take when he was only thirteen, are a kind of personal diary and an exhortation to change the status quo. They won him the first prize ever awarded by the Rencontres, which launched him on an artistic career. Lastly, the Nigerian Rotimi Fani-Kayode, whose work was shown alongside that of Sidibé in a section curated by *Revue Noire*, photographed his own nude body in a London studio to explore the complex issues of race and homosexuality. During his stellar but brief career, which ran from 1983 to 1989, when he died prematurely of AIDS, he utilised photography as a means of escaping from the restraints of reality while evincing its perverse nature. He wrote: "As an African working in a western medium, I try to bring out the spiritual dimension in my pictures so that concepts of reality become ambiguous and are opened to reinterpretation. This requires what Yoruba priests and artists call a technique of ecstasy." ("Traces of

Seydou Keïta
Untitled, 1956–57
Gelatin silver print
Courtesy of CAAC – The Pigozzi
Collection

Ecstasy", in Rotimi Fani-Kayode and Alex Hirst, *Photographs*, Éditions Revue Noire, Paris 1987, p. 6).

As well as studio photographs, the first edition of the Bamako Rencontres showcased images that were completely diverse regarding subject and style, including reportages that explored serious social problems in depth. The scourge of apartheid, which had been officially abolished the year before the exhibition, was the focus of various South African photographers' work. Santu Mofokeng was born in 1956 in Soweto, a Johannesburg suburb known for being one of the main arenas of the battle against racial segregation. He displayed the images he created when he was a member of Afrapix, a collective of photographers who used their medium as a tool for political action and resistance. Alongside him, Jenny Gordon and Ingrid Hudson documented the same reality, but from an altogether different standpoint, because the fact that they were white women gave them access to quite other places and situations, but did not arouse the interest of the media, which in that period were hungry for blood and violence. Completed by a historical display of antique photographs documenting independence, from the national archives of Mali and Guinea, the 1994 Rencontres not only embodied the goals set by the directors Huguier and Descamps, by identifying the common attributes of African photography and enabling the authors to communicate with each other and the outside world, but was also the launching pad for a series of significant structural changes. In fact, the exhibition activities culminated in a joint appeal by young African photographers for training facilities and specialized tools, and an announcement by Mali's Ministry of Culture that a Maison Africaine de la Photographie was to be created, which would house the Rencontres as from the 6th edition, to be held in 2005. Moreover, the interest generated on a global scale contributed to an entire creative world's definitive admission to the major museum circuit and the art market.

Bibliography
Bell, C., O. Enwezor, D. Tilkin, and O. Zaya. *In / sight. African Photographers, 1940 to the Present.* New York: Guggenheim Museum, 1996.
Bester, R., and O. Enwezor. *Rise and Fall of Apartheid. Photography and the Bureaucracy of Everyday Life.* Lakewood: Prestel, 2013.
Bonetti, M.F., and G. Schlinkert. *Samuel Fosso.* Milan: 5 Continents, 2004.
Enwezor, O. *Contemporary African Photography from The Walther Collection. Events of the Self. Portraiture and Social Identity.* Gottingen: Steidl, 2010.
Enwezor, O. *Snap Judgments. New Positions in Contemporary African Photography.* New York / Göttingen: International Center of Photography / Steidl, 2006.
Fani-Kayode, R., and A. Hirst. *Photographs.* Paris: Éditions Revue Noire, 1987.
Magnin, A. *Seydou Keïta.* Zurich: Scalo, 1997.
Magnin, A. *Malick Sidibé.* Zurich: Scalo, 1999.

Malick Sidibé
Portrait of Mlle Kante Sira, 1965
Silver gelatin print, 30 x 40 cm

Samuel Fosso
Autoportrait, Les Années 70's,
1975
Silver gelatin print, 50 x 50 cm
Courtesy of jean-marc patras /
galerie paris

Santu Mofokeng
National Union of Mineworkers
Meeting, Khotso House, 1987
Gelatin silver print

Rineke Dijkstra

Beaches

Codax: Zurich, 1996

Rineke Dijkstra was born at Sittard, Holland, in 1959. After studying photography at the Gerrit Rietveld Academie in Amsterdam, she started out as a commercial photographer, working for newspapers and advertising agencies in particular. Within this sphere, she gained considerable experience as a portraitist. Soon, however, she felt the need to distance herself from a system in which everything is perfectly orchestrated and the subjects themselves – often successful personalities – have complete control over their image, and became interested in a more natural and authentic means of confronting reality. On the basis of these premises, in 1992 Dijkstra embarked on her first project that was totally separate from her professional production. It consisted in a series of portraits of adolescents, either alone or in small groups, standing on a beach with the sea in the background. She drew her inspiration from a self-portrait she had taken the previous year at a swimming pool where she was doing physiotherapy to aid her recovery from a nasty bicycle accident, and found that her pose and expression were strongly influenced by the preceding physical activity in that it lowered her

defences and made her more spontaneous. This widened the gap between intention and effect that Diane Arbus – inevitably a point of reference for the Dutch photographer – describes in a famous quote from the monograph devoted to her in 1972: "Our whole guise is like giving a sign to the world to think of us in a certain way, but there's a point between what you want people to know about you and what you can't help people knowing about you. And that has to do with what I've always called the gap between intention and effect." (*Diane Arbus*, Aperture, New York 1972).

So Rineke Dijkstra's first photographic book, which came out in 1996, consisted in a collection of eighteen images of young bathers photographed during the four years she had just spent on beaches in the United States, United Kingdom, Belgium, Poland, Ukraine, and Croatia. The Zurich publisher Codax opted for a limited edition of 250, which soon sold out. Here the subjects' lack of self-awareness derives simply from their age, since they are too young to be able to control the way they look in front of the camera. Hripsimé Visser writes: "In psychoanalysis an adolescent is compared with a crab

that loses its shell. When that happens the animal hides under rocks until its new shell has hardened, because if it is wounded in this defenceless stage it will bear the scars for life. The comparison with the way in which Rineke Dijkstra – who herself grew up in a neighbourhood by the sea – has hauled her 'shell-less' adolescents from their hiding places in order to display them in their vulnerable nakedness is seductive." (*Rineke Dijkstra: Portraits*, Schirmer Mosel, Munich 2004). What is manifest in her images, therefore, is a state of transition, evident from both the subjects' uncertain attitudes and slightly out-of-proportion bodies which, halfway between those of a child and a grownup, are often awkward and partially covered by a swimsuit (or clothing that has the same function) which protects them from any kind of voyeurism but, at the same time, reveals their shape. Even more contradictory is the relationship between these individuals and certain figures taken from art history, as exemplified by the young Polish girl in a green costume (*Kolobrzeg, Poland, July 26, 1992*) who evokes Botticelli's Venus. Any similarities between the two are completely accidental (Dijkstra never poses her subjects, allowing

them to act freely in front of the lens); if anything, they indicate the distance between a classical model and the equally seductive aberrations of life. Titled simply with the name of the place and the date on which the shots were taken, Rineke Dijkstra's photographs are indebted to August Sander's typological approach, eschewing any direct reference to the identity of the subjects. Although combined with an attempt to remove all traces of a social mask, this choice nonetheless assumes a pseudo-political value, as if the author wished to protect the adolescents' privacy while investigating their innermost drives. The confirmation of various stereotypes, whereby the adolescents' different nationalities are reflected in certain physical attributes or the style of the swimsuits they are wearing (differences between American and European subjects are particularly evident), is thus accompanied by an analysis of their behaviour, from the expressions on their faces to the position of their hands, as distinguishing features of their specific personalities.

In *Beaches* the identification of the constant stereotypes and the individual variables is made easier by the repetition of the same compositional scheme in each of the images in the series, according to an even more rigorous logic than that applied in Sanders' ambitious categorisation project. All the subjects are placed in a frontal position in the centre of the shot, the same distance from the lens and looking directly at the camera. The positions they adopt on the shore-line – at the exact spot where the beach meets the sea – which accentuate its elusive, transitory nature, are basically unvaried. From a technical standpoint, Dijkstra uses a 4 x 5 view camera, capable of rendering the tiniest details of her subjects' bodies. She mixes daylight with the light generated by an electronic flash, which makes the subjects in the foreground stand out sharply against a geometric, but not neutral, background formed by three overlapping fields of colour: earth, water, and sky (or air). The bodies come to life through their encounter with these powerful elements. At the same time, the sharp simplicity of the overall image makes these figures emerge towards the viewer and gives them an impalpable lightness. They are weightless monuments, which found their definitive place in the art world when they were unveiled at the Venice Biennale in 1997.

Bibliography
Blessing, J., S.S. Phillips, and J. van Adrichem. *Rineke Dijkstra: A Retrospective.* New York: Guggenheim Museum, 2012.
Dexter, E., and T. Weski. *Cruel and Tender. The Real in Twentieth-Century Photography.* New York: Harry N. Abrams, 2003.
Stahel, U., and H. Visser. *Rineke Dijkstra: Portraits.* Munich: Schirmer/Mosel, 2004.
Visser, H. *In Sight. Contemporary Dutch Photography from the Collection of the Stedelijk Museum.* Amsterdam: Stedelijk Museum, 2005.

Selfportrait, Marnixbad,
Amsterdam, June 19, 1991
C-print
Courtesy of Marian Goodman
Gallery, New York / Paris

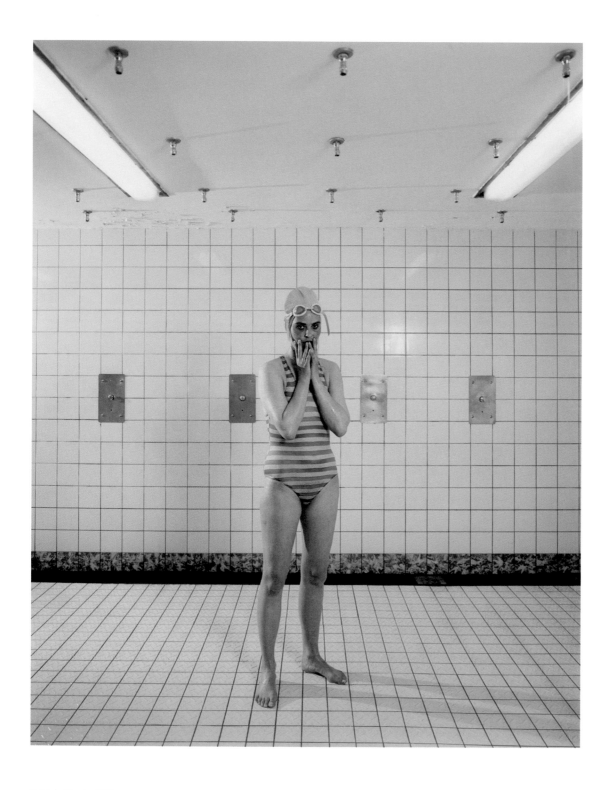

Brighton, England, August 7,
1992
C-print
Courtesy of Marian Goodman
Gallery, New York / Paris

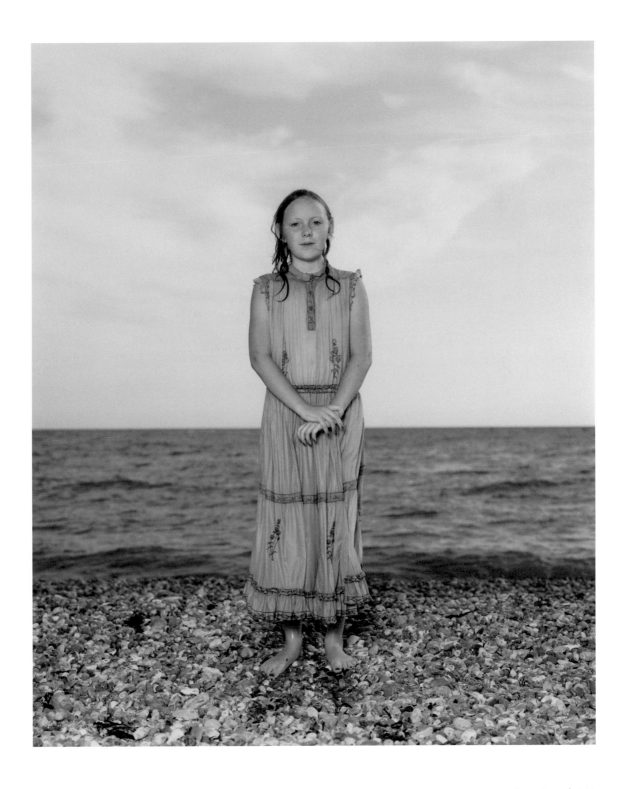

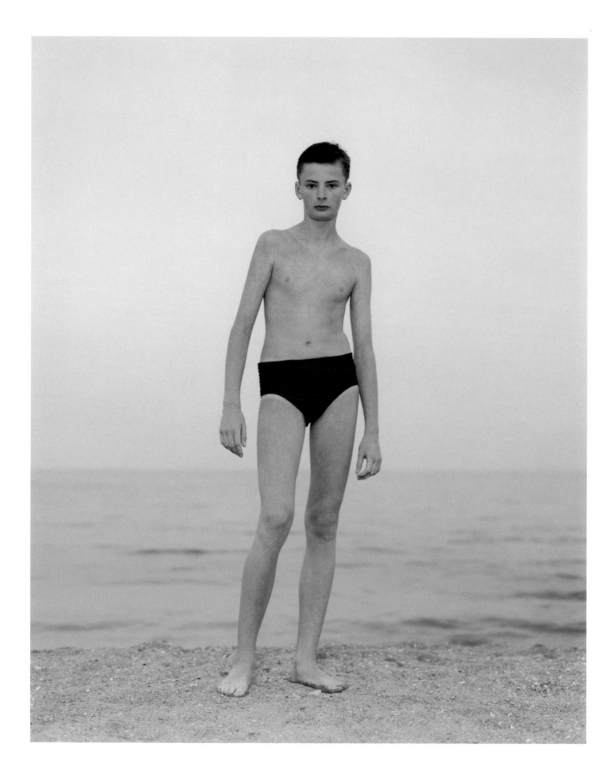

Dubrovnik, Croatia, July 13, 1996
C-print
Courtesy of Marian Goodman
Gallery, New York / Paris

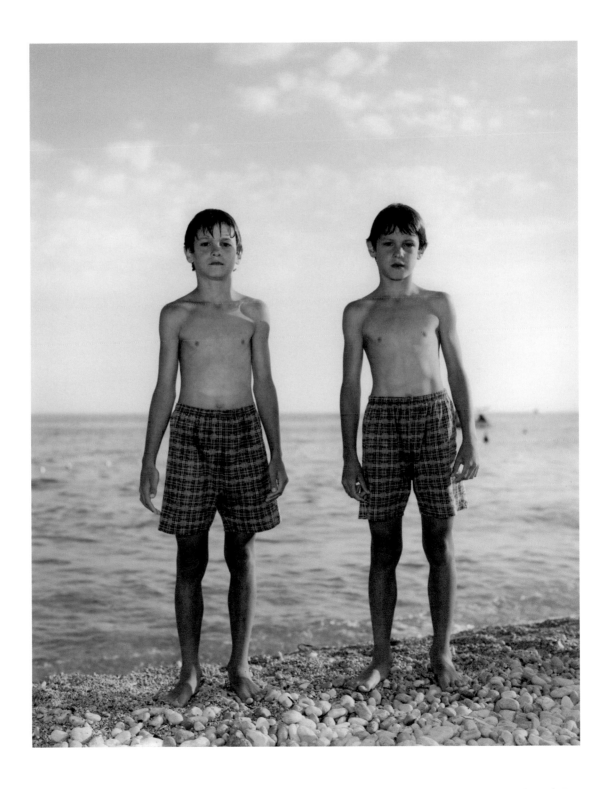

Hilton Head Island, SC, USA,
June 24, 1992
C-print, 40.64 x 30.48 cm
San Francisco, San Francisco
Museum of Modern Art,
Accession Committee Fund
purchase

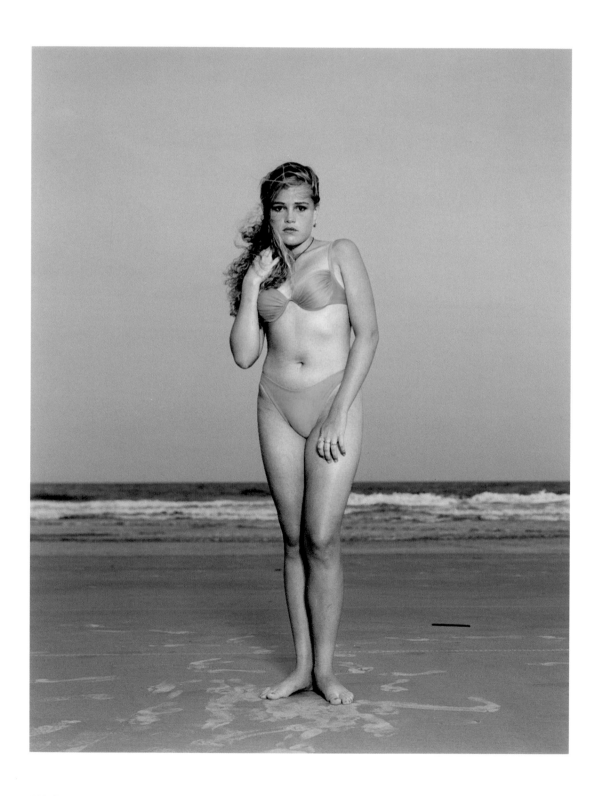

Kolobrzeg, Poland, July 26, 1992
C-print
Amsterdam, Stedelijk Museum

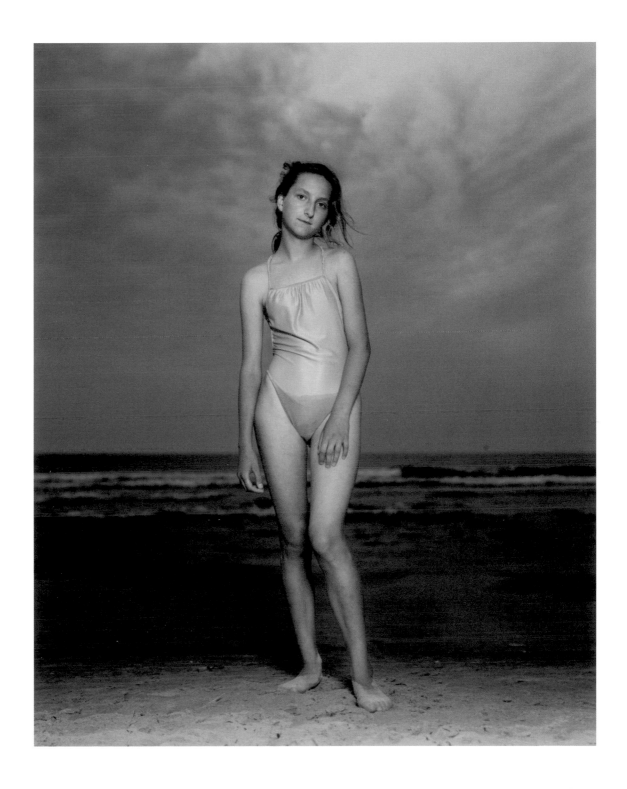

Charlotte Cotton

Photography
in the 21st century

The story of photography in the 21st century so far is fast paced and diverse. Perhaps the dominant feature of the photography today is its pluralism, a characterisation that reflects a medium operating in a range of coexisting creative and social contexts. Within such a schema, photography as a medium for artistic expression and a dominant physical presence within contemporary art practices is rarely contested today, its process of legitimisation as an art form having been consolidated in the late 20th century. As previous essays and case studies in this book attest, artists using photography over the past twenty-five years have crafted a myriad of unique visions of the medium that consciously tailored photographic concepts to be part of the discourses of contemporary art. One of the most important and still highly relevant strands of photography's power within contemporary art is its enduring capacity to directly embody reality. Photographs that are shown in art galleries continually reference specific personal and political events in the world – photographs of micro and macro realities – and photography acts as a vehicle to bring mediated signs of life into the contemplative space of art. Concomitant to this are the ways in which artists use the language of quotidian and "non-art" photography as a device and visual cue to draw viewers into a critical relationship with art through the familiar visual language of photography.

Commensurate with a newly established status as a contemporary art form, many photographic artists in the 21st century have been creatively preoccupied with exploring photography's relationships with other artistic mediums. At the end of the 20th century, photography's propensity for luxurious production values akin to the scale and ambition of figurative painting was prominent. There was a keen interest in the art world for constructed tableaux photographs, where the photographer's role is closer to that of a cinematic director, orchestrating every detail of a preconceived scene for the camera. This alignment of photography with the conventions and affect of the more established art form of painting has been superseded in the 21st century with photography's relationships with (and as a component of) sculpture and installation art, as well as a re-alignment of contemporary photography with the medium's early 20th-century Modernist art history, discourses that now constitute the most prescient photographic gestures within contemporary art.

In the 21st century, we consider photography to be both a tool for our independent artistic expression and a vehicle for our everyday social communications, without a sense of disabling contradiction. The range of new technologies for photographic capture, post-production, printing and dissemination call forth fundamental changes in our notion of what a photographer is and blur the already soft boundaries between "professional", "amateur", and "artist" photographer. Additionally, photography as part of the creative industries (alongside other fields such as film and recorded music) is reconfiguring, prompted by the challenges and changes to the commercial models for advertising, publishing, news media and consumer technologies. Photography in the 21st century is also commonly envisioned as an empirical mass of on-line

Walead Beshty
Three-Sided Picture (MRY), January 12th 2007, Valencia, California, Fujicolor Crystal Archive, 2010
C-print, 67.3 x 57.2 cm
Courtesy of the artist; Regen Projects, Los Angeles; and Thomas Dane Gallery, London

Jason Evans
From *NYLPT*, 2013
Courtesy of MAPP Editions Ldt.

images that is the visual data from which we shape a dynamic social language for our time. Collectively, these broad and dominating trends within photographic culture have led us to the point where the authored photographic act is not necessarily that of capturing a millisecond of real time with a camera (which was the classical criteria of photographic artistry since the mid-20th century) but dispersed through the processes of pre-conception, editing, sequencing, dissemination, and the construction of context for photographic ideas.

Contemporary art photography has become a highly self-conscious set of practices and processes, and through its increasingly specialised and rarefied character has become something of a counterpoint to the idea of photography-at-large as an ever-increasing empirical mass of on-line imagery. The first general trend that we have seen in contemporary art photography in light of Web 2.0 and phenomenal growth in image-led social media has been to reinforce the notion of photography as a material form and a somewhat rarefied artisanal gesture that is tailored for the contemporary art market. The active preservation of photography's physical printmaking in the 21st century has become the almost exclusive concern of artists (and sections of amateur photography culture still promoting the craft of photography), which reflects how most workaday types of photography no longer result in the production of actual photographic prints. What has happened in the 2010s is that the inherent "objecthood" of the photographic print – a physical form rather than a neutral or invisible framing of a real moment – has become pronounced. Many contemporary art photographers are using and contemplating this fact, and creatively working with the idea that photography is an active process of choices and decisions of the *maker* who *renders* a photograph and, significantly, this is apparent to the viewer as a consequence of our shared dematerialised relationship with

photographic images in our daily lives. Artists' responses to the shifting characteristics and behaviours of photography are as individualised as you might expect of creative practitioners who are expressing their original ideas. But these responses are, to some degree, both personal *and* generational.

By the mid-2000s many established and mid-career contemporary art photographers were making headway in translating their analogue practices into digital processes. The motivation for the majority was to find continuity for their photographic practices and ones that they could control in the face of the almost wholesale shift of photographic technology industries away from analogue capture and production, and the well-accepted aesthetic conventions of contemporary art photographers. While it was an established idea since the early 1970s that art photographers would use sophisticated but not necessarily the new or professionally desired photographic technologies of the day, the dawning of the properly digital era of professional and high-end amateur photographic equipment meant that analogue processes used by artists went from being simply not in common usage to being practically historic and anachronistic. Close to the turn of the new millennium there was a disconnection between the wet, chemical darkrooms that had served independent photographers for over 150-years as a quasi-alchemic and experimental space, and the new software consoles for photographic postproduction (controlled by digital technicians) and pigment printers in air-conditioned digital darkrooms that were primarily geared towards commercial photography clients. There was justifiable resistance from independent art photographers to move into new and expensive digital photographic processes and partly explains why the conversion of artistic creativity into a digital mode was gradual. For many established art photographers, the early 2000s was a period of hybridisation of analogue and digital techniques, still using sheets of photographic film and then scanning (mainly) transparencies to become digital image files. The preferred photographic printing process of the early 21st century was the Lightjet process that was made by passing analogue light-sensitive photographic paper under a laser light exposure of a digital image scan, which fused new image-making techniques with the desired quality of analogue printing papers. For art photographers, incorporating digital processes into their practices was led by a desire to push these newly available technologies to match the aesthetic standards set by analogue photography. By the mid-2000s the transition into digital processes was genuinely happening as they became trusted and acceptable mimics of analogue traditions, and digital cameras became economically manageable for serious contemporary art photographers. It is only from this point onward that we have begun to see the development of a genuinely digital dialect into the story of contemporary art photography.

In 2009 the well-established British photographer Paul Graham (b. 1956) published a twelve-volume limited-edition book entitled *Shimmer of Possibility*, and it quickly became recognised by the photographic community for articulating how digital capture could meaningfully add

new phrases to the language of photography. Graham utilised a digital camera's capacity to capture an infinite numbers of frames and in so doing was poetically narrating the subtle and unfolding coincidences of daily life that happen, unrecorded, all around us. In his photographic sequences, tightly edited to around six to ten images each, Graham uses digital photography's rapidity and seeming endless attention upon its subjects as the governing framework for his observational photography, distinct from but equivalent in its profundity to the way that he had previously used the discipline of a single sheet or a finite roll of photographic film. The ways in which contemporary photographers are creatively exploring the capacities of digital capture has led to a cultural renaissance for street photography, which was becoming a somewhat exhausted genre of art photography. Projects such as artist James Nares's (b. 1953) high-definition video *Street* (2012) re-animates a rich conversation between photography's long-standing role as a chronicler of life on city streets with new image-making technologies. *Street* is an hour-long edit of Nares's video footage (shot on a high-speed camera from a car moving along streets in Manhattan) slowed down in order to hold the viewer's attention somewhere between real-time and the static photographic image, encouraging us to consider the photographic scenes that are constantly generated within the choreographic flow of passers-by. Jason Evans's (b. 1968) book *NYLPT* (2013) is another innovative marker of how new technologies can be used to extend and rethink established ideas about photography. *NYLPT* is published as both a consciously old-fashioned duotone book of Evans's black-and-white double-exposure photographs (the double exposures made "in camera" on analogue negative film) and also as an App. Using an Open Source randomising algorithm (more typically used for generating on-line security codes) the App version of *NYLPT* creates unique sequences of six hundred images from the project. When each sequence is played, it is accompanied by a low frequency and slow oscillation sound design, and generates a unique combination of image sequence and sound environment. At the heart of the project is the enduring quality of photography (and in particular street photography) as an act that is governed by chance, and while we are at the very beginnings of photographers' exploration of the animated and algorithmic potential of e-publishing we can already see that essential ideas about photography can be creatively and imaginatively played out in these new digital arenas.

At the same time as mid-career art photographers were making their transition from analogue to digital processes in order to sustain existing careers, artists who had been graduating from MFA program*me*s in art schools since the mid.1990s were working through the pivotal shifts in photography in different ways. If there is an overarching sensibility that has been cultivated by art-school training – the predominant pedagogy since the late 1990s for contemporary art photographers – it is the articulation of a very deliberate relationship with photography. This art school generation of photographers, many born in the 1970s, forged their relationships with photography via analogue processes and a

Eileen Quinlan
Smoke & Mirrors #77, 2005
UV laminated chromogenic print
mounted on Sintra, 61 x 50.8 cm
Courtesy of the artist and Miguel
Abreu Gallery, New York

Eileen Quinlan
Smoke & Mirrors #90, 2005
UV laminated chromogenic print
mounted on Sintra, 61 x 50.8 cm
Courtesy of the artist and Miguel
Abreu Gallery, New York

Eileen Quinlan
Smoke & Mirrors #123, 2006
Silver gelatin print mounted on
aluminium, 101.6 x 76.2 cm
Courtesy of the artist and Miguel
Abreu Gallery, New York

canonical history of photography. While marvelling at the prospect of
photography as a rapidly changing field of visual language in a digital
era, they still acutely treasure the sensory pleasure and marker of
authenticity that the physical form of photography represents.

One of the most literal signs of contemporary art photographers'
critically engagement with the materiality of photography has been the
re-animation of abstract photography, a highly aestheticised form of
photography that has been like an experimental staccato through the
story of photography since its conception in the 19th century.
Contemporary art photographers' use of photographic abstraction is a
conscious citing of avant-garde practices from the early 20th century.
Among the works most often cited by contemporary art photographers
today are Moholy-Nagy's (1895–1946) black-and-white photographic
darkroom experiments and Man Ray's (1890–1976) Rayographs,
whereby he placed small objects onto light-sensitive sheets of
photographic paper, which when exposed captured the unique imprint
of the object's forms and shadows. The contemporary relevance of early
20th-century avant-garde practices is not simply concerned with
photographic technique and style, but is also understood as a timely
reflection back to a moment in visual culture which is parallel with
today. Just as we can see the preponderance of contemporary art
photographs that openly declare their status as hand-made objects in an
era defined by the unfathomable mass of on-line imagery, so too avant-
garde artists abstracted and montaged photographic language as a
reaction to the explosion of image-dissemination via the picture press in
the early 20th century, a no less culturally radical "image explosion" than
we have experienced in the Web 2.0 epoch.

Of direct influence upon contemporary art photographers using
abstraction today are American artists and educators James Welling and
also Barbara Kasten, whose work since the 1970s showed how
photographic abstraction could contribute to Postmodern discourses of
art. Both artists' work bridge two key ingredients for contemporary art
photography – namely, the setting up of a photographic framework

within which something unexpected or intuitive can happen, blended with a critical enquiry where photography is both the vehicle and the subject of the work. Well-received examples of contemporary art photography that meditates upon the inherent materiality of photography include the large-scale photograms of Walead Beshty (b. 1976), made by folding large sheets of photographic paper into three-dimensional shapes while in the pitch black of a darkroom, and then exposing the creased photographic paper to light. The signs of these darkroom actions are left in the work, in the small tears and creases in the photographic paper and the shapes of colour made by the folded paper's irregular exposure to light.

Eileen Quinlan's (b. 1972) *Smoke & Mirrors* is series of photographs made with the often *"invisible"* props of an analogue still-life photography studio. Each of her images is an unmanipulated, document of the play of light and textures within small-scale arrangements that Quinlan has made in her studio from mirror fragments and smoky vapours. Quinlan makes imperfections and mistakes (an inevitable by-product of the analogue photographic processes she uses) part of her subject, foregrounding the kind of photographic details or visual interferences that would be ordinarily retouched out of a conventional commercial still-life image using Photoshop. The idea of photography as a unique and experimental visual language that embodies the concerns of contemporary artistic practice is eloquently conveyed in the work of Jessica Eaton (b. 1977). In particular, Eaton's use of "in camera" techniques such as multiple exposures, calibrated to primary colours in her ongoing series *Cubes for Albers and LeWitt*, is a declaration of appreciation for a medium that operates well beyond the simulation of human vision and within the realms of alchemic possibilities.

Such approaches are indicative of much contemporary art photography of the late 2000s, which adopted the position of a counter-argument to the broad scheme of photography in a digital epoch. This strain of contemporary art photography distils and abstracts essentialist ideas about photography as a medium contingent upon happenstance and experimentation and intended as a counterpoint to the perfected exactitude of commercial image-making. In particular, there are many ways in which photography's relationship with sculpture is being played out at this time. The permutations of the relationship between photography and sculpture in the 21st century are many, and both forms of art practice have shifted from being considered discrete disciplines of art and, instead, are now two timely and closely aligned aspects of the materials and palette being used by contemporary artists. We are seeing different interplays, including photographs embedded into sculptures; photographs of sculptures constructed by the photographer for the camera; photographs of found objects propped and stacked into sculptural forms; and installations that present photographs as discrete forms arranged with sculptural elements and objects. There are precedents for today's photo-sculptures (and in particular from the 1970s and 1980s) with principal artists including Robert Heinecken (1931–2006) and, latterly, Isa Genzken (b. 1948),

artists who have a deep understanding of photographic language and
how it can operate within the discourses of contemporary art.
Sara VanDerBeek (b. 1976) was one of the first of a new generation of
art-school graduating photographers utilising sculpture in the early
2000s to receive critical attention in the contemporary art world.
Her elegant and thoughtful photographs of sculptures (made for her
camera and destroyed afterwards) often used photographic material that
was either found or from her personal archive to construct constellations
of unexpected and symbolic visual relationships. In more recent work,
VanDerBeek interplays actual sculptural elements such as totem-like
structures made from painted concrete that make a direct citation of
Minimalist sculpture, alongside her photographs framed to prompt a
sculptural and interactive experience (such as using subtly mirrored
glass in the frames) of her gallery installations. Other artists including
Emmeline de Mooij (b. 1978) bring photography into play with
printmaking, soft sculpture, and textile works, installing her work in
combinations that dramatise the physical properties of the mediums with
which she works and collectively emphasise the idiosyncrasy of human

Sara VanDerBeek
Installation view, Metro Pictures,
New York, 2013
Courtesy of the artist
and Metro Pictures

Emmeline de Mooij
Installation, Legion TV, 2013

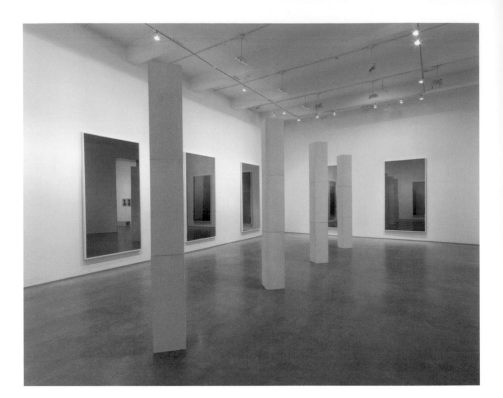

mark-making and ordering of things of which photography is part.
One of the most refined artistic visions for the physical and material
essence of photography is played out in the work of Liz Deschenes
(b. 1966). Her *Tilt/Swing* installations, which she began making in 2009
are visceral, yet succinct, distillations of photographic ideas. *Tilt/Swing*
is an installation of almost blank, metallic photograms (made by
exposing photographic paper to the ambient low light of night skies)
placed in a circular formation on the floor, walls and ceiling of gallery
spaces. The installation enacts Bauhaus artist Herbert Bayer's (1900–85)
1935 *Diagram of 360° field of vision*, a proposal for an immersive
exhibition experience to be viewed from multiple vantage points.
Deschenes fills Bayer's structure with the seemingly empty or subjectless
photographs. Over the course of Deschenes's exhibitions of *Tilt/Swing*

visitors explore the multiple vantage points proposed by Bayer, their own reflections in Deschenes's silver-toned photographs becoming the temporary subjects of these mirroring photographs dependent on the viewers' movements. With an equally direct economy of means, Deschenes's *Transfer* series (1997–2003) presents small framed photographs of pure blocks of rich colours made with the historical dye-transfer process, a skilled process practised by a mere handful of artisan printers today. By using this complex and intricate printing process (which uses pigments and extremely accurate printing matrices rather than light sensitive chemicals) devoid of a photographic image, Deschenes calls attention to the process itself and makes a purely photographic phenomena a literally tangible experience for the viewer. Colour photography has been the dominant form of photography,

including art photography, for over twenty years. With black-and-white photography no longer a default material in any significant areas of photographic practice (aside from some amateur camera-club traditions) the rich heritage of monochromatic photography has been re-evaluated by many young contemporary art photographers, including those who are now attending art school where black-and- white photographic darkroom techniques are no longer the mandatory start of a technical education in the medium.

Shannon Ebner's (b. 1971) photographic and sculptural work concerns language – both in her deployment of the spoken and written languages of politics, protest, and experimental literature, and also in her use of photography, in such a way as to be considered as a language of visual signs [235]. Predominantly working with black-and-white photography and monochromatic sculptural forms, there is a strong sense in her work of photography being deployed as a metaphor for things breaking down, or functioning through false claims and rhetoric. It is a challenging and far-from-simplistic proposal for photography, but one that Ebner confidently stages in the context of art spaces, reliant on the visitor's capacity to internalise the prompts and provocations that Ebner lays out.

As was ever true of art, many of the best contemporary art photographers place a high expectation upon the viewer of their artworks and installations to be sentient and engaged, rather than an easy or passive consumption of photographic forms. Another artist, who along with Liz Deschenes and Shannon Ebner creates powerful intellectual and physical experiences of photography, is Carter Mull (b. 1977). Mull's installations in particular construct a dynamic sense of the hybridity of media – as a world of image-signs, a trajectory of mark-making and reproduction, and a fusion of analogue and digital output. Carter Mull's art work offers gallery – based experiences that animate our symbolic knowledge of the media environments in which we live. In a very different way, the American artist Trevor Paglen (b. 1974)

Shannon Ebner
Installation view at the exhibition
"The Sun & The Sign", Wallspace
Gallery, New York, February 2007
Courtesy of the artist and Wallspace
Gallery, New York

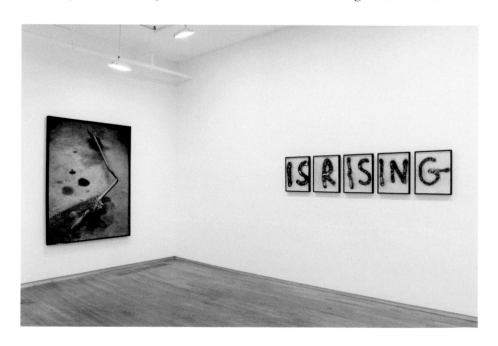

Carter Mull
Alice, 2011
Lightjet type C-print and pasted print
on gloss paper
Edition of 5 + 2 AP
Courtesy of the artist and Marc Foxx
Gallery, Los Angeles

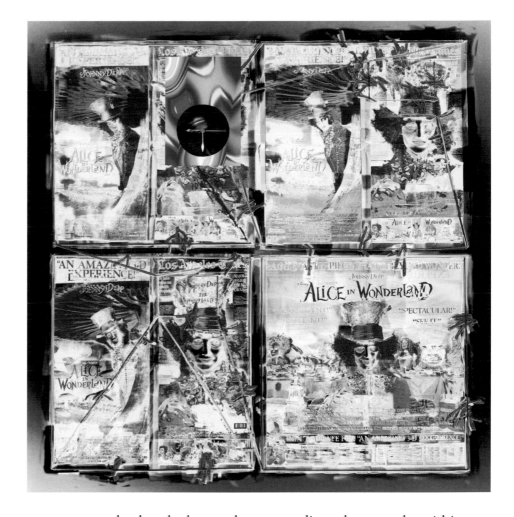

creates artworks that deploys and contextualises photography within a much more expansive media history. Much of his practice has been concerned with visualising the unseen and covert forces that underpin militarisation. For instance, in his 2008 series *Other Night Sky*, Paglen created telescopic long exposure photographs of the night sky in Nevada, and mapped the movement of classified US military aircraft. Paglen places photography within a long trajectory of scientific and experimental history and human endeavour to model, visualise, and know the unseen factors that govern us and, in so doing, proclaims a role for contemporary artists as investigators and correctors of the mediated version of reality that we typically receive and consume. The use of photographic imagery as a highly structured visual language is not a new concept for artists to wrestle with, and has its strongest routes in Postmodernist practices in the 1970s and 1980s. Within Postmodernist and Post-structuralist theories, the idea developed that the meaning of a photographic image is not inherent but defined by an image's context and its relationship to the scope of image language within contemporary culture. One of the most important effects of Postmodernist ideas upon the notion of the art photographer was a wholesale questioning of the conventions of a photographer's authorship being literally present in a "signature style" and approach to photography. Instead, within Postmodernism we began to see the emergence of a much more sophisticated use of photographic style, whereby artists were deploying photographic language as a tool rather

Roe Ethridge
Wemeia and Surf Forecast, 2011
C-print, 151.8 x 132.1 cm
UniCredit Art Collection –
HypoVereinsbank

Elad Lassry
Squirrel, 2012
C-print, painted frame,
36.8 x 29.2 x 3.8 cm
Edition of 5 + 2 AP
Courtesy of the artist and David
Kordansky Gallery, Los Angeles

than the more romantic Modernist idea of photography as a direct outputting of an artist's unique vision. What is distinct to the current moment is that the Postmodernist idea of photographic imagery as codes and signifiers is now entirely naturlised in the way that we use photographic imagery in social media, and in the course of our daily lives. The shift in the emphasis for the recognition of artistic authorship away from a consistent photographic style and towards the often elaborate acts of sequencing and editing of images for gallery exhibitions and artists' books is a very fertile area of contemporary art photography, one that responds to our lived experience of photography. The work of artists including Roe Ethridge (b. 1974), and Elad Lassry (b. 1977) in the late 2000s, knowingly displayed a varied lexicon of photographic signs, conventions, and clichés, oscillating between a visceral pleasure of such finely crafted photographic prints and a critical detachment in already being familiar with their iconography. The authorship of the photographic images *per se* becomes almost secondary to the cumulative meaning of imagery in the approaches of photographers including Marie Angeletti (b. 1984), who spaces her photographs on the walls in art galleries into visual "phrases", encouraging us to extract meaning from the contingent relationships between images.

Photography publishing in the 2010s is a diverse and extremely active area of photographic creativity, with especial creative flourish in the areas of self publishing and small independent art publishing houses. And while the printed photobook has been the primary vehicle for contemporary art photography (as opposed to the art gallery context) in Asia and principally in Japan for some time, photobook publishing in the Northern Hemisphere has been especially creative in the 21st century. The lyrical and text-less books of Japanese photographer Rinko Kawauchi (b. 1972) since the early 2000s have become the internationally recognised exemplars for the creative potential of contemporary photobook publishing, and the form through which her photography became internationally well known. The creative energy around photography publishing is felt in their presence at photography and art fairs and biennials throughout the world, and photobooks

(including rare and out-of-print books from photography's history) reflects the burgeoning of a collectors' market for photography in analogue book form. There are some contemporary art photographers who are strongly identified with their control of the context for their photographic projects through their creation of mainly self-published books, including Charlotte Dumas (b. 1977), Nigel Shafran (b. 1964), and Stephen Gill (b. 1971). Photographers have also begun to front their own independent publishing ventures, an infrastructure for publishing their own projects and those of like-minded artist. Examples include Alec Soth's (b. 1969) *Little Brown Mushroom* and Jason Fulford's (b. 1973) co-direction of J+L books, and also Shane Lavalette's (b. 1987) small print-run journal *Lay Flat*, dedicated to new photography. Similarly, we are seeing photographers collectivise in order to better disseminate and garner critical attention for their individual publications. One of the earliest on-line hubs for new contemporary art photography and publishing was set up in 2005 by photographer, publisher and curator Tim Barber (b. 1979) and entitled www.tinyvices.com. The site exhibits photographers' portfolios, and also features a place to purchase and be informed about books from the myriad of small, independent photobook publishers and collectives. Other models of note that have been created to be a platform for independent and individual photographers who publish photobooks, is the London-based Self Publish Be Happy (www.selfpublishbehappy.com), started by Bruno Ceschel (b. 1976). The Artists' Books Co-op (www.abcoop.wordpress.com) is a co-operative of over twenty photographers based internationally, who self-publish and, together, present their titles at publishing fairs and photography events across the world.

Ideas and conversations about the scope of contemporary art photography created by the hundreds upon hundreds of young practitioners as yet not recognised in the exhibition programmes of art galleries and museums are eloquently curated by the first generation of photo bloggers. There is an informal intelligence and sense of a

Marie Angeletti
Works of Others – VV28', 2012
Installation view – 1st Part

community's shared interests and concerns to be found in the sites of photographers and writers including Joerg Colberg at his *Conscientious* blog, Andy Adams's *Flak Photo*, Marc Feustel's *Eye Curious,* and Aaron Schuman's on-line photography magazine *Seesaw.* Jeff Ladd's *5b4* has offered a considered curation of photographic culture, as has Jen Beckman's *Personism* and Marco Bohr's *Visual Culture.* The on-line perspectives of Laurel Ptak have been especially innovative in its defining of the creative scope of photography in a post-Internet age. From 2006 until 2011, she curated www.iheartphotograph.com, which constantly introduced its readers to emerging ideas and artists.

In response to the impact of Web 2.0 and visual social media upon our relationship with photography, we are seeing the rise in the number of contemporary art projects that use the vast "archive" of photographic imagery on-line as the source material for artist-authored projects.

It is perhaps not surprising that in an era where there are literally billions of new photographic images being produced and posted on-line every year, that many photographic artists would react by not containing their authorship within the conventional millisecond of shooting or capturing a photograph. Daniel Gordon's (b. 1980) source material is images found on-line, which he prints in his studio and from which he collages often quite classical pictorial scenes (including still-lifes and portraits) that he then photographs. The torn edges and rough adhesion of hundreds of colour images is intentionally messy and neurotic, and creates a really pleasurable interplay between the seduction of the Google image material and their luscious colouration and seamless Photoshop, and the attraction of the artist's obviously intensive and time-consuming handwork. There is a unique conversation happening in Gordon's work between these very different but coexisting notions of photography as both an algorithmically driven mass of perfected images and a hand-rendered and idiosyncratic form of artistic expression. Another contemporary practitioner whose photographs make you think

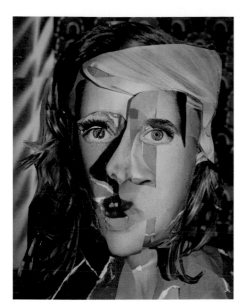

Daniel Gordon
Red Eyed Woman, 2010
Courtesy of the artist and Wallspace
Gallery, New York

about the making of photographs in a digital epoch is Lucas Blalock (b. 1978). His photographs of mainly studio-based still-life arrangements use the vocabulary of digital post-production tools in ways that are the antithesis of the seamless conventions of commercial retouching. By using digital image-making tools in a manner that is clearly manipulated and authored by him, Blalock seems to encourage us to appreciate the aesthetics of digital image-making in a way that is connected to an older, unreconstructed Modernist appreciation of uniquely photographic visual language and the artist's capacity to craft a signature style from it. Artie Vierkant's (b. 1986) iterates a related standpoint in his *Image Object* project, which includes gallery installations of sculptural forms (that vary in materials and architectural structure in each venue) that are derived from the common aesthetics of digital software. For the on-line and printed publication of *Image Object*, Vierkant adds further layers of digital information, creating another version of his project that is specifically tailored to its publishing context. What is interesting about Vierkant's project is how it confidently positions the gallery as just one platform for his artistic idea while coexisting with other versions of the project that are customised with equal thoughtfulness for alternative sites of photographic presentation.

The image-creators who are making these new departures within contemporary art photography are a generation who began their artistic lives within the 21st century and naturalised to this haptic and social era of photography. We are seeing the beginnings of a new phase in contemporary art photography which is becoming one in which its practitioners take multiple stances in their artistic practice, as artisans, editors, data visualisers and disseminators of photographic ideas.

In their hands, photography is a locative medium capable of being within, outside, and between artistic definitions and continuing to be – simultaneously – a tool of dissemination, a vehicle for ideas, a lexicon of aesthetics, a quotidian language as well as a vital material form of contemporary art.

- **Wolfgang Tillmans**
- **Boris Mikhailov**
- **"The Museum as Muse: Artists Reflect"**
- **Martin Parr, Alec Soth**
- **Luc Delahaye**
- **"Between Past and Future: New Photography and Video from China"**

Wolfgang Tillmans

"Wer Liebe wagt lebt morgen"

Kunstmuseum, Wolfsburg, 7 September – 17 November 1996

When the young Wolfgang Tillmans' solo exhibition opened at the Kunstmuseum in Wolfsburg in 1996, he had been interested in photography for about twenty years and his production was already very prolific. He was born in Remscheid in 1968, and as a child he began collecting images he found in magazines and pasting them in copybooks. When he was still a teenager he started using a black-and-white photocopy machine to experiment with the possibilities offered by recycling photographic material, enlarging the originals by up to 400% and assembling them (the collages by Schwitters and the Dadaists were a basic source of inspiration for this). It was the time when the Cold War ended, the time of Generation X, the scourge of AIDS and the institutionalisation of the peace and homosexual rights movements, in which Tillmans actively participated. The subjects of Tillmans' photographs taken in this period are connected with all this and were soon published in *i-D* and *Prinz*, where they appeared as journalism, advertising, and fashion photos, though he eschewed any commercial purpose (Tillmans never accepts photo commissions from companies or newspapers and periodicals). In addition to being interested in important social issues, Tillmans, who had in the meantime moved to England in 1990 (first he studied at the Bournemouth and Poole College of Art and Design and then he settled in London, where the phenomenon of Young British Art was emerging), photographed everything that was part of his everyday world, ranging from evenings in clubs in which he played techno music to his friends, to urban views and the vegetables on his table or in the fridge, from nature to sunsets, making this mix the focus of his work. This was a kind of synthesis of the approaches of William Eggleston (democratic), Nan Goldin (diaristic) and Gerhard Richter (encyclopaedic), which reproduced the situation of hyper-stimulation and hyper-information typical of today's world. While there is not everything, there is *something* of everything in his collection of images, which immediately becomes a reservoir of fragments that can be used in different ways and in different combinations.

Following the same principle of open-mindedness, in parallel to their

appearance in periodicals, the same photos have been exhibited in museums and spaces devoted to art, resulting in a twofold interpretation of Tillmans' work and a doubling of his career, since he has become a protagonist both of underground culture and of the international art scene. The Wolfsburg exhibition "Wer Liebe wagt lebt morgen", 7 September – 17 November 1996, was a key moment in this process, since it contributed to the institutionalisation of an oeuvre that was also a fundamental point of reference in the anti-institutional milieu. From the outset Tillmans' work did not develop exclusively along the lines of content and style, as usually happens, but also questioned its context. It was therefore inevitable that the staging of his exhibitions should acquire particular importance. They are in fact conceived as actual environmental installations, in which the images and the space mutually modify each other. In Wolfsburg, Tillmans worked with the curator Annelie Lütgens and personally chose the size, sequence, and positioning of the photographic prints, according to a logic that placed the show as a whole on the same level as the individual photographs. The museum became an arena, the show became a workshop that expressed the relationship between the artist and the exhibition space. Compared with the more traditional ways of mounting a photographic exhibition, these changes were radical. First and foremost, the works were not placed in a single row, nor did they create precise geometric patterns on the walls, but were arranged with the same freedom as one has when doing the layout of a book or a newspaper, using the whole available surface between the floor and the ceiling. A cross between a picture gallery and a teenager's bedroom, thus he created a kind of world of images within which some were isolated and others combined to form constellations that helped to guide the viewer's reading of them. Secondly, both a hierarchical ordering of the photographs and a sense of narrative were excluded, and were replaced by leaps and coincidences, which in the catalogue Helen Molesworth associates with "a succession of travel notes, photographic notes in a diary, or annotations". Finally, there were different sizes of prints (the idea of a standard size so deep rooted in photography was eliminated) and they were hung without frames or passe-partout, but simply with four nails in the corners. This is the opposite of all the rules of museum conservation – aimed at preserving objects for eternity – and accentuates the transient nature of the works exhibited. In a similar fashion, each photo acquired a sculptural value and stimulated a physical relationship between viewer and image. Tillmans exhibited a series of extremely heterogeneous photographs in "Wer Liebe wagt lebt morgen", whose only common factor lies in their graphic quality. The oldest date from the mid-1980s, and the latest were taken during the months before the exhibition, but all of them display the German artist's concentration on the compositional and chromatic aspects, which he gradually simplified and over the years developed images that became increasingly essential and abstract. Acting as a link there were also numerous photos of clothes thrown randomly onto pieces of furniture and floors: jackets, crumpled T-shirts and jeans which, while this is a field Tillmans favours for his formal

research, evoked the warmth of the person who had worn them and expressed that sexual tension that we find throughout the artist's oeuvre. This culminates in some male nudes that are so explicit and spontaneous they are reminiscent of Mapplethorpe's early work.

The catalogue of the exhibition contains 135 photographs and three essays by Annelie Lütgens, Helen Molesworth, and Collier Schorr.

On the last pages there are also illustrations of the layouts of some of Wolfgang Tillmans' earlier shows that draw attention yet again to the dynamic nature of his work, which pivots on the combination of images and the way they are presented.

Bibliography
Tillmans, W. *Wolfgang Tillmans*. Cologne: Taschen, 1995.
Tillmans, W. *If One Thing Matters, Everything Matters*. London: Tate, 2003.
Obrist, H.U. *The Conversation Series: Wolfgang Tillmans*. Cologne: Walther König, 2008.
VV.AA. *Wolfgang Tillmans*. New Haven: Yale University Press, 2006.

Isa, Dancing, 1995
C-print, 61 x 51 cm
UniCredit Art Collection –
HypoVereinsbank
Courtesy of Galerie Daniel
Buchholz, Köln / Berlin

Minato-Mirai-21, 1997
C-print, 207.5 x 137.5 cm
UniCredit Art Collection –
HypoVereinsbank
Courtesy of Galerie Daniel
Buchholz, Köln / Berlin

Boris Mikhailov

Case History

Scalo: Zurich, 1999

"Welcome to Russian capitalism!" writes Boris Mikhailov in the introduction to the volume, and his exclamation echoes loudly in our brain as we study the collection of 431 photographs in *Case History*. The volume is completed by a conversation between the theoretician Victor Tupitsyn and the artist Ilya Kabakov, and was published by the Swiss company Scalo in 1999. Executed a few years after the break-up of the Soviet Union, the project documents the dramatic effects of the new political and economic structures on Ukraine's population, through systematic exposure that counters the general tendency of the institutions to hide everything that does not coincide with an ideal of growth and prosperity behind a glossy exterior. This project was sparked by the photographer's return to his native city, Kharkov, after a few years' absence, where he came up against a reality that was largely at odds with his memories, creating a powerful discrepancy between past and present.

Born in 1938, Mikhailov had already interpreted the crucial phases of his country's recent history in previous works, producing a kind of apocryphal historiography that contested official accounts. Indeed, his photographic career had got off to a reactionary start: at the age of twenty-eight he had taken some amateur nude shots of his wife that were inspired by Czech avant-garde images of the 1920s, which were found by the KGB and cost him his job as an engineer. This approach taught him that photography was a potent tool for recording and transforming an event, and his early series subtly overturned the imagery of Soviet propaganda: in *Red* (1968–75) the colour of Communist ideology is transferred from the symbols of power to the most diverse objects, while in *Luriki* (1976–81) he hand-coloured family portraits that he had either found or taken especially for the occasion, parodying the way in which the regime embellished a reality that was generally dark and depressing.

The message is clear despite the delicate, allusive tones Mikhailov was obliged to adopt to question from within the system that punished any critical or rebellious act with imprisonment. After the collapse of the Soviet bloc, his narrative could become more explicit. This can be seen in the images of his body and that of his wife, partially naked and partially clothed in Nazi uniform, in the series *If I Were a German*, which

expresses the relief that comes with regaining one's freedom and condemns any kind of tyranny. It is also evident in the photos taken with a panoramic camera (built in Kharkov) of down-and-outs in *By the Ground* and *At Dusk*, who are clearly incarnations of the failure of both socialism and the policies of perestroika and glasnost introduced by Mikhail Gorbachev. *Case History* was a logical development of this, a visual document of the disastrous combined effects of the breakdown of the Communist and then the capitalist system: the two principal twentieth-century politico-economic models. Mikhailov based *Case History* on his observation of a specific social group that had formed as a direct consequence of the advent of capitalism, which created an ever-widening gap between the different levels of society. The group was made up of *bomzhes*, homeless people forced to live on the fringes of the city in unacceptable conditions, and who were virtually non-existent when the collective dimension prevailed over individual expression. They are the anti-heroes, the protagonists of this story, on whom the axe of poverty has mercilessly fallen, robbing them of everything: from their homes to their

clothes, from their teeth to their dignity. It is the scandalous loss of dignity that is brought home to us by Mikhailov's photographs in which alcoholics, drug addicts and street kids reveal the scars that the recent past has left on their bodies, displaying injuries, deformities, growths and rashes, as signs of both material and existential poverty.

Case History is destabilising because of what is revealed in each image and the process behind its execution. On the one hand, the photographer chooses not to sublimate poverty in any way, opting instead for the raw representation of its terrible consequences. On the other, he contradicts the practice and ethics of photo-reportage in one fell swoop by intervening directly in the mise-en-scène of some of the situations depicted. In fact, most of the subjects were approached with the help of Mikhailov's wife and were perfectly aware of the presence of the photographer, who convinced some of them to have their picture taken and to show their naked bodies in exchange for a few roubles. The contrived effect is particularly evident when their poses echo stereotypes of Christian iconography, which are often worked out beforehand by Mikhailov, and *Case*

History is actually filled with saints and Madonnas, Pietàs, and Depositions. However, all this does not undermine the authenticity of the representation, which lies in the pale skin and swollen flesh of the protagonists, in their filthy environment and in their lost, haunted gaze. There is nothing sensational about these photographs, they transmit a sense of responsibility. As for the voyeuristic aspect of such an approach, Mikhailov explains himself in his accompanying text: "From an ethical standpoint, I have to say that I don't find anything to be ashamed of. Of course, I often felt embarrassed while I was taking the photographs. But generally speaking it is dangerous to talk about morality when you're wearing a full-length fur coat and the others haven't even got the money to replace their patched shoes, and when a creditor arrives he is often killed instead of paid."

Bibliography
Teboul, D. *Boris Mikhailov: I've Been Here Once Before.* Munich: Hirmer, 2011.
Tupitsyn, V. *The Museological Unconscious. Communal (Post)Modernism in Russia.* Cambridge, MA: MIT Press, 2009.
VV.AA. *Boris Mikhailov: A Retrospective.* Zurich: Scalo, 2003.
VV.AA. *Boris Mikhailov.* Berlin: Distanz, 2012.

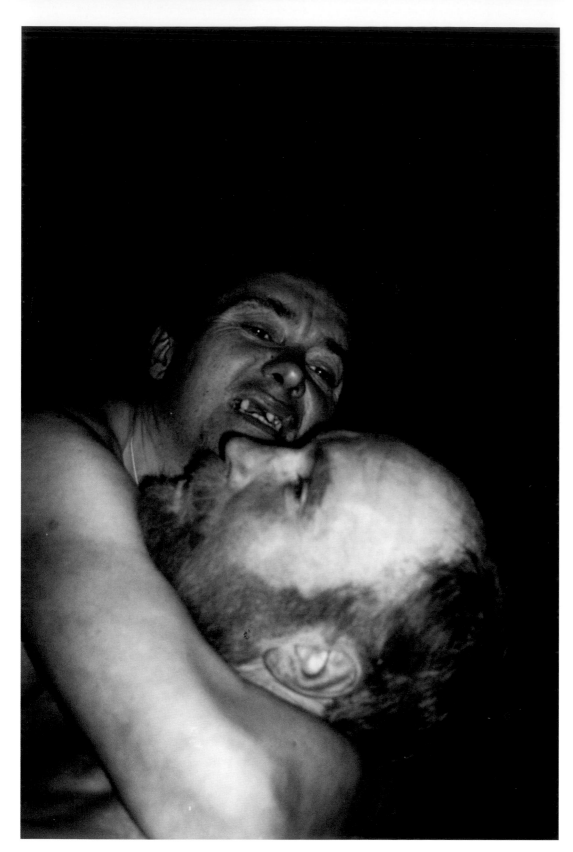

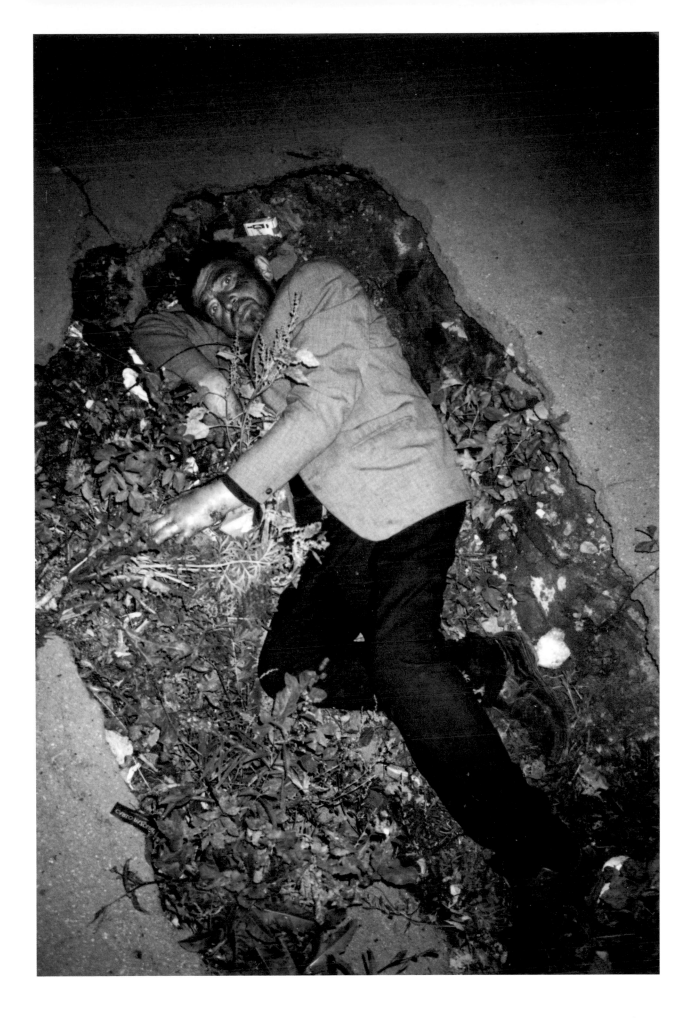

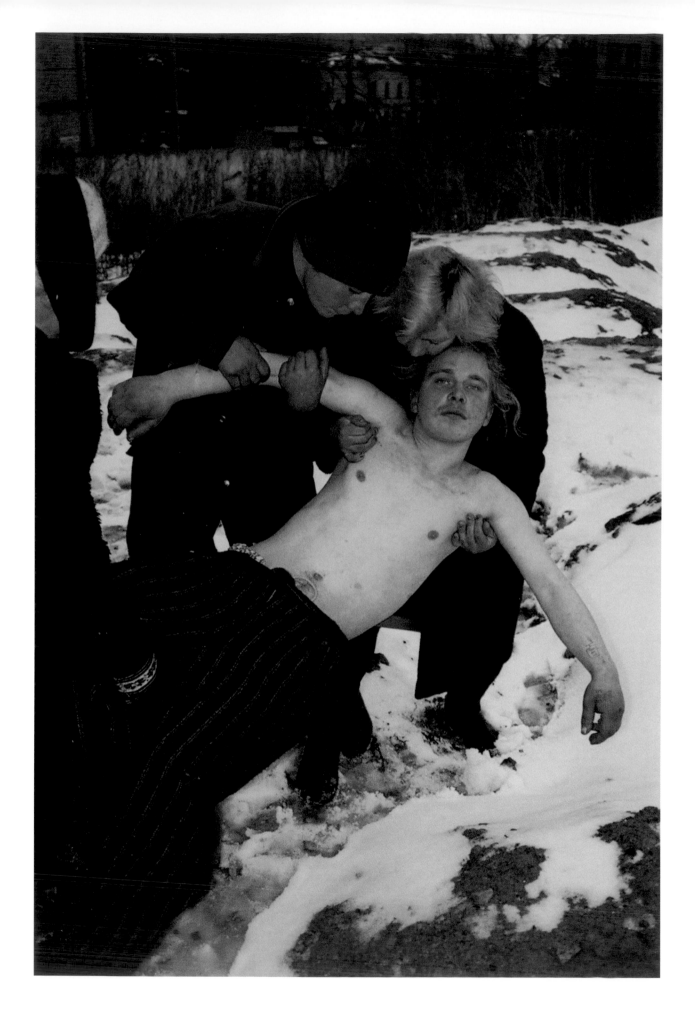

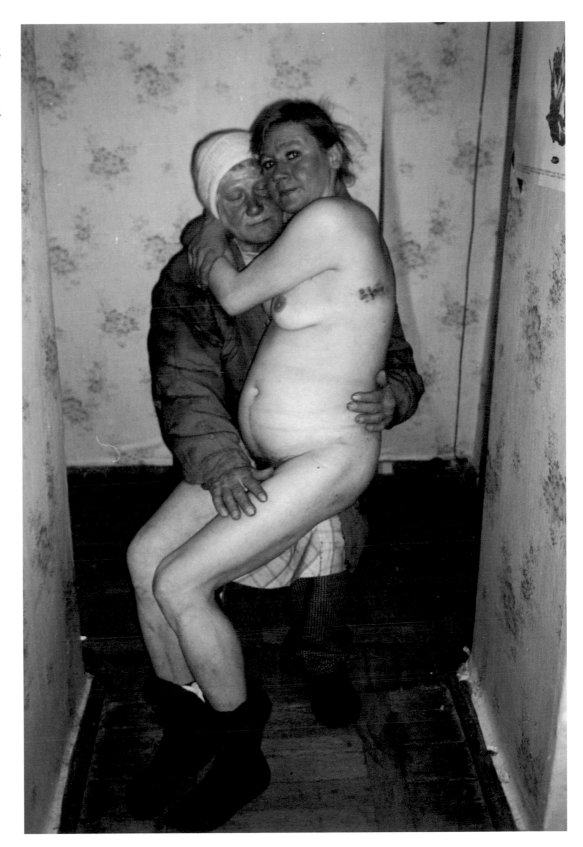

"The Museum as Muse: Artists Reflect"

The Museum of Modern Art, New York, 14 March – 1 June 1999

"According to the *Grande Encyclopedie*, the first museum in the modern sense of the word (that is to say, the first public collection) would seem to have been founded on 27 July 1793, in France, by the Convention. The origin of the modern museum would thus be linked to the development of the guillotine." The well-known critique by Georges Bataille, published in 1930 in the fifth issue of the Surrealist magazine *Documents*, of which he was a founder (see Georges Bataille, Isabelle Waldberg, and Robert Lebel, *Encyclopedia Acephalica*, Atlas Press, London 1995, p. 64), is based on two of the museum's primary functions since its birth. The first is conservation, which would make it a place of death in Bataille's view, and the second entertainment, which would deprive art of its subversive impetus by separating it from all the rest: "A museum is like the lungs of a city – every Sunday the crowds flow through the museum like blood, coming out purified and fresh." To these we can add another role traditionally performed by these institutions, which are often conceived as helping to educate the public about the fields to which they are devoted. Combined with the recent tendency to create a space of socialisation, this presents a richly structured framework. Whatever we may think, there is in fact no doubt that the museum is a crucial element in the cultural definition of the post-Enlightenment civilisation, so much so as to arouse the interest not only of philosophers but also of historians, economists, politicians and sociologists as well of course as artists, who have used the reflections developed in these disciplines to place the institution at the centre of their works. This was the fulcrum of the exhibition that opened on 14 March 1999 at the MoMA in New York with the title "The Museum as Muse". As stated in the catalogue, "Recognizing the variety of motives and interests that artists have brought to the subject, this exhibition is designed to illuminate the approaches taken by artists and discuss the aspects of the museum's life on which they have chosen to settle." Organised by Kynaston McShine, curator of the MoMA department of painting and sculpture as from 1968, "The Museum as Muse" was a large-scale exhibition of 188 works by sixty authors held in the International Council Galleries on the ground floor of the museum's central building. Five of these works were specifically commissioned for the occasion (from Michael Asher, Daniel Buren, Janet Cardiff, Mark Dion, and Louise Lawler) and another two were presented exclusively on the museum's website, thus also exploring the effects of its recent expansion into virtual space. The result was an unprecedented show where the way in which the subject of the works coincided with the place hosting them created a sense of circularity. (An emphasis on the experiential aspect is in any case a recently established feature of the museum.) While the works included were extremely heterogeneous, including paintings, sculptures, drawings, installations, videos and performances, photography was granted pride of place, presumably on account of two intrinsic characteristics of this medium. First, unlike painting, photography has also addressed subjects other than the classic themes of great art, such as religion, history, war and love, from the very beginning of its history, including interiors and exteriors of museums. (The show concentrated mainly on the second half of the twentieth century but also included earlier works.) Second, the photographic operation itself constitutes a form of collecting,

which corresponds to one of the primary activities of these institutions. Divided into five thematic sections, the exhibition thus began with one devoted precisely to this medium entitled *Photographs: the Object and the Museum in Use*. Starting with some examples of nineteenth-century documentation (including images by Charles Thurston Thompson of the Louvre, Roger Fenton of the British Museum, and Gustave Le Gray of the 1852 Paris Salon), it proceeded with images by reporters (Eve Arnold, Henri Cartier-Bresson, Elliott Erwitt and David Seymour) attesting to the vitality of the museum, and arrived at the works of authors who regard the museum as their natural sphere and examine some aspects of its operations. These include Thomas Struth's large *Museum Photographs*, which explore the relationship between masterpieces of art and their viewers, Jeff Wall's monumental *Restoration* (1993), where the action of the evidently posed figures is made futile and ephemeral, the entrances, corridors and other interstitial spaces of great institutions photographed by Candida Höfer, and Vik Muniz's *Equivalents* (1995), produced by aiming the lens at the marble floors of the MoMA, whose random patterns recall the clouds shot by Alfred Stieglitz for his celebrated series of that name. Finally, among the artists commissioned to produce new works, Fred Wilson simply decided to select some images from the MoMA's photographic archives showing what goes on behind the scenes.

The exhibition continued with a section (*Natural History Collections*) devoted to works on museums of natural history and ethnography, often oriented towards analysis of ways of classifying reality. In addition to the works of Charles Willson Peale, whose self-portrait *The Artist in his Museum* (1822) was the earliest item on show, Mark Dion and Susan Hiller, this included the following: dioramas photographed in black and white by Hiroshi Sugimoto in order, paradoxically, to restore an impression of truth to the original representations; the eighty Ektachromes of Lothar Baumgarten's slide projection *Unsettled Objects* (1968–69), where the original setting of the Pitt Rivers Museum, Oxford, dating from 1874, is appreciated for its aesthetic value independently of any scientific considerations; and *Angola to Vietnam** (1989), where Christopher Williams presented images of glass replicas of plants in the Harvard Botanical Museum from countries where political disappearances were recorded in or before 1985, the year when the photographs were taken.

The next room (*Artist-Collectors and the Personal Museum*) held works produced through the application of authentic museological principles. Displayed among the precedents of this approach was Marcel Duchamp's *Boîte-en-valise* (1935–41), a leather case containing sixty-nine reproductions (some of which photographic) of the French artist's earlier works. This was followed by the works of Joseph Cornell, Marcel Broodthaers, Claes Oldenburg, Barbara Bloom, Herbert Distel, the Fluxus group, and Christian Boltanski, whose *Archives* (1997) consists of 400 portraits in black-and-white of anonymous people hung as though waiting to be assigned a name on metal frames reminiscent of those used in museum storerooms.

Museum Practices and Policies, one of the largest sections, was instead devoted to works that examine the political, bureaucratic and business dynamics that govern the functioning of the museum. Hans Haacke, Jac Leirner, General Idea, Louise Lawler, and Vito Acconci were among the

artists exhibited there. Alongside their works are photographs taken by Garry Winogrand and Larry Fink of the art public during fashionable events and inaugurations. The series *After van Gogh* (1994) instead illustrates the well-known practice of Sherrie Levine, whose photographs of images of works of art taken from books investigate the act of reproduction, the value of the fetish and the relationship between the original (or copy) and the spectator. The photographs of Sophie Calle's *Last Seen...* series of 1991, showing the empty spaces left after the theft of works by Degas, Flinck, Manet, Rembrandt, and Vermeer (as well as a Napoleonic eagle and a vase) in 1990 from the Isabella Stewart Gardner Museum in Boston are placed alongside descriptions of the same given to the French artist by employees of the museum, thus juxtaposing the concepts of loss, photography, and memory.

The exhibition ended with a room devoted exclusively to works concentrating on the physical space of the museums, its buildings and their architectural design, which is revised and altered. Alongside the works of Christo, Richard Hamilton, Ed Ruscha, Robert Smithson, and Komar and Melamid were the studies by Jan Dibbets of the way in which both natural and artificial light affect the perception of museum spaces. Dennis Oppenheim's black-and-white photographs served instead solely to record the ephemeral operation whereby the artist American attempted to transplant the museum of Cornell University simply by outlining its floor plan in the snow at a nearby wildlife park. This marked the start of the now well-established debate on the effective identification of the work. Does it consists exclusively in the action carried out by the artist *in loco*, or also in the remaining photographic records? This is one of the questions that accompany the use (but also the acquisition and cataloguing) of works like *Gallery Transplant* (1969), injecting a further element of complication into the relation that has always existed between photography, art collecting and museums.

Bibliography
Alberro, A., and B. Stimson. *Institutional Critique: An Anthology of Artists' Writings*. Cambridge, MA: MIT Press, 2011.
Calle, S. *Ghosts*. Paris: Actes Sud, 2013.
Crimp, D. *On the Museum's Ruins*. Cambridge, MA: MIT Press, 1993.
Marcoci, R. *The Original Copy. Photography of Sculpture, 1839 to Today*. New York: The Museum of Modern Art, 2010.
Mézil, E. *Vik Muniz: Le Musée Imaginaire*. Paris: Actes Sud, 2012.
VV.AA. *The Last Picture Show: Artists Using Photography 1960–1982*. Minneapolis: Walker Art Center, 2003.
Williams, C. *Angola to Vietnam*. Gand: Imschoot Uitgevers, 1989.
Wilner Stack, T. *Art Museum*. Tucson: Center for Creative Photography, 1995.

Marcel Duchamp
Boîte-en-valise, 1935–41
Leather valise containing
miniatures replicas, photographs,
colour reproductions of works
by Duchamp, and one "original"
drawing *Large Glass*, collotype
on celluloid, 19 x 23.5 cm;
whole 40.7 x 38.1 x 10.2 cm
New York, The Museum of
Modern Art, James Thrall Soby
Fund, inv. 67.1943.a-rrr

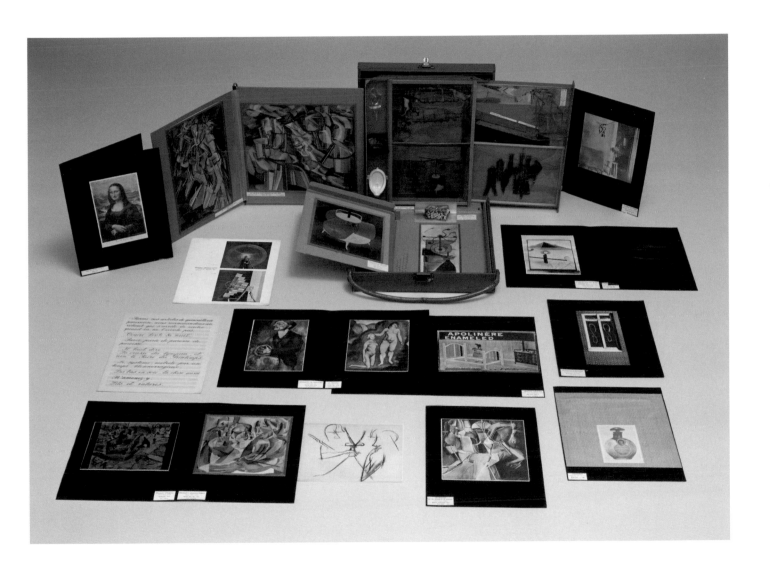

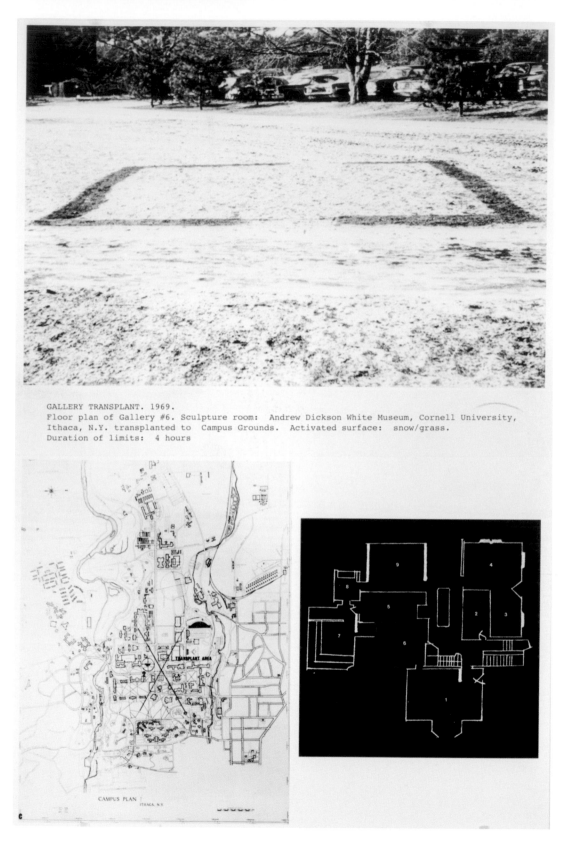

GALLERY TRANSPLANT. 1969.
Floor plan of Gallery #6. Sculpture room: Andrew Dickson White Museum, Cornell University,
Ithaca, N.Y. transplanted to Campus Grounds. Activated surface: snow/grass.
Duration of limits: 4 hours

Dennis Oppenheim
Gallery Transplant, 1969
Floor plan of Gallery #6. Sculpture
room: Andrew Dickson White
Museum, Cornell University,
Ithaca, NY. Transplanted
to Campus Grounds.
Activates surface: snow/grass.
Duration: 4 hours
Black and white photography,
marked photographic map and
floor plan, 152.4 x 101.6 cm
Courtesy of Dennis Oppenheim ~
studio

Christian Boltanski
Les Archives, 1987
Installation for Documenta 8,
Kassel, 1987
Grids, ca. 348 x 400 cm each
Toronto, Ydessa Hendeles Art
Foundation
Courtesy of the artist and Marian
Goodman Gallery, Paris / New
York

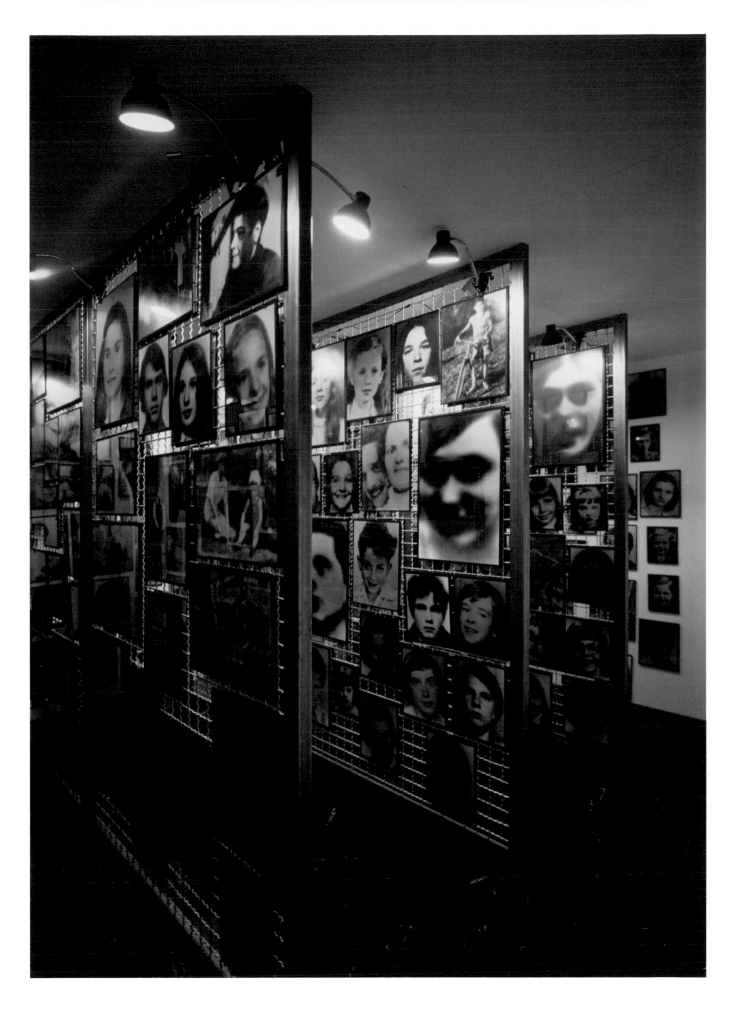

Sophie Calle
Vermeer, The Concert
from the series *"Last seen...,*
1991
One framed colour photograph,
169 x 129 cm
One framed text, 86 x 79 cm
Courtesy of Galerie Perrotin

"On March 18, 1990, five drawings by Degas, one vase, one Napoleonic eagle, and six paintings by Rembrandt, Flinck, Manet, and Vermeer were stolen from Isabella Steward Gardner Museum in Boston. In front of the spaces left empty, I asked curators, guards and other staff members to describe for me their recollections of the missing objects."

Vik Muniz
The Rower, from the series
Equivalents, 1993
Gelatin silver print

alternating images of very different kinds: vast landscapes of the southern states, interiors rotted with damp, and carefully posed portraits that bear witness to the intense relations between the photographer and his subjects. The result is a rich and complex panorama of contemporary America constructed not through a survey of events in the public domain, but rather the accumulation of minimal personal histories placed side by side with a series of symbols that speak of the nation's past and its plunge into the post-September 11 climate of terror.

In pushing the envelope of photojournalism, documentary photography and any other compartmentalisation of the discipline, Soth thus makes a substantial contribution to the process leading to its consideration as a unique and complex system. At the same time, his work is circulated and appreciated in the fields not only of information but also of art, with shows in the world's most illustrious museum and galleries as well as the founding of an independent publishing house and a blog with a large following. *Sleeping by the Mississippi* is one of the primary expressions of this mechanism whereby roles, genres and functions cross with one another to form a new, magmatic channel of communication.

Bibliography
Bajac, Q. *Parr by Parr. Quentin Bajac Meets Martin Parr. Discussions with a Promiscuous Photographer*, Paris: Les Éditions Textuel, 2010.
Engberg, S. *From Here to There: Alec Soth's America*, Minneapolis: Walker Art Center, 2010.
Phillips, S.S. *Martin Parr*, London: Phaidon, 2007.
Soth, A., and F. Zanot, *Conversazioni intorno a un tavolo* (original title *Ping Pong Conversations*), Roma: Contrasto, 2013.
VV.AA., *Magnum Magnum*, London: Thames and Hudson, 2009.
Williams, V. *Martin Parr*, London / Roma: Phaidon / Contrasto, 2002

Martin Parr
British Flags at a Fair, Sedlescombe, 1995–99

Martin Parr
Ireland, Dublin, O'Connell Bridge,
from *Bad Weather*, October 1981

Martin Parr
G.B. England, Bristol, 1995–99

Alec Soth
Charles, Vasa, Minnesota, 2002

Alec Soth
USA, Hotel, Dallas City, Illinois,
2002

Alec Soth
USA, Venice, Louisiana, 2002

Born in 1962 in Tours, France, Luc Delahaye began taking photographs when he was in his twenties, driven by a desire to tackle situations that were different from his ordinary everyday experience by travelling. This urge soon launched him on a successful career in the field of photojournalism. He first entered Magnum Photos in 1994 as a nominee, becoming a full-fledged member in 1998, and also a permanent contributor to *Newsweek*. His preferred field of action was war zones from the Middle East to Rwanda, Haiti, and the Balkans, where he captured images that were published in magazines throughout the world and which have gained him important professional recognition, including three first prizes in the "news" category at the World Press Photo (1992, 1993, 2001), and two Robert Capa Gold Medals (1992, 2001).

This succession of positive results, however, did not stop Delahaye from questioning his own approach and from going beyond the limits imposed by the practice and the ethics of reportage to introduce elements more in line with artistic research. In fact, two main features of the images of the most celebrated founders of

Magnum, Capa and Cartier-Bresson, were gradually eliminated from his work: firstly he replaced the "decisive moment", considered a factor that made the image sensational and guided the viewer's reading of it, with intermediate moments with virtually no action; secondly he avoided any physical and emotional closeness to his subjects by moving back a few steps (he chose the middle distance) and including the context in the shot. In both cases Delahaye toned down the persuasive power of photography and, by contrast, he gradually assumed the stance that the camera was virtually incapable of furnishing an objective account of reality. Thus he reconsidered the typical journalistic dynamics of constructing news, but without being critical, since he exploited his closeness to the information system to increase the scope of an investigation into the ontology of his medium and the power relationships it establishes between photographer, subject, and public. The inevitable presence of the photographer on the margins of the scene he is shooting, which results in him influencing and intruding on it, is the focus of the theoretical investigation in Delahaye's early projects, undertaken in parallel to his

professional work. In Paris, for example, he asked some homeless people to have their photos taken in an automatic photo booth at the Gare du Nord, and simply limited himself to collecting the results, showing them in an exhibition and publishing them in a book entitled *Portraits/1* (1996). Apart from the reuse of pre-existing material (for *Memo* Delahaye selected eighty portraits published on the obituary pages of a Sarajevo daily), the French photographer participated minimally in the production of an image, he merely triggered the process (he gave 20 francs to the *clochards* and put the money in the photo machine) before disappearing. For his next project, *L'Autre* (1999), inspired by the famous series by Walker Evans, he captured the faces of passengers on the metro without them being aware, by hiding his camera in his clothes and pressing the button from a pocket every time someone sat down opposite him. Apart from the moral issue of exploiting the images of people without their knowing it (in journalism there is recourse to the right of reporting) these photographs elude both the photographer's and the subject's control. They are simply determined by the strict application of a system and they are the basis from

which, after experimenting with minimising intention, Delahaye could go back to looking at the world through a lens.

Fully in line with the above-mentioned considerations, the stance the French photographer adopted in the following images was profoundly philosophical. It was not sufficient for him to suspend judgement of the situations in front of him, leaving the viewer completely free to interpret them, but, like the Stoics, his attitude was apathetic and so he excluded all emotional involvement from his choices. In 2001 when he began to combine this with some extremely topical subjects the result was explosive. Reproduced in the volume *History* in 2003, in fact, thirteen images of the same places frequented by photojournalists from Iraq to Palestine, the UN Building in New York to the International Criminal Court in the Hague where the Slobodan Milošević trial took place, provoke a violent conflict between the art system and the information system. In fact, these two contexts already clash in the editorial format of the publication: an unbound file published in only 100 copies by Chris Boot, London, clearly a far cry from the illustrations in news and geopolitical magazines. This

choice reflects the way images are produced for exhibitions in museums and art galleries, and their monumental size (about 110 x 230 cm) leads them to be immediately regarded as works of art and establishes a physical relationship with the viewer.

Taken with a Technorama camera using a 6 x 12 cm film, the scenes immortalised by Delahaye are directly transferred from the present to history. Despite the fact that in all cases they show real circumstances, and are only rarely the result of combining different negatives, their rich details and precise composition makes them seem like reconstructions in the manner of Jacques-Louis David or Théodore Géricault's large paintings, though without their epic tone. Like history painting and unlike reportage, these photographs are individually self-sufficient, but instead of anticipating a single narrative development they are open to countless possibilities of interpretation. Michael Fried writes: "Unlike a photojournalistic image, which is effective only insofar as it makes a single vivid point, Delahaye's panoramic pictures in their richness and complexity – also, in a manner of speaking, their simplicity and muteness – leave the viewer to shift for himself or herself: in the

photograph of the dead Taliban fighter, to notice, to be disturbed by the single piece of straw lying across the man's face." (Michael Fried, *Why Photography Matters as Art as Never Before*, Yale University Press, New Haven 2008, p. 184).

The extended shot means exactly this: the photographer does not focus on the news item, but by including everything surrounding it causes it to become lost in the mass of information his camera is able to record. Thus, for example, the refugees seen in the distance in a camp at Jenin seem like detritus on the ground they are treading, while the smoke from the American bombardments of some enemy outposts blends with nuances of the sky. Like the most admired photojournalism, the beauty of these images is what attracts our attention, but while in the first example it is mixed with a heroic ideal, here it is an end in itself. Delahaye says in an interview for the digital magazine *Artnet*: "Reporters in the press see the Afghan landscape but they don't show it, they are not asked to. All my efforts have been to be as neutral as possible, and to take in as much as possible, and allow an image to return to the mystery of reality." Shortly after

the publication of *History*, in 2004 Delahaye decided to turn his back on his hard won fame in the world of photojournalism and leave Magnum to devote himself exclusively to artistic research.

Bibliography
Delahaye, L. *Luc Delahaye, 2006–2010*. Gottingen: Steidl, 2011.
Dufour, D., and J.Y. Jouannais. *Topographies of War*. Gottingen: Steidl, 2012.
Fried, M. *Why Photography Matters as Art as Never Before*. New Haven: Yale University Press, 2008.
Weski, T. *Click Doubleclick. The Documentary Factor*. Cologne: Walther König, 2006.

Jenin Refugee Camp, 2002
C-print, 111 x 239 cm
Courtesy of Luc Delahaye &
Galerie Nathalie Obadia, Paris /
Brussels

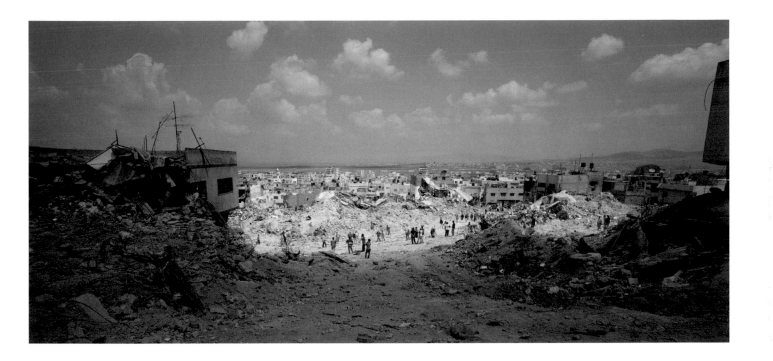

Taliban, 2001
C-print, 111 x 237 cm
Courtesy of Luc Delahaye &
Galerie Nathalie Obadia, Paris /
Brussels

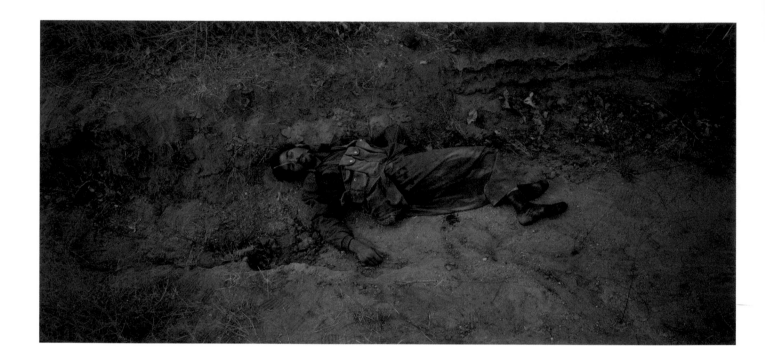

US Bombing on Taliban Positions,
2001
C-print, 112.2 x 238.6 cm
Courtesy of Luc Delahaye &
Galerie Nathalie Obadia, Paris /
Brussels

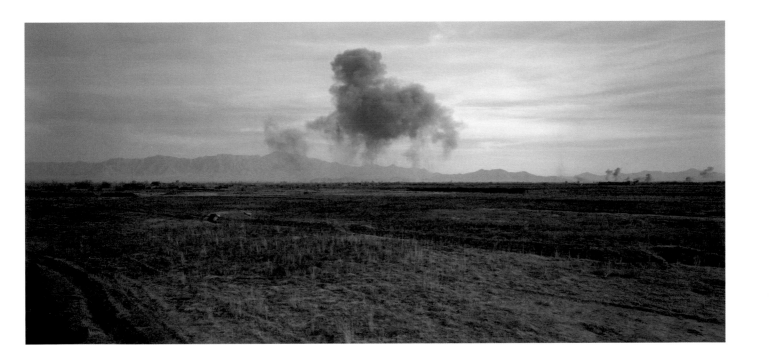

Baghdad IV, 2003
C-print, 111 x 245 cm
Courtesy of Luc Delahaye &
Galerie Nathalie Obadia, Paris /
Brussels

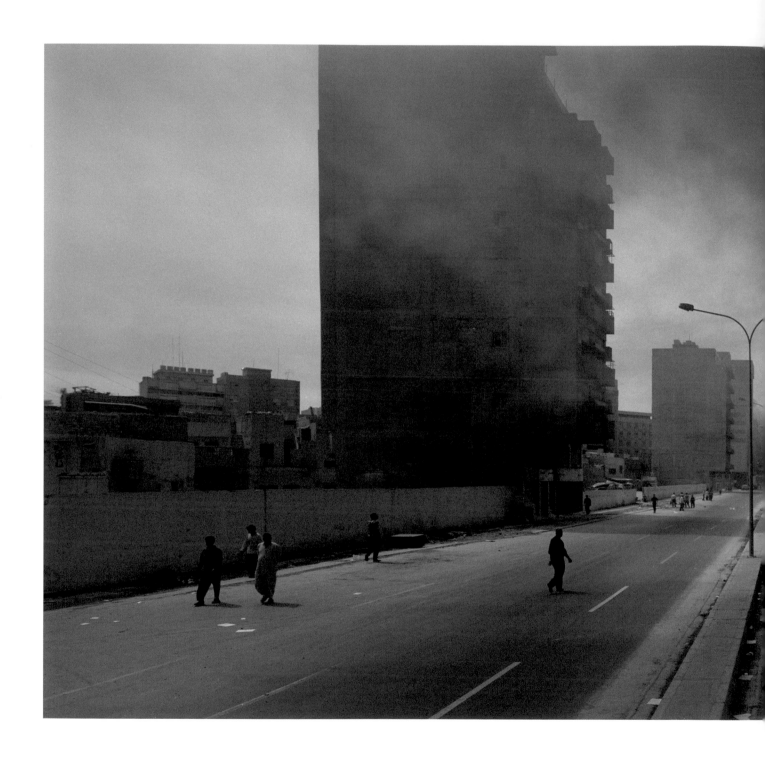

"Between Past and Future: New Photography and Video from China"

International Center of Photography / Asia Society,
New York, 11 June – 4 September 2004

Gao Brothers
An Installation on Tiananmen, 1995
C-print, 87.63 x 61.68 x 10.16 cm
Courtesy of © Hua Gallery, London

Since the clashes in Tiananmen Square that culminated in the massacre on 4 June 1989, all avant-garde artistic activity has virtually been prohibited in China, and photography has gone back to being the exclusive prerogative of the government. After the founding of the People's Republic of China in the postwar years, this iron rule had dominated, except for an opening up during the 1980s, when the exponents of the so-called Chinese New Wave liberated photographic production from its propagandist function and conferred on it the status of an art. It was then, for the first time ever in China, that it was possible to admire the images of the most important American and European photographers, from Walker Evans to Henri Cartier-Bresson, from Robert Frank to Cindy Sherman, and use their influences in novel combinations. Alongside the often naïf reprise of pictorialist and abstractionist motifs, and of a generic formalist trend, some photographers opted for the adoption of a documentary style, mostly associated with subjects of political and social interest. Aside from the fragmentation and frequent misunderstandings due to the speed of this process and the lack of the cultural background that Western photographers drew upon, what characterised this phase was the powerful drive towards experimentation. The years of repression that followed the tragic events of 1989 did not lead to the elimination of this tension, on the contrary, they gave the younger generation the possibility of digesting the lessons of the previous generation and starting up again with a wider knowledge of the international context and renewed self-awareness. Refusing any connection with commercial and amateur photography, from the outset the Chinese photographers born in the 1960s and 1970s considered themselves exponents of a rapidly expanding artistic field.

"Between Past and Future: New Photography and Video from China", was the first major group exhibition to present an account of this recent fervid period, which brought about the overthrow of the previous structures and a redefinition of new lines of research, to the Western public, thus providing a new point of view. Curated by Wu Hung and Christopher Phillips, the exhibition presented about 130 works executed by sixty-four Chinese artists between 1994 and 2003 to viewers at six museums in the United States and Europe. Leaving on 11 June 2004 from the International

Center of Photography in New York, it travelled to Chicago, Seattle, London, and Berlin, before reaching its final destination two years later, the Santa Barbara Museum of Art.

Conceived to promote an understanding of a world that was virtually unknown and summarise its main features the exhibition was divided into four sections corresponding to the themes explored by the new Chinese photographers: the past, identity, the body and the environment. "History and Memory" was the title of the section devoted to the artists who engaged with the collective memory of their country. Located at the beginning of the show it contributed to providing some historical facts about two crucial and opposing periods of the past. The remote past, corresponding to tradition, the terrain in which to put down roots and a yardstick for evaluating the art of the present; the recent past, dominated by the communist ideology of the second half of the twentieth century, which was by contrast reduced to a series of stereotypes of power to be fought in order to assert individual freedom. Thus, for example, the story narrated on a famous scroll painted by Gu Hongzhong in the tenth century is

reprised and updated by Wang Quingsong in *Night Revels of Lao Li*, a biting criticism of the state's interference in the art world, which often took the form of censorship. While the Gao brothers distorted Mao's face by simply photographing from below his large portrait still at the entrance to the Forbidden City (*An Installation on Tiananmen*). The sections "Performing the Self" and "Reimagining the Body" contained a series of works focusing on an investigation of the human being. This is a crucial issue for a people raised in the belief that the community should prevail over the individual, so much so that it was the theme of half the works selected, in fact, the portrait is the most frequent genre adopted by the young Chinese photographers and videomakers. Self-portraits often occur in these researches and they become actual performances staged in front of the lens, so it is difficult to distinguish whether their artistic value lies in the action photographed, in the image of it, or in both. In particular, Rong Rong's photos show the activities of the main community of performers in the area of Beijing East Village, inspired by body art and featuring violent, masochistic gestures. Apart from their diversity, whether they are portraits or

self-portraits, snapshots or mise-en-scènes, these photos have a basic common denominator: they never follow a typological programme, but are an expression of individuality, accentuating its uniqueness, distinction and strength. The last section of the exhibition, "People and Place", contained works that question changes in the environment and particularly the abandonment of the rural areas and the emergence of new urban cultures. The alienation that afflicts the inhabitants of the cities, which have been rendered unrecognisable by the few years of capitalism and mass immigration, is reflected in the works of artists who concentrate on the demolition of whole areas. For example, Zhang Dali drew his own profile on walls that were about to be demolished, turning them into a support for an art work and identifying himself with them when they fell. Others like Luo Yongjin and Wang Jinsong stress the ugliness of the new buildings by creating large photographic mosaics indicating the emerging, disproportionate residential compounds. Consequently, nature is reduced to a distant mirage taken from an antique painting in the case of the series *Spring Festival on the River* by Hong Hao, who uses the collage

technique to add scenes shot in the main streets of Beijing, and it is a dreamy element in the background of Yang Fudong's videos bathed in a lyrical and surrealistic atmosphere. In China the unprecedented speed and scale of the upheaval in economic and social structures has been accompanied by the development of a new artistic tradition. The exhibition illustrated the features of this new tradition in the field of photography and video, which, apart from the above-mentioned thematic divisions, can be summed up as follows: a fascination with new technologies; a postmodern tendency to combine apparently incongruous ideas; a preference for the rarefaction of Conceptual Art; the use of symbolic elements and the frequent combination of reality and fantasy through devices such as the use of mise-en-scènes, retouching, performance and storytelling. Concluding his essay in the catalogue Christopher Phillips writes: "Regarding these works, you find yourself hurtling toward China's future, with one eye turned to its rapidly receding past."

Bibliography
Berghuis, T.J., M. Kovskaya, and K. Wallace. *Action – Camera. Beijing Performance Photography.* Vancouver: Morris and Helen Belkin Art Gallery, 2009.
Erickson, B. *China Onward. Chinese Contemporary Art 1966–2006. The Estella Collection.* Humlebæk: Louisiana Museum of Modern Art, 2008.
Hung, W. *Transience: Chinese Experimental Art at the End of the 20th Century.* Chicago: Smart Museum of Art, 1999.
Hung, W. *Exhibiting Experimental Art in China.* Chicago: Smart Museum of Art, 2000.
Hung, W. *Reinterpretation: A Decade of Experimental Chinese Art, 1990–2000.* Guangzhou / Chicago: Guangdong Museum of Art / Art Media Resources, 2002.
Hung, W. *Rong Rong's East Village.* New York: Chambers Fine Arts, 2003.
Minglu, G. *Inside Out: New Art from China.* San Francisco: San Francisco Museum of Modern Art, 1998.
Roberts, C. *Photography and China.* London: Reaktion Books, 2012.
Tinari, P. *Hans Ulrich Obrist: The China Interviews.* Beijing: Office for Disclosure Engineering, 2009.
VV.AA. *Outward Expressions, Inward Reflections.* Beijing: Three Shadows Photography Art Centre, 2008.

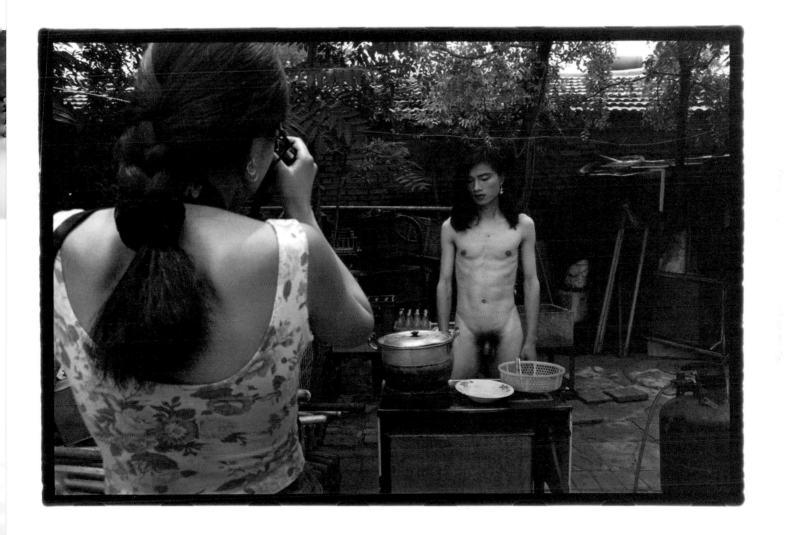

Walter Guadagnini

A Narrative of the Present

Happy moments

Scene one. A male figure sitting on the sidewalk on a sunny day in front of a building, of which we can see the brick wall and a window. It is characterised by crisp geometric forms: the array of bricks, the window, a black vertical shadow cast by a projecting side wall and a banister inside. The man is sitting in a position that can hardly be comfortable, with his forearm resting on the raised knee of his bent left leg while the right is bent double and flat on the ground. Milk splashes out of the carton in his right hand to form a big, white blob in mid-air, its shapelessness contrasting with the order of the surface behind him, and instead echoing the free growth of the grass in the cracks of the sidewalk on the left and the bush in front of the window.

Scene two. The courtyard of a modern residential complex typical of the 1960s, the central point of an agglomeration of high-rise buildings that surround the space where six Chinese people of various ages stand in a semicircle. They are all looking up towards the centre of the circle at a ball thrown by one of them and frozen by the camera in mid-air. Other figures are also seen – two girls crossing the space, two old men and another man – in the course of a slideshow lasting over twenty-five minutes, which presents the scene described from countless viewpoints accompanied by a very relaxing soundtrack.

Scene three. A frontal, Black-and-white half-length photograph of Fidel Castro standing against a black background, his arms hanging straight down beside his rigid, hieratic body, and staring expressionlessly into the camera.

Scene four. A white American convertible of the 1960s occupying most of the visual space, shot in three-quarter view so as to show the front, while also suggesting the length of the body and its overall line.

It stands in an apparently empty parking lot, motionless and solitary. A man can be seen in the driver's seat with his left arm hanging out of the window. There is a fence in the background with an anonymous field behind it providing no evidence as to the scene's specific location.

In *Milk* (1984), one of Jeff Wall's first and best-known photographs, a key role is played by one of the constituent elements of the photographic vocabulary and rhetoric established during the twentieth century, namely the principle of the instantaneous nature of the image, understood not only as photographic possibility but also as a value in itself, sometimes even as the very essence of photography. In the common and more widespread perception, far from the specialised, high-brow, minority theories following completely different paths, the ability to capture the decisive moment is seen, or was at least until the advent of digital photography, as the primary yardstick for evaluating the skill of a photographer, whether professional or amateur.

Jeff Wall
Milk, 1984
Transparency in light-box,
187 x 229 cm
Courtesy of the artist

Equally important is the camera's ability to show what does not appear visible in the everyday physiology of vision. It is no coincidence that Harold Edgerton's photographs are among those best known and most loved at the popular level, like the close-ups of animals and nature published in *National Geographic*.

Jeff Wall addresses these stereotypes by placing the element of the photographer's technical ability in parenthesis through the inexplicable and apparently pointless nature of the scene and the entire apparatus of representation set in action. Why devote a light-box measuring nearly 2 × 2.3 metres to a scene whose importance – in the economy of our knowledge of the world – is inversely proportional to its size? At the same time, viewers cannot escape a whole series of questions as to the before and after, which again lead them inevitably into a blind alley. What happened before? What made him do that? What will happen next? If a banal snapshot, albeit well-constructed and fascinating in its technical development, is given the measurements of a history painting, there must be a reason, an underlying story to justify its scale.

By one of the countless paradoxes to which Jeff Wall's images give rise, the transition appears to take place in *Milk* directly from the aesthetic – or perhaps creed – of reportage to the world of so-called high art without going through the fundamental intermediary channel of the documentary style.

The element of specifically artistic appreciation is essential to justify the very existence of this image, which would not be given the attention needed to establish dialogue with the viewer in other contexts. It requires a viewer accustomed to the codes of contemporary art, rather than one used to looking at photographs accompanied by narrative captions in newspapers, at which such images had been aimed for many long years.

A game of extraordinary subtlety, involving not only perfect mastery of the medium and the capacity to rework the pictorial and photographic codes of image construction and interpretation but also an understanding of the channels of dissemination of photography in relation to those of art, allows Wall to take the photograph into the museum without forgoing its everyday banality. In actual fact, the instantaneous nature of the scene becomes a strength in that it offers the possibility of transition to the certified cultural dimension of painting (albeit genre painting).[1] This would account for the artist's repeated references to Manet, the authentic guiding light of his early work. The words he devoted to the author of *Olympia* appear to describe his own position with respect to the photographic culture that preceded and was to follow him: "Manet is the gravestone of the *Salon*; as such, it is superseded by the developments of modern art in the new territories, the 'independent spaces' that first reached maturity in the 1870s and 1880s and became *our* place of absolute inversion, of 'culture in the pure state', in the following century. After his death, Manet was truly without successors. He is still in the happy condition of not having any. But

the contemporary culture of absolute fragmentation that appears in the galleries and dominates them in 1984, in both the pictorial and the photographic field, historically emerged from the long transformation of the 'independent spaces' of the modern art of the nineteenth century in the museum and *Salon* enclosures of our era."[2] David Claerbout selected the 180 images – shown for about twelve seconds each – that make up *Sections of a Happy Moment* (2007) out of over 50,000 taken in four different studio sessions with "fifteen cameras simultaneously, aimed at one or two people". These then became the protagonists of the scene set in a housing complex, found in an archive and then photographed, empty. Photography, slideshow, film: more than twenty years after Wall's image, the Belgian artist is still addressing the subject of the snapshot, pushing the boundaries of the vocabulary but especially of the discipline even further. Photographs that are transformed into other-than-self and become such again at the price of an irreparable loss of meaning (though existing on the market, Claerbout's photographs really stand as the memory of an event, not so much the one that never happened represented on the surface as the viewer's experience of the slideshow) but still concentrate on the subject of the instant, the halting of time at the click of the shutter.

Claerbout works on the paradox of the relationship between space and time, as it is only through the presence of various viewpoints that the obsessive dilation of a single moment into twenty-five minutes and fifty-seven seconds takes shape and that this dilation taken on a paradoxically narrative course, if this term is understood as an attitude of expectation with respect to a succession of events on the part of the viewer. Expectation that is moreover doomed to frustration or rather to go on responding to the mechanisms of the static image in general and the photograph in particular, as we ask

Hiroshi Sugimoto
Fidel Castro, 1999
Black and white photograph,
149 x 119 cm

what happened before that instant was frozen and what will happen when it begins to flow again.

The viewing of *Sections of a Happy Moment* has at least two phases. The first involves understanding what is being seen, the nature of the scene witnessed and – as in the case of Wall's work – why it should be given such importance. The second is enjoyment, once the mechanism of construction has been grasped, of the visual and above all mental consequences of the strategy of vision and thought adopted by the artist. Fully in the spirit of Duchamp, this enjoyment is linked to the frustration of being faced with a celibate machine. This expressive choice on Claerbout's part clearly presupposes a "new" type of viewer, different also from the viewer of the mid-1980s, because while it is true that the appreciation of any work of art requires a certain amount of time, one based on these premises and constructed in this way demands at least enough attention to understand the mechanism involved.

Despite the absence of the narrative development of a considerable part of contemporary art – starting from photography and proceeding into video – the path indicated is certainly that of presence in a specific place at a specific time. A snapshot that continues in time, the crucial instant transformed into an infinity of moments, all with the same value, which together make up the narrative of a nonexistent event in a space that appears three-dimensional but is two-dimensional by nature. The artist himself confirmed the centrality of these elements in his reading of the work: "As the slideshow progresses the playfulness of the moment becomes like heavy, cast matter. Indeed the scene hands in its momentaneous lightness for a feeling of being controlled like propaganda. As often in my work *duration* is an important tool for altering what we see, unlocking the flow of time from a fixed situation."[3]

As realistic as two photographs in black and white can be, the works of Hiroshi Sugimoto and Gerard Byrne shift the accent from the construction and use of the image to its interpretation, to the mechanisms through which the viewer is induced to interpret what is seen. Both belong to series, unlike those of Wall and Claerbout, which stand as works in their own right that have no need of other images in order to be understood or completed. A viewing of the two complete series leads, however, to diametrically opposite results. *Fidel Castro* is part of a series of waxworks in the Madame Tussaud's Wax Museum shot between 1994 and 1999, so that seeing other images from the series reveals that it is not a portrait from life but a photograph of a sculptural object.

Byrne's instead belongs to the series *1984 and Beyond* (2005–07), comprising a video and an installation of at least twenty photographs shot on Fuji 400 film and printed in black-and white in the traditional 17 × 26-cm format, with equally traditional framing. The subjects are things made in the 1960s and 1970s or simply related to the period in shape or design. Viewing the entire series

therefore does not decrease but indeed increases the ambiguity of the reading, which is actually cleared up by the knowledge both of the title of the series and of when it was produced.

In actual fact, the ambiguity of Sugimoto's photograph could also be revealed by a look at its date, because Castro looked a lot older in 1999 than he does in this image. It is, however, also true that – to remain in the field of the relationship between photographs and viewers – we seldom pay any particular attention to the dates of studio portraits of famous figures because they live in another temporal dimension. Moreover, we now have the ingrained habit of perceiving any portrait of the powerful as something manipulated.[4]

In any case, crucial importance attaches in both photographs first of all to the choice of framing. Only if the shots are framed in such a way as to eliminate any possible indication of when (in the case of Byrne) and where (in the case of Sugimoto) they were taken can they produce their effect of estrangement, which does not depend at all on the camera and its technical characteristics but on our relationship with the images it produces.

Even the sharpest eye and mind still appear to assume the reality of an analogical photograph in the absence of evidence to the contrary. In actual fact, both Sugimoto that Byrne perform two actions that guide our reading of the images and emphasise the nature of the photograph as an object, rather than an imprint of reality. They do not tell us what these images are not, and they extrapolate them from their context. As a result, two images that are crystal clear in themselves and extremely simple to describe are imbued with basic ambiguity.

No less important is the stylistic choice taken by the two artists in adopting the tradition of documentary photography, which runs from Atget, Sander, and Evans through the 1970s and on to the present, with a continuity of intent and expression that may be unequalled in the history of photography. A style that has always

Gerard Byrne
From the series *1984 and Beyond*, 2005–07
Three-channel DVD on LCD screens, nonlinear duration: approx. 60 mins total, set of twenty gelatin silver photographs
Dimensions variable
and 46 x 39 x 4 cm
Courtesy of Lisson Gallery, London

had a sort of ethical foundation in its more rigorous manifestations, and whose salient characteristic is the faithful rendering of what lies in front of the camera. Stylistic choices that explicitly avowed the element of posing and the deliberate adoption of strongly ideological strategies of vision (consider the "New Topographers") but led in any case to the creation of images whose circumstantial truth was not to be questioned.[5]

The adoption of this style once again causes viewer to lower their guard and trust. The problem is that the trust placed in vision can lead to the most disparate conclusions, and not necessarily most in line with what appears on the surface of the photographic print. The caption can therefore still act as a necessary tool and an integral part of the photograph itself, even to the point of providing – as in these cases – the key for a correct reading, at least as regards the subject represented. And it is in fact from this that we can then proceed to a further and obviously more complex level of interpretation. Without the date, which is, however, an element of the caption, how would we know that Byrne was interested "in this kind of entropic scenario, where Time collapses, and the appearance of the world ca. 2006–2007 somehow looks exactly like the world in 1963. The idea of temporal difference is confused and rendered ambiguous"?[6] The image in itself would tell us nothing about all that, but these photographs instead have a great deal to say about the mechanisms of seeing, and therefore of using the photograph.

Archives

Image. A showcase in a museum containing various materials, old photographs, letters, pages from scientific books, instruments used by ethnologists, maps, precise drawings and sketches of animals and plants. Other showcases with materials of the same kind.

"*Fauna* is the result of a photographic and literary collaboration with Pere Formiguera commenced in 1985. It consists of a multidisciplinary installation focused on a fantastic bestiary: photographs, X-rays, field sketches, maps of travels, zoological descriptions, texts, sound recordings, videos, stuffed animals, laboratory instruments, objects, letters and so on. The idea was to appropriate the typical exhibitive rhetoric of zoologists and museums of natural history, where the avalanche of data, the density of detail and the aura of rigour that surrounds them are capable of making the visitor accept any content. A trial of strength is thus created between the authority of the institution, its control over information, and the public's ability to react. To give our project shape we created the story of the German naturalist Professor Peter Ameisenhaufen and his assistant Hans von Kubert, and concealed our identity as authors behind a chance discovery of their archives. We thus introduced a new work of counterfeiting memory that involves the work of historians, archaeologists and palaeontologists. We developed Ameisenhaufen's biography and scientific research by interpreting a series of pseudo documents and red herrings mixed up with real ones, which brings us back to the debate on authenticity. *Fauna* is a reflection not only on models of reality and the credibility of the photographic image but also on scientific discourse and the artifice underlying any knowledge-generating device."[7]

Is what you see what you see?

Above and beyond the similarities and differences between these works, they share two elements that are crucial to any definition of the panorama we shall seek to outline below. They are images that work on the linguistic codes of photography and that call the relationship between photography and the viewer into question through the ambiguity of the relationship between the image and its interpretation. They replace Frank Stella's late-modern dictum "what you see is what you see" with the postmodern "what you see is not (necessarily) what you think you see".

Two further preliminary considerations. The fact that three of them were produced in the 1980s and 1990s, on the eve and during the early years of the digital revolution, is in no way coincidental and has an important consequence.

The advent of digital technology radically altered the perception of the photograph precisely in connection with the assumption of reality. The generation grown up in this era is in fact the first in history not to attach primary and fundamental importance to the relationship between photograph and reality, and to the apparent resulting need for the former to adhere to the latter. While manipulation is among the constituent characteristics of the perception and use of digital photography, it was a possibility

contemplated for the analogical mind, but one that involved at least two corollaries. First, it affected and falsified the very nature of the photograph; second, it required a set of technical skills that made it impracticable for the majority of consumers.

These considerations hold both for self-aware photography (historical examples include straight photography and the endless disputes about the "authenticity" of photojournalistic images) and for amateur photography. (To remain at the lowest level of practice, anyone today can change the colour of the eyes in an unsuccessful photo of a relative, while only those with specific knowledge could do so in the analogical era.)

As a result, the advent of digital photography has made it necessary for numerous artists to redefine some of the constituent elements of their language, starting precisely with the concepts of documentation, reality, perception, staging, reconstruction and falsification, which were to characterise the photography of the 1990s and 2000s.

It should also be pointed out that the images considered so far were produced with a very precise target, namely the world of art with its institutions and public.

They were born to be exhibited on the artistic circuit and to live inside it. This element necessitates their form (large format, slideshow, installation) and assumes the viewer. From the insider to the simple art lover, this is someone who has knowingly sought out the place offering a specific experience.

It is no coincidence that in calling the language into question, all these works in some way assume complicity – either prior or posterior – on the part of the viewer. Moreover, they call the language into question in a context that this challenge has actually institutionalized for over a century.[8]

An-My Lê
29 Palms: Colonel Greenwood,
2003–04
Gelatin silver print, 66.04 x 95 cm
Edition of 5
New York, Murray Guy

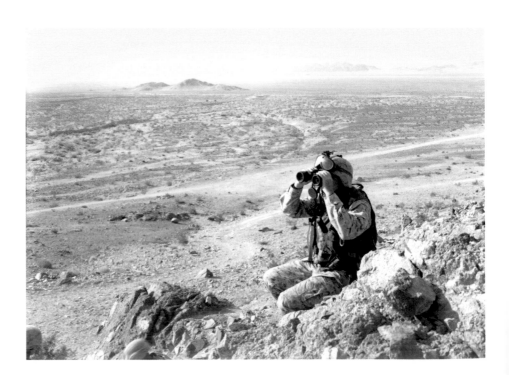

Kader Attia
Les Rochers Carrés, 2009
C-print
Courtesy of private collection
and of the artist / Galleria Continua,
Siena

Hrair Sarkissian
Execution Squares, 2008
Archival inkjet print
Athens, Kalfayan Galleries
Courtesy of the artist and Kalfayan
Galleries, Athens / Thessaloniki

A question naturally arises at this point. Could what were once known as "concerned" photographers, concentrating on current events and themes of an explicitly political and social character and therefore historically involved in a different kind of use, not have been involved in this process of redefining the forms, boundaries, and indeed foundations of the language? While the answer is obvious *a posteriori*, the course of this evolution presents more than one point of interest, above all in the light of the foregoing considerations.

In a recent post on the blog of the Fotomuseum Winterthur, David Campany points out that the historical complexity of the press photograph was in some way diminished by the adoption of a single photojournalistic language as a normative model. He gave the example of two photo essays of 1968 related on the Vietnam War, one by Don McCullin and the other by Eve Arnold, differing substantially in linguistic terms and published in the same issue of the *Sunday Times Magazine*. The first displays the characteristics of classic photojournalism, and is indeed one of McCullin's most celebrated works. The second instead uses a vocabulary that is unquestionably closer to the codes of fashion photography than news or war reporting. The first was produced in the field with the proximity to events institutionalised by Capa's celebrated dictum that if a photo is unsuccessful it is because you weren't close enough. The other was produced in the United States in one of the training camps for recruits soon to leave for the front. Far from making any judgement on their respective quality, Campany reflects on their language with an explicit reference to the present time: "The contents page of the magazine pairs the photo essays by McCullin and Arnold under the heading 'America in Vietnam, Vietnam in America'. Two photographers, two visual strategies, two incongruent but equally valid ways to represent the Vietnam war early in 1968. How smart of the editor. And how respectful of the intelligence of the readership! McCullin's pictures have been recycled endlessly while Arnold's are forgotten, never reproduced subsequently. Why is this? McCullin's pictures fit the narrow – and largely retrospective – idea of what photojournalism should have looked like and how it functioned. In some respects we

Sophie Ristelhueber
Installation view of *Fait* (1992):
monography show of Sophie
Ristelhueber at the Jeu de Paume,
Paris, 2009
Courtesy of Jeu de Paume, Paris

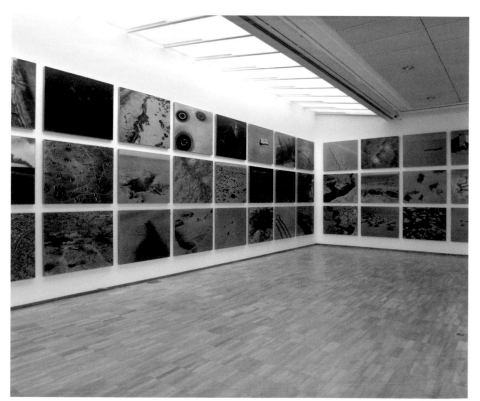

Adam Broomberg & Oliver Chanarin
Chicago, 2006–13
Photographic prints on wallpaper
Mini Israel, 2006, video
Installation view, "Territori instabili",
Centro di Cultura Contemporanea
Strozzina, Palazzo Strozzi, Florence,
2013
Courtesy of the artists

can see Arnold's approach as a precedent for the more recent 'conceptual turn' in documentary photography (a horrible term I know). Think of Broomberg & Chanarin's Chicago, their series of photographs of the fake Palestinian settlement built by the Israeli military for training; or An My Lê's documentation of US preparations in Californian deserts for war in the Gulf; or Sarah Pickering's images of police and fire department training facilities. But let's not forget Arnold was doing this in a mainstream magazine, not the sandpit of art with its greater freedoms but far more limited audience."[9]

If we take the names and titles mentioned by Campany and add others such as Kader Attia (*Les Rochers Carrés*), Sophie Ristelhueber (*WB*), Bruno Serralongue (*Kosovo*), Jo Ractliffe (*As Terras do Fim do Mundo*), Jananne Al-Ani (*Shadow Sites*), Hrair Sarkissian (*Execution Squares*), François-Xavier Gbré (*Mali Militari*), Trevor Paglen (*Limit Telephotography*), Taryn Simon (*The Innocents*), Ahlam Shibli (*Death*), Taysir Batniji (*The Watchtowers, West Bank / Palestine*), Francesco Jodice (*What We Want*) and Michael Wolf (*Paris Street View*), what emerges is an authentic tradition that addresses the themes of classic photojournalism through substantially different strategies of vision and communication.[10] The constituent elements of these strategies include the centrality of the caption as an indispensable key to interpreting and decoding the work. In absence of captions, all these works are mute, also in emotive terms.

They are, in many cases, very pleasant and fascinating aesthetically, but they do not communicate.

It is only the captions – of varying length and descriptive weight – that reveal all the richness of meaning enclosed in the images, the ambiguity of the scenes shown, the complexity of the situations photographed. In short, they open up a dimension, also in narrative

terms, that leads to the reasons for the shot and its presentation in a specific form. As Benjamin wrote nearly a century ago, "Will the caption not become the most important component of the shot?"[11] This gives rise to a series of not so marginal considerations.

It is curious to note that the fundamental presence of the caption coincides with the absence of these images from the pages of newspapers, when the relationship between image and text was one of the cornerstones of the illustrated press from the very outset. This is precisely the point, however, as these artists address a public other than the general readers of magazines. While professional photojournalists complain of the now chronic lack of commissions from newspapers, these authors – unquestionably prompted also by the practical economic considerations of the crisis in traditional journalism – have chosen to target a public that is far smaller numerically but at the same time more prepared to respond to alternative (albeit not necessarily antagonistic) visual information and to collaborate with the authors in decoding the work. Because in the caption has lost the central importance it once had in the pages of *Life* and similar publications, while the public of galleries and museums has now introjected the practice of the explanation of the work as an integral part of their approach to it, as a necessary element of its functioning. This is unquestionably one of the legacies of the heyday of Conceptual Art, of the endless variations in the relationship between text and image experimented in the 1960s and 1970s. A new generation of photographers thus grew up between that mode of image production and use, and the search for freer spaces of expression. Freer with respect both content – as the events of 11 September 2001 and the wars in Iraq show, the large-circulation press is now subjected to a form of iconographic

censorship that is as evident as it is invisible – and to the physical shape of the images themselves, which can appear in a whole host of forms in the artistic sphere.

Here we find the other crucial element of this part of the contemporary photography, which links up with the examples given at the beginning of this essay. Many of these images are not only enigmatic on first sight but also deliberately ambiguous when they are not explicitly false. The ambiguity and the falsification of reality thus become part of an authentic linguistic strategy. What do I see when I look at the buildings of Broomberg & Chanarin's *Chicago*? What are the forms shot by Jananne Al-Ani traces of? What are Batniji's Becher-like towers? The best way to make manifest the ambiguity of information, and sometimes of the very writing of history, is to use an equally interrogative language, one making it possible also to maintain ample leeway for interpretation in relation to subjects of inherently great complexity that presuppose more questions than answers.

As regards the mechanisms of writing history and the difficulty of arriving just at a clear reading of events in their material succession, consider the extraordinary work produced by Walid Raad on events in Lebanon at the end of the last decade, the construction of a fictitious archives in which – as in the above-mentioned installation of Fontcuberta – it becomes impossible to distinguish between true and false, between real and fabricated evidence, the authentic fragment and the fake. This reflection on the difficulty of recounting history while it is in the making has found a new and surprising interpreter in recent years in Richard Mosse, whose *Infra* of 2010–11, followed the next year by the large-scale video installation *The Enclave*, presents some similarities and one significant difference with respect to the works considered so far. Mosse is in fact the only one to work directly in the field and photograph the fighting under way, and hence the only one to adopt the methodology of the classic reporter, as emerges

Ahlam Shibli
Untitled (Trackers no. 38), 2005
C-print, 37 x 55.5 cm
Courtesy of the artist and Fondazione
Cassa di Risparmio di Modena,
Fondazione Fotografia, Modena

Taysir Batniji
The Watchtowers, 2008
Series of 26 photographs
Digital prints, 50 x 40 cm each
Courtesy of Fondazione Cassa
di Risparmio di Modena,
Fondazione Fotografia, Modena

from several of his images. By using an old infrared film, however, Mosse turns everything shot into a sort of chromatic hallucination, a vision as delirious as the subjects appearing before his camera. The displacement stems from a choice that, as he tells us, represents "a way of thinking through the conflict in Congo … I was dealing with the unknown, negotiating my own ignorance. Since infrared light is invisible to the human eye, you could say that I was literally photographing blind. I had crossed a threshold into fiction, into my own symbolic order. Yet I was trying to represent something that is tragically real – an entrenched and endless conflict fought in a jungle by nomadic rebels of constantly shifting allegiances."[12]

In the self-evident nature of the images and their essential blunt realism, an approach diametrically opposed to that of Walid Raad, Mosse too is involved in redefining the limits of the language, midway between documentation and reinvention, starting from the admission his own inability to understand completely what is going on around him, what he himself is photographing.

Documentary style, collage, reportage, regardless of the expressive form chosen by the individual artists (also including photographs in traditional formats, wallpapers, installations and slideshows), we are in any case dealing with images of photographic origin that – unlike those of the pre-digital era – are not based on the principle of the assumption of the photograph's correspondence to reality, but on its nature as an object capable of activating meaning by virtue of its special relationship with the world of communication, its lasting quality, its nature as a figure of time and hence of memory.

A place of reflection, radially connected with the idea of documentation, this form of photography follows on from the work initiated in the 1980s and develops its premises in two fundamental directions. The first involves the semantic level, as what is photographed is connected with events, places and people with a direct impact on the news and history of the times. If the point of reference for *Milk* is genre painting, for *Infra* it is history painting. (The most radical in this sense is perhaps Serralongue, a sort of reversed Wall, who addresses the typical themes of photojournalism and obeys the linguistic codes of reportage, differing from that tradition only in the scale of the photographic object, elevating politics and social events to the status of history by means of cultural codes and positioning on the scale of symbolic values.) The second regards the need to address a world of information totally altered by the advent of the Internet and the culture and economy connected with it.

While all this certainly explains why these authors work within the artistic context and how they operate there, it does not solve the question of the loss of a considerable number of possible users, a loss that also appears somewhat incongruous given the strongly social character of their work. In other words, the risk is that once Susan Sontag's legitimate demands as regards the aestheticisation of pain have been met – and once it has been realised that, as Andy Warhol pointed out, a gory bloody loses its effect when you see it

Richard Mosse
The Enclave, 2013
6-channel video installation
Installation view, "Territori instabili",
Centro di Cultura Contemporanea
Strozzina, Palazzo Strozzi, Florence,
2013
Courtesy of the artist and Jack
Shainman Gallery, New York

over and over – in the light of these insights and observations, people will take refuge in a ghetto, which may be as gilded and cultured as you like but is still ultimately a ghetto.

At the time in the 1980s and 1990s when photography became institutionalised by entering not only the museums, universities and academies but above all the market as one of the disciplines of contemporary art on a par with painting, sculpture, and installation, it necessarily shared the same destiny of becoming irreparably marginal with respect to the major flows of communication.

A condition accepted and in some cases even sought after, but one that, combined with the condition of the positioning and definition of photography – and the work of art in the broad sense – within the new systems of communications, merits examination in a new and conclusive chapter.

Heaps

Scene one. A black wall with writing on it. A tragic story of violence and death, of genocide. After the wall, a space opens up with a huge table, measuring five metres by five, covered with an enormous heap of slides, exactly one million. The slides can be looked at one by one in the viewers on the sides of the table, but we soon realise that the image is always the same: a pair of eyes looking at us.

Scene two. About a million photographic prints flood the spaces of a museum, inviting (or forcing) the visitor to move along paths paved with images and lie on beds of photographs. The photographs are all those loaded in the space of twenty-four hours on the Flickr photo management and sharing site and then printed. There is no criterion of selection other than time.

The differences between Alfredo Jaar's *The Eyes of Gutete Emerita* (1996) and Erik Kessels's *24 Hours of Photos*, presented for the first time at the 2011 FOAM in Amsterdam, concretely show the

distance between digital and analogical photography. Not only in quantitative terms, which in any case have a considerable effect on the perception of the photograph in the first decade of the new century, but also in qualitative terms, as they represent different approaches to the very idea of photography and its definition as a specific field of contemporary practice, culture and information. Before going any further it should be pointed out that in addressing these subjects, we should try to avoid falling into the short-sightedness often induced by reading the present from too close a distance and remember that the theme of the excessive production and circulation of images is nearly as old as photography itself and resurfaces at every technological turning point. From the revolution of the negative, which multiplied the number of prints, to the introduction of the *carte-de-visite* format, from the birth of Kodak cameras in the early twentieth century to the reproduction of images in newspapers and weekly magazines in the 1920s and the spread of the Instamatic and the Polaroid in the 1960s and 1970s, there is no event that has not given rise to talk about the incredible, unimaginable and above all indefensible quantity of images that were going to submerge the world. It is, however, then discovered that the world is capable to producing still more and, all in all, such Biblical floods can be survived quite easily, providing of course that we alter our relationship with the image, and especially with the photograph.

A look at artistic production can serve to clarify some aspects of these historical phases. In very recent years, after a long period of tarnished appeal, collage is again being practised with great frequency by the new generation of artists. In a whole variety of forms, from the most traditional to those connected with the principles and the practices of computer technology, the collage has become an inescapable presence in the exhibitions of the most recent artistic production. It should be pointed out in this connection that it played an equally key part in defining the artistic

Erik Kessels
24 Hours of Photos, FOAM in
Amsterdam, 5 November 2011
Courtesy of the artist

panorama during the last century, first in the 1920s and then in the 1950s and 1960s, two periods characterised by the impression of an invasion of images comparable to that of the present day.

The spread of the popular illustrated press in the first, and the birth and spread of television in the second, constituted cultural and technological shocks that were certainly no less great for the time than those we are now living through. There appears to be an almost automatic connection between the birth and spread of the popular illustrated press, television and the Internet, and the birth and the spread of a culture of collage. (Nor is it any coincidence that the aesthetic of Dada and Pop Art are grounded on reference to mass culture.)

It is as though, in order to counter the over-abundance of images and the resulting feeling of powerlessness to control their flow, artists felt the need to regain control through the act of cutting and repositioning them – in spatial and above all visual and semantic terms – at will, thus asserting a power of selection challenged by the new forms assumed by the world of images and those governing them.[13]

Here lies the nub of the present-day question, not so much in the quantity of images as in their channels of production and circulation. Alfredo Jaar's extraordinary work is in fact still embedded in an operational and communicational praxis that belongs historically to the tradition of photography, which the artist characterises by further accentuating the conceptual premises of creation and especially use.[14]

Jaar is actually addressing the subject of the perverse relationship within the sphere of information between the quantity of images available in absolute terms, and the censorship – silent in this case – that conceals them from the public. The tragedy of Rwanda, to which the work refers, was systematically ignored by the mass media, and the eyes of one of the countless victims, who saw and experienced first-hand one of its many tragic events, are there to recall not only the massacres but also the culpable silence of those who had the power but did nothing to prevent them. At the same time, the artist takes the theoretical assumptions regarding the futility of the repeated representation of violence, the progressive anaesthetisation of consciousness supposedly caused by the reiterated presentation of suffering, to develop a lateral strategy designed to capture attention through apparent inexplicability on the one hand, and visual impact on the other.[15] In any case, Jaar does not renounce but indeed asserts his role as creator of the work, one that certainly requires the viewer's readiness to examine the rationale of its modes of manifestation, but which remains within the boundaries of sharply defined artistic field. The very use of the slide can be seen as a choice intentionally connected with mechanisms of production and use belonging to the recent past, almost as though to suggest a timeless character of the work, lying outside the flow of information.

Alfredo Jaar
The Eyes of Gutete Emerita, 1996
Zurich, Daros Latinoamerica Collection
and Houston, the Museum of Fine Arts
Courtesy of the artist and Galleria Lia
Rumma, Milan / Naples

Kessels does the exact opposite, transforming twenty-four hours of virtual images in an jumbled heap of photographs. They are all different from one another, but their diversity counts for nothing in terms of their comprehensibility. And while Jaar adopts a precise stance with respect to the mechanisms of image circulation, the Dutch artist instead confines himself exclusively to recording and activating data that already exist. From the shipwreck of meaning of the images, despite everything, Jaar saves one, just one that becomes a symbol and icon of an entire historical event. Kessels makes the shipwreck tangible and quantifiable with the mixture of horror and fascination that the sight of every shipwreck arouses in the spectator not directly involved in the tragedy. Jaar essentially asserts that the artist is still assigned the task of creating and selecting the images, whereas Kessels appears to see the artist solely as a figure capable of giving new meaning and context to choices made elsewhere. These are obviously two extremes, and the space between them is occupied by a considerable proportion of the current work, whose broadly political aims address the new panorama created by the new media. It is admissible in this connection to add a further consideration of technical character alongside those regarding the central importance of the Internet in defining the new dimension of the photographic image. In addition to the possibility of uploading photographs directly, a crucial element of recent years is unquestionably the transformation of cameras into something different from their

original form and function. They have become an integral part first of cell phones and then of smartphones, and incorporated video capabilities at the same time, thus fostering the interweaving of languages. The crossing of disciplinary boundaries, which is today common practice, has very different origins and reasons from those historically established in the early years of the last century.
The transition from photography to video, for example, is wholly natural today precisely because the instruments available prompt this approach, and not as an anti-academic choice, as instead happened in the shift from painting to photography in the sphere of the historical avant-garde movements.
While the languages of the fixed image and the moving image remain different, they are both embedded in one and the same

instrument. And while the photographic image transformed into an object that is still printed on paper follows its own path and meets its public through the traditional channels, its connections with the world of the Internet on the one hand and the moving image on the other open up new avenues. This is the terrain of the hybridisation of instruments, channels of information, disciplines, styles, and above all roles, something that is not yet clearly defined but in any case marks an inescapable stage in the attempt to understand the panorama now taking shape.

We can only agree in this connection with Fred Ritchin. Taking up McLuhan's celebrated metaphor of driving while looking in the rear-view mirror, he points out that most of the people who use the Internet as a platform to circulate photographic images are simply using a completely new channel with completely old systems, and hence obviously harnessing only a tiny fraction of its potential.[16]

What returns to the forefront in particular is the question of the relationship between artist and public, which remains one of the most interesting in this period. On the one hand, precisely as a result of the greater ease of access to technologies of photography and editing, it is possible for some artists – such as Francesco Jodice (*Citytellers*), Ursula Biemann (*The Maghreb Connection*), and Oliver Ressler & Zanny Begg (*The Right of Passage*) – to create authentic documentaries, sometimes of great visual quality, for circulation either through artistic institutions or through television networks. Borrowing some characteristics from journalism and historical research, inserting some elements of a syntactic and grammatical nature that slightly but decisively alter the canonical structure of the documentary form, these authors sometimes succeed in addressing a public differing substantially from that of the art circuit.

While introducing new forms connected with unorthodox socio-political readings – and mostly aimed at a decidedly limited number of viewer by the standards of TV audiences – into mainstream information certainly proves very complex and hard to achieve, this is in any case a significant approach both in linguistic terms and as regards reflection on the mechanisms for the circulation of artistic products in contemporary society.

Deliberately avoiding the direct involvement of the public in the creation of the work is a further step directly connected with specific use of the new technologies. Among the now innumerable examples of such practices, attention can be drawn to Ritchin's own works (especially the one produced with Gilles Peress during the other great human and political tragedy of the last few decades, namely the war in former Yugoslavia), those of Bielicky & Richter, the *I am NEDA* project of the German-Iranian photographer Diana Djeddi and the work of the Italian collective Les Liens Invisibles. Entire shows are now based on materials from the most varied sources with the common feature of being part of a flow of information, such as the recent exhibit devoted to the Egyptian uprisings, held at the Braunschweig Museum of Photography.[17]

Different forms of a single visual and communicational strategy grounded in interaction between authors and users, which not only modifies the work in the course of its existence but constitutes the conceptual prerequisite for its birth. A form of participation that has the clear political aim of wresting information as much as possible from the control of the major networks by means of the same instruments, albeit obviously not the same economic resources.
In this sense, photographic practices end up undergoing hybridisation – just as photography itself has been hybridised in the course of its latest technical evolution – but do not cease to exist as a key part of a larger array of tools available to artists. And the very definition of documentation has become something hybrid that requires updated keys of interpretation.

By way of a conclusion

The concentration of official images in the hands of a few highly controlled managers and the simultaneous availability of an infinite number of images freely circulating on the Internet (an amount that it is moreover almost impossible to control without resorting to mechanisms of censorship that paradoxically end up, however, drawing still more attention to the subjects concerned, as the case of Ai Weiwei shows) also obviously affects the decisions of those who have chosen to use photography – in its various forms – as their primary means of expression to document and describe the world. Further factors of influence in this respect obviously include questions regarding the susceptibility of photographic images to manipulation, falsification and management, which are not exclusively peculiar to the digital era but have acquired specific characteristics during it, as we have seen.
In all this, in this constant mixing of tools and language, in the constant redefinition of roles that make this period as hard to

understand as it is fascinating to observe, we shall now end with one last scene from *Kurdistan – In the Shadow of History* by Susan Meiselas, an extraordinary book first published in 1997 and then brought out in more complete edition in 2008. Consisting of 400 pages of documents, images and writings from private and public sources in every part of Kurdistan, including both professional and amateur photographs, it was created by asking the Kurds involved in the historical events examined for material in order to safeguard the memory of a people persecuted for centuries and now on the verge of extinction. The book took years to create and has also been developed on the Internet in a perfect integration of the various possible spirits of photography and its documentary and political vocation. The author, who made her name back in the 1970s and 1980s with now-historic photo essays and reportage, reserved negligible space in it for her own photographs and instead acted as the director of a collective history, demonstrating that photography can be not only the source of extraordinary images but also the trigger of a complex system of relations that may help us to understand something about the world, and above all preserves its memories. Because this ultimately remains, in our age too, the essence of the photographic experience, the primary reason for its indispensability in both the private and the public sphere.

[1] Wall actually reworks all the genres and sub-genres of the pictorial tradition, from landscape, portrait and still-life to history painting, while also varying the linguistic modes of the image's creation and appearance. The completeness and complexity of his vision and works as well as their influence on his contemporaries and successors make him perhaps the only truly indispensable figure for any kind of analysis of the evolution of the artistic and photographic language over the last thirty years.

[2] J. Wall, "Unity and Fragmentation in Manet", in *Parachute* 35, Montreal, summer 1984 (retranslated here with reservations from the Italian version, "Unità e frammentazione in Manet", in *J. Wall, Gestus. Scritti sull'arte e la fotografia*, Quodlibet Abitare, Macerata 2013, pp. 138–39).

[3] D. Claerbout, "Entretien", interview with C. van Assche, in C. van Assche (ed.), *David Claerbout, The Shape of Time*, exhib. cat., Centre Pompidou – JRP/Ringier, Paris/Zurich 2008, p. 9.

[4] See the interesting *Ritratti del potere – Volti e meccanismi dell'autorità*, exhib. cat. (Florence, Centro di Cultura Contemporanea Strozzina, 1 October 2010 – 22 January 2011, curator Franziska Nori), Silvana Editoriale, Cinisello Balsamo.

[5] The definition of *documentary* in the photographic sphere has been one of the most debated issues from the outset. For a general overview, see the classic work of O. Lugon, *Le style documentaire. D'Auguste Sander à Walker Evans 1920–1945*, Éditions Macula, Paris 2001, See also S. Phillips, "Documenti, documentazione e fotografia documentaria", in W. Guadagnini (ed.), *La Fotografia. Una nuova visione del mondo 1891–1940*, Skira, Milan 2012, pp. 228–49; E. Dexler and T. Weski (eds.), *Cruel and Tender. The Real in the Twentieth-Century Photograph*, exhib. cat. (London, Tate Gallery, 5 June – 7 September 2003).

[6] G. Byrne, "On Magazines, Photography and Time", interview with Malene Vest Hansen, in *Sum* 1, Copenhagen 2007, p. 91. Byrne offers a very precise definition in the same interview of his own relation with the documentary and the present day: "There are other ways of working with the camera than the documentary/fiction opposition. My work has a basis in fact at some level, but it does not fetishise the idea of truth. ... What I am trying to do through these projects – and you can frame it in a political way or not – is at some level to investigate how we form a narrative of the present."

[7] J. Fontcuberta, *Scherzi della natura*, exhib. cat., Palazzo delle Esposizioni-Contrasto, Rome 2001, pp. 38–39. The relationship of

contemporary artists with the museum, its materials and its authority, and with archives has been examined acutely in two exhibitions: "The Museum as Muse. Artists Reflect", curator Kynaston McShine (New York, MoMA, 1999; catalogue published by Harry N. Abrams); "Archive Fever. Uses of the Document in Contemporary Art", curator Okwui Enwezor (New York, ICP, 2008; catalogue published by ICP/Steidl). See for both, entries by Francesco Zanot in this volume.

[8] It should be recalled in this connection that the artists working at the same time as Wall or slightly later include James Casebere, Thomas Demand, and Stan Douglas, whose sometimes strongly social and political views of photography as part of a complex mechanism of image construction and interpretation constitute an integral and fundamental part of this discourse.

[9] D. Campany, "Backwards and Forwards", in *Still Searching – An Online Discourse on Photography*, 2 May 2013, http://blog.fotomuseum.ch/2013/05/3-backwards-and-forwards/.

[10] This list is clearly very incomplete and indicative of a widespread cultural climate. An attempt has been made to apply the overall label *aftermath photography*, but this proves a vague and general term including very different authors who choose not to document the event itself but its consequences. Focusing more on the subject than the reasons for photographing, this is a limited definition that even ends us including figures like Robert Polidori, who have little in common with those mentioned above. Among the numerous recent opportunities for in-depth reflection on these subjects, attention should be drawn to the Brighton Biennial of 2008 ("Memory of Fire", curator Julian Stallabrass); "Antiphotojournalism", (Barcelona, Centro la Virreina, and Amsterdam, FOAM, 2011; curators Carles Guerra and Thomas Keenan); "Topographie de la guerre", (Paris, Le Bal, 2011; curators J. Jouannais and D. Dufour). Another recent project characterised on the whole by a similar approach is "*Transition – Paysages d'une société*", a photographic survey of the social landscape of present-day South Africa by twelve South African and French photographers. See the catalogue, *Transition – Paysages d'une société*, ed. F. Hébel and J. Fleetwood, published by Xavier Barral Editeur, les Rencontres d'Arles and Market Photo Workshop.

[11] W. Benjamin, "Kleine Geschichte der Photographie", in *Literarische Welt*, Berlin 1931. The very old and complex question of the key importance of the caption in defining the very nature of the photograph was addressed most of all in connection with the birth of the illustrated magazines and in the period dominated by Conceptual Art. See the essays by G. Badger, U. Pohlmann and Camiel Van Winkiel in the second and third volumes of this series for a basic overview of these subjects. It is, however, interesting to note that many contemporary artists refer explicitly to the words of Benjamin and of Bertold Brecht, authors who would seem to be far removed, at least ideologically, from the major trends in contemporary thought. Broomberg & Chanarin's recent *War Primer II* is indeed a reworking of a little-known work on photography by Brecht.

[12] A. Schuman, "Sublime Proximity: in Conversation with Richard Mosse", in *Aperture* 203, New York, summer 2011 (http://www.richardmosse.com/textpress/). It is interesting to note that Mosse, like Wall, has an academic background in art history. Another key element to understand the evolution of the photographic culture over the last thirty years is in fact the process of institutionalisation that has turned photography into one of the academic arts, with all that this entails.

[13] Suffice it in this connection to recall John Heartfield's explanation of his reasons for focusing on collage: "I started making photomontages during the First World War. There are a lot of things that got me into working with photos. The main thing is that I saw both what was being said and not being said with photos in the newspapers. … I found out how you can fool people with photos, really fool them. … You can lie and tell the truth by putting wrong titles or wrong captions under them, and that's roughly what was being done" (from a conversation of 1967 with Bengt Dahlbäck, then director of the Moderna Museet in Stockholm, cit. in P. Pachnicke and K. Honnef, *John Heartfield*, exhib. cat. (various venues from 1991 to 1994), Harry Abrams, New York 1993. As we can see, the caption reappears constantly as an open question in the field of communication through photography. For the relationship between the growth of the mass media and avant-garde artistic practices, see also the work of David Joselit. I am indebted to Charlotte Cotton for bringing this to my attention.

[14] These practices clearly draw inspiration from the reflections and works of some artists active in the 1970s, including Martha Rosler, Alan Sekula, and Victor Burgin, whose views on the status of photography are combined

with an explicitly political reading of the use of images in contemporary society.

[15] It is interesting to note that these observations are made by an artist who uses photography irregularly as one of the possible artistic practices. For an exhaustive reading of the series of works by Jaar, see D. Levi Strauss, *Between the Eyes. Essays on Photography and Politics* (Aperture, New York 2003), a key work that is still one of the most illuminating analyses of the political use of photographic images.

[16] See Ritchin's classic work *After Photography* (W.W. Norton, 2009) and his recent *Bending the Frame: Photojournalism, Documentary and the Citizen* (Aperture, New York 2013). For the open questions about information in this period and context, see also C. Chéroux, *Diplopie*, Le Point du Jour, Paris 2009. For the transition from analogue to digital, see the volume edited by H. von Amelunxen, S. Iglhaut, F. Rotzer, *Photography after Photography: Memory and Representation in the Digital Age* (G + B Arts, Amsterdam 1996).

[17] "Kairo. Offene Stadt. Neuer Bilder einer andauernden Revolution", Braunschweig, Museum fur Photographie, 28 September 2012 – 23 December 2012, catalogue published by Spector Books, Leipzig. Other exhibitions capable of interweaving different languages and fields of knowledge include two held in Florence at the Centro di Cultura Contemporanea Strozzina: "Identità Virtuali", 20 May – 17 July 2011, and "Declining Democracy", 23 September 2011 – 22 January 2012 (catalogues published by Silvana Editoriale, Cinisello Balsamo). Organised by Franziska Nori and the present author and inaugurated at the same venue in September 2013, "Territori Instabili" addresses some of the subjects discussed here.

- The Atlas Group and Walid Raad
- "From Here On: Neo Appropriation Strategies in Contemporary Photography"
- Adam Broomberg & Oliver Chanarin

The Atlas Group and Walid Raad

The Thruth Will Be Known When The Last Witness Is Dead

Verlag der Buchhandlung Walther König: Cologne, 2004

The Truth Will Be Known When The Last Witness Is Dead. Documents from the Fakhouri File in the Atlas Group Archive, is the full title of the volume published in 2004 by the German company Walther König in association with the French publishing houses La Galerie de Noisy-le-Sec and Les Laboratoires d'Aubervilliers. The author, identified on the white cover as The Atlas Group is actually one person: the Lebanese artist Walid Raad, who founded the fictitious collective with the aim of analysing, documenting, and disseminating Lebanon's recent history, with a particular focus on the period between 1975 and 1991, when the country was rocked by civil war.

Born at Chbanieh in 1967 and raised in predominantly Christian east Beirut, Raad emigrated with his family to America in 1983, due to the worsening tensions with Israel following its invasion of Lebanon in 1982. He initially studied medicine at Boston University, before devoting himself to photography and obtaining a Ph.D. in the Visual Arts and Cultural Studies at the University of Rochester. After settling in New York, he created The Atlas Group in 1999, claiming that it was the owner of a vast archive of documents that could be classified in three main categories: "Type A (attributed to an identified individual); Type FD (found documents); Type AGP (attributed to The Atlas Group)". The archive was another of the Lebanese artist's inventions; nonetheless, it was precisely this material that provided the basis for a project that explored both the Middle-East situation and the relationship between photography and truth while, at the same time, experimenting with various approaches to the photographic narrative and verifying the ways in which it could be integrated with other disciplines (his production encompasses video, performance and writing – in English, Arabic and French – as well as materials taken from more or less official, reliable and technologically updated news media). Conscious of the fact that history is ever-changing, Raad constructed a complicated device for observing the Arab world, stressing the importance of photography not so much as a tool for gathering evidence but as a means of fabricating it.

The Truth Will Be Known When The Last Witness Is Dead is the first monograph on The Atlas Group. The volume brings together a series of documents from the first of the three categories specified above (Type A), donated to the imaginary artistic and cultural association by a certain Dr Fadl Fakhouri. He too is fictitious (Fakhouri is one of the most common surnames in the region comprising Lebanon, Jordan, Syria, and Palestine). According to the book he is "the most renowned historian of Lebanon" and his gift includes "226 notebooks, 24 photographs, and 2 films", only some of which are published here, namely three extracts from three different notebooks and all the photographs. Notebook 72 (*Missing Lebanese Wars*) contains some old cuttings from the local newspaper *Annahar* with photographs of the end of various horse races that took place the day before. Alongside them are a series of notes that describe how Marxists, Islamists, Maronites, and Socialists would meet every Sunday at the racecourse, where they did not bet on the outcome of the race but on whether the photo-finish operator would press the button just before or just after the winning horsed passed the post. In Notebook 38 (*Already Been in a Lake of Fire*), on the other hand, there are images of the car models used as bombs to carry out 145 attacks in Lebanon between 1975 and 1991, while Notebook 57

(*No, Illness Is Neither Here Nor There*) brings together photos taken by Fakhouri himself of all the doctor's and dental surgery signs he saw on the street between 1976 and 1978, grouped according to specialisations. Lastly, the twenty-four photographs in an envelope (*Civilizationally, We Do Not Dig Holes To Bury Ourselves*) consist in as many self-portraits taken by Fakhouri at the end of the 1950s while travelling to Rome and Paris, which generally (and mysteriously) refer to totally banal situations. This complex visual and literary corpus has various effects, one of them being to completely disorientate the viewer, who is constantly torn between trust and mistrust, even after having become familiar with the artist's modus operandi. Nurturing a suspicion that the content is not truthful is a form of resistance that stems from several factors, including the documentary value of the photograph, the attribution of the project to a group organisation and the transference of authorship to a non-artistic context – because, as Raad states in an interview with J. A. Kaplan, "artists are not allowed to write history – they need the authority of a credentialed historian" ("Flirtations with Evidence", in *Art in America*, October 2004, p. 137). In parallel to the development of the narrative, which is imaginary and horribly real at the same time, photography itself is analysed both as a language and a means of communication. Hence each section of the book is devoted to a specific issue: the hijacking of public opinion by the media (Notebook 72); the coldness any kind of documentary account brings to reality (Notebook 38 and Notebook 57), and the inability of this type of image to provide explanations (*Civilizationally...*). Imbued with political meanings, the artist's original strategy of rewriting history achieved important recognition prior to the publication of *The Truth Will Be Known When The Last Witness Is Dead* and to the terrorist attacks of 11 September 2001, which completely shattered the feeling of unassailable security that had previously pervaded the entire Western world. As it happens, in 2002 the Atlas Group was invited to display its work both at Documenta 11 in Kassel and the Whitney Biennial in New York, and the following year a wide photographic installation on the theme of car bombs (*My Neck Is Thinner Than A Hair: Engines*) was presented at the Venice Biennale.

Bibliography
Chouteau-Matikian, H., A. Gilbert, and B. Stimson. *Walid Raad*. London: Whitechapel Gallery, 2011.
Cramerotti, A. *Aesthetic Journalism. How to Inform Without Informing*. Bristol: Intellect, 2009.
Enwezor, O. *Archive Fever. Uses of the Document in Contemporary Art*. Gottingen / New York: Steidl / International Center of Photography, 2008.
Knape, G. *Walid Raad: I Might Die Before I Get a Rifle*. Gottingen: Steidl, 2011.
Merewether, C. *The Archive*. Cambridge, MA: MIT Press, 2006.
Nakas, K., and B. Schmitz. *The Atlas Group 1989–2004*. Cologne: Walther König, 2007.
VV.AA. *Mapping Sitting*. Beirut: Mind the Gap / Arab Image Foundation, 2005.
Warner Marien, M. *Photography. A Cultural History (3rd ed.)*. Kingwood: Prentice Hall, 2010.

*Miraculous beginnings / No,
Illness is Neither Here Nor There*,
1993/2003
Two channel video (no audio),
1 minute, 50 seconds
Courtesy of Paula Cooper Gallery,
New York

*Notebook volume 72: Missing
Lebanese Wars: Plate 134,*
1998/2004
1 of 21 archival digital prints,
34 x 24.8 cm each
Courtesy of Paula Cooper Gallery,
New York

Description of the Winning Historian:

Mercurial and blunt. Slight, effete, sour
and unsure of himself. Snotty and brazen

*Distance Between Horse
and Finish Line:*

- 40

Race Distance:
1400 m.

Winning Time:
1:54

Average Speed:
42.3 km/hr.

Historians' Initials and Bets:

1. KS -016
2. MM -216
3. FF -801
4. PH +380
5. HG -279
6. RO +668
7. AB -080
8. SK -022

Winning Historian / Time:
SK - 22

photographer to inserts his own figure in images of some local volcanoes, Hans Aarsman collects snapshots of objects so as to placate the desire to possess them, Corinne Vionnet superimposes hundreds of tourist photographs of some of the world's most famous landmarks to reconstruct the sightseer's imaginary archetype, Kurt Caviezel inventories frames extracted from webcams in every corner of the planet, and Doug Rickard uses Google Street View to travel all over America, thus updating a consolidated tradition of the national culture.

Above and beyond all social and procedural questions, the work of these artists is ultimately characterised by the consideration of photography as a unified language. Their manipulation of the initial materials does not therefore constitute a superseding of the intentions that led to their creation, but on the contrary an operation of respectful (albeit sometimes amused) accompaniment. Rather than displaying an elitist attitude, the artists featured in this exhibition defend the originals to the point of accepting their mediocre technical and aesthetic quality. Artistic investigation is thus interwoven with the innumerable functions attributed to photography in the contexts from which the images are drawn, making "From Here On" a sort of celebration of the variety of its applications. In the same way, there is little discussion on the theme of authorship. Instead of raising questions about their own role, the creators of these works focus attention on the amateur photographers and automatic devices that captured the images. To quote Chéroux once more: "At issue here is no longer the 'death of the author' proclaimed by Roland Barthes in 1968, but his simulated suicide. For the appropriationist working in the totally digital age, the point is not longer to deny his status as author, but rather to playact or feign his own death in the full knowledge that he's not fooling anybody." A participatory logic is thus established: technology, the amateur photographer, and the viewer, are all on the same level as the artist in helping the work to take shape.

Bibliography
Aarsman, H., C. de Cleen, J. Germain, E. Kessels, and H. van der Meer. *Useful Photography # 2*. Amsterdam: KesselsKramer, 2002.
Bajac, Q. *Après la photographie? De l'argentique à la révolution numérique*. Paris: Gallimard, 2010 (it. trans. *Dopo la fotografia. Dall'immagine analogica alla rivoluzione digitale*. Rome: Contrasto, 2011).
Burnett, R. *How Images Think*. Cambridge, MA: MIT Press, 2004.
Campany, D., and E. O'Toole. *Doug Rickard: A New American Picture*. New York: Aperture, 2012.
George, A.R., G. Peress, M. Shulan, and C. Traub. *Here Is New York: A Democracy of Photographs*. Zurich: Scalo, 2002.
Mailaender, T. *Extreme Tourism*. Paris: RVB Books, 2011.
VV.AA. *Joachim Schmid: Photoworks 1982–2007*. Gottingen: Steidl, 2007.
Wolf, S. *The Digital Eye. Photographic Art in the Electronic Age*. Lakewood: Prestel, 2010.

Doug Rickard
#40.805716, Bronx, NY (2009),
from the series *A New American
Picture*, 2011
Archival pigment print
Courtesy of Yossi Milo Gallery,
New York

Kurt Caviezel
Bird 3, from the series *Animals*,
2009
Inkjet on laid-paper on aluminium,
110 x 190 cm
Courtesy of the artist

Corinne Vionnet
Al-gizah, from the series *Photo
Opportunities*, 2006

Thomas Mailaender
Extreme Tourisme, 2008
Lambda print, 75 x 100 cm,
in burned wood frame
Edition of 5

**Adam Broomberg
& Oliver Chanarin**

Holy Bible

Mack Books / Archive of Modern Conflict: London, 2013

Adam Broomberg (Johannesburg, 1970) and Oliver Chanarin (London, 1971) first met during the early 1990s in Italy, where they were both working as photographers for *Colors*, a magazine of Oliviero Toscani and Tibor Kalman offering in-depth coverage of geopolitical developments, news and multiculturalism through large-scale use of photography. The basis of the ensuing artistic partnership consolidated over the years is a shared interest in the political, ethical and cultural value of the photographic image and its relationship with the representation of historical events. Over the next two decades, having set up a studio in London, Broomberg and Chanarin produced an abundance of work characterised both by marked thematic continuity and by a broad variety of stylistic and procedural choices, appearing primarily in book form. *Trust* (Westzone, London 2000), an ethnographic and sociological study of the human face and its expressions midway between Duchenne de Boulogne and Munch's painting *The Scream*, has in fact been followed by numerous books both for normal distribution and produced independently and in limited editions, including *Ghetto* (Trolley, London 2003), *Chicago* (SteidlMACK,

Göttingen 2006), *Fig* (Steidl, Göttingen 2007), *People in Trouble Laughing Pushed to the Ground* (MACK, London 2011) and *Black Market* (Chopped Liver Press, London 2012).

In 2012, in line with a gradual move away from taking photographs in favour of the use of archival materials, the duo drew upon the boundless visual universe of the Internet for a project inspired by Bertolt Brecht's *Kriegsfibel* or *War Primer*, where the celebrated German intellectual presented eighty-five images taken from newspapers of the period, each accompanied by an epigram in place of the original caption to emphasise the ambiguity of photography. Published in 1955, this simultaneously poetic, educational, rigorous and desperate operation gave concrete form to Brecht's ideas about the political use of the medium. As he wrote in *Arbeiter Illustrierte Zeitung* in 1931, "The tremendous development of photojournalism has contributed practically nothing to the revelation of the truth about the conditions in this world. On the contrary, photography, in the hands of the bourgeoisie, has become to terrible weapon *against* the truth." Starting with the title, Broomberg & Chanarin conceived *War Primer 2* as a sort of sequel to

Brecht's work with the addition of a further level. Each illustration of the original book is juxtaposed with another photograph taken from the recent iconography of the so-called war on terrorism, thus remixing the previously reworked meanings and reflecting on the relations of interaction developed not only between images and words but also between images themselves.

Published in London by MACK in a run of just one hundred, with the new photographs attached by hand to copies of an English edition of Brecht's work (Libris, London 1998), *War Primer 2* won the prestigious Deutsche Börse Photography Prize for Broomberg and Chanarin in 2013 and paved the way at the same time for their next work.

During a visit to the Brecht Archive in Berlin during the preparation of *War Primer 2*, Broomberg and Chanarin came across the playwright's personal copy of the Bible, curiously adorned with a photograph of a racing car on the cover and with other images and annotations inside. While this improper use of the scriptures was probably due to the lack of a notebook to jot things down and collect mementoes, it was sufficient to prompt the Anglo-South African pair

develop their own version of the most widely circulated and controversial literary text in the history of humanity. Published in 2013 by MACK and Archive of Modern Conflict, *Holy Bible* is a reproduction of the volume in its standard form, complete with a cover of black leatherette, gilt lettering and cloth bookmark, with 512 photographs inserted (this time typographically) and some passages highlighted in red. All the images are from the same source, namely the Archive of Modern Conflict, a huge private collection of materials all connected with war that does not, however, eschew the inclusion of various items that attracted the attention of its creators in accordance with a subjective and versatile approach. (The AMC was founded in the early 1990s by the Canadian tycoon David Thomson and is now run by Timothy Prus and Edwin Jones.) *Holy Bible* is thus full of all kinds of photographs, including shots of road accidents, police records, family snapshots, scientific studies of diseases and deformities, chemical and military experiments, including stills from newsreels, and of course the coverage of the most disparate wartime events, priority being given in any case to anonymous and unofficial imagery. Each photograph is not only

separated from its original context, to which no reference is made, but also associated with one or more deliberately highlighted passages in the Bible, thus focusing on semantic potential rather than any illustrative purpose. (There is no connection, for example, with the precious edition of the Bible published in England in 1861 with twenty albumin prints by Francis Frith showing the places where the events related in the Old and New Testaments took place.) To give just a few examples, the funeral of two US soldiers is juxtaposed with the verse "She smote off his head" (Judges 5: 26), a child dressed as a kamikaze with "As is the mother, so is her daughter" (Ezekiel 16: 44), and an explosion that sends debris hurting towards the photographer with "Cursed be the man that maketh any graven or molten image" (Deuteronomy 27: 15). Some photographs of a series on conjuring tricks reappear every so often throughout the book, always accompanying the words "and it was so", the reiteration of which in the Bible (in the Hebrew version the expression "vyhi" appears 613 times) constitutes a literary expedient that ultimately accentuates the illusionistic tension.

The result of a complicated process of appropriation and superimposition, Broomberg and Chanarin's *Holy Bible* is at the same time an investigation into the dynamics of the wielding of power through images and sacred writings. The ideas of the radical Israeli philosopher Adi Ophir, whose *Two Essays on God and Disaster* (the Van Leer Jeruslem Institute) is cited here in an extract, acts as a guide for the treatment of the second subject, identifying a relationship of continuity between divine and governmental violence. In a taut reconstruction of the events described in the Old Testament, from the Tower of Babel to Sodom and Gomorra by way of the Seven Plagues of Egypt, Ophir points out the sheer amount of death and brutality associated with the appearances of God ("Right from the beginning, he was the lord of catastrophe"), who unleashes His fury when His commandments are not obeyed. He draws an inescapable parallel: "The relations between divine and earthly economies of violence underwent a significant transformation with the emergence of the modern state and its consolidation as a totality (of spaces, people, associations, etc.), a multi-apparatus that strives to control everything it contains and to contain everything it can control. On the one hand, the state has become a potential or actual generator and facilitator of large-scale disasters, and the destructive power of some states has been brought to perfection. On the other hand, the state has also become a facilitator, sponsor, and co-ordinator of assistance, relief and survival in times of disaster. In both cases, the state has taken, or might seem to be taking his role as the chief author of destruction and the ultimate agent of providence." Consideration of the fact that photographs are taken by aiming the camera at the subject in order to capture a part of its surface makes it clear that *Holy Bible* is a great epic on the representation of suffering and on the forces that cause and justify it.

Bibliography
Broomberg, A., and O. Chanarin. *War Primer 2*. London: MACK, 2011.
Dillon, B. *Curiosity. Art and the Pleasures of Knowing*. London: Hayward Publishing, 2013.
Ewing, W.A. *Out of Focus: Photography*. London: Booth-Clibborn Editions, 2012.
Stallabrass, J. *Memory of Fire: Images of War and the War of Images*. Brighton: Photoworks, 2013.
Van Gelder, H., and H.W. Westgeest. *Photography Theory in Historical Perspective*. New York: Wiley-Blackwell, 2010.

Holy Bible, pp. 6–7
2013 MACK & The Archive
of Modern Conflict

Genesis Page 6

Page 7 **Genesis**

sons and daughters. {11:20} And Reu lived two and thirty years, and begat Serug: {11:21} And Reu lived after he begat Serug two hundred and seven years, and begat sons

commended her before Pharaoh: and the woman was taken into Pharaoh's house. {12:16} And he entreated Abram well for her sake: and he had sheep, and oxen, and he asses, and

the Egyptians shall see thee, that they shall say, This [is] his wife: and they will kill me, but they will save thee alive. {12:13} Say, I pray thee, thou [art] my sister: that it may be well with me for thy sake; and my soul shall live because of thee.

{12:14} And it came to pass, that, when Abram was come into Egypt, the Egyptians beheld the woman that she [was] very fair. {12:15} The princes also of Pharaoh saw her, and

{14:1} And it came to pass in the days of Amraphel king of Shinar, Arioch king of Ellasar, Chedorlaomer king of Elam, and Tidal king of nations; {14:2} [That these] made war with Bera king of Sodom, and with Birsha king of Gomorrah, Shinab king of Admah, and Shemeber king of Zeboiim, and the king of Bela, which is Zoar. {14:3} All these were joined together in the vale of Siddim, which is

[is] in Hebron, and built there an altar unto the LORD.

the salt sea. {14:4} Twelve years they served Chedorlaomer, and in the thirteenth year they rebelled. {14:5} And in the fourteenth year came Chedorlaomer, and the kings that [were] with him, and smote the Rephaims in Ashteroth Karnaim, and the Zuzims in Ham, and the Emims in Shaveh Kiriathaim, {14:6} And the Horites in their mount Seir, unto El-paran, which [is] by the wilderness. {14:7} And they returned, and came to En-mishpat, which [is] Kadesh, and smote all the country of the Amalekites, and also the Amorites that dwelt in Hazezon- tamar. {14:8} And there went out the king of Sodom, and the king of Gomorrah, and the king of Admah, and the king of Zeboiim, and the king of Bela (the same [is] Zoar;) and they joined battle with them in the vale of Siddim; {14:9} With Chedorlaomer the king of Elam, and with Tidal king of nations, and Amraphel king of Shinar, and Arioch king of Ellasar; four kings with five. {14:10} And the vale of Siddim [was full of] slimepits; and the kings of Sodom and

high God, the possessor of heaven and earth, {14:23} That I will not [take] from a thread even to a shoelatchet, and that I will not take any thing that [is] thine, lest thou shouldest say, I have made Abram rich: {14:24} Save only that which the young men have eaten, and the portion of the men which went with me, Aner, Eshcol, and Mamre; let them take their portion.

{15:1} After these things the word of the LORD came unto Abram in a vision, saying, Fear not, Abram: I [am] thy shield, [and] thy exceeding great reward. {15:2} And Abram said, Lord GOD, what wilt thou give me, seeing I go childless, and the steward of my house is this Eliezer of Damascus? {15:3} And Abram said, Behold, to me thou hast given no seed: and, lo, one born in my house is mine heir. {15:4} And, behold, the word of the LORD [came] unto him, saying, This shall not be thine heir; but he that shall come forth out of thine own bowels shall be thine heir. {15:5} And he brought him forth abroad, and said, Look

now toward heaven, and tell the stars, if thou be able to number them: and he said unto him, So shall thy seed be. {15:6} And he believed in the LORD; and he counted it to him for righteousness. {15:7} And he said unto him, I [am] the LORD that brought thee out of Ur of the Chaldees, to give thee this land to inherit it. {15:8} And he said, Lord GOD, whereby shall I know that I shall inherit it? {15:9} And he said unto him, Take me an heifer of three years old, and a she goat of three years old, and a ram of three years old, and a turtledove, and a young pigeon. {15:10} And he took unto him all these, and divided them in the midst, and laid each piece one against another: but the birds divided he not. {15:11} And when the fowls came down upon the carcases, Abram drove them away. {15:12} And when the sun was going down, a deep sleep fell upon Abram; and, lo, an horror of great darkness fell upon him. {15:13} And he said unto Abram, Know of a surety that thy seed shall be a stranger in a land [that is] not theirs, and shall serve them;

despised in her eyes: the LORD judge between me and thee. {16:6} But Abram said unto Sarai, Behold, thy maid [is] in thy hand; do to her as it pleaseth thee. And when Sarai dealt hardly with her, she fled from her face.

{16:7} And the angel of the LORD found her by a fountain of water in the wilderness, by the fountain in the way to Shur. {16:8} And he said, Hagar, Sarai's maid, whence camest thou? and whither wilt thou go? And she said, I flee from the face of my mistress Sarai. {16:9} And the angel of the LORD said unto her, Return to thy mistress, and submit thyself under her hands. {16:10} And the angel of the LORD said unto her, I will multiply thy seed exceedingly, that it shall not be numbered for multitude. {16:11} And the angel of the LORD said unto her, Behold, thou [art] with child, and shalt bear a son, and shalt call his name Ishmael; because the LORD hath heard thy affliction. {16:12} And he will be a wild man; his hand [will be] against every man, and every man's hand against him; and

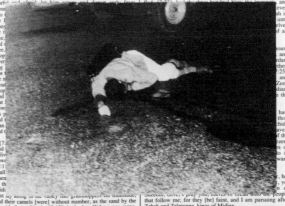

Appendix

Glossary

CCD

This stands for *charge-coupled device*, a device for the movement of electrical charge, usually from inside the device to an area where the charge can be manipulated. In addition to widespread use in astronomy, the CCD is the key component of digital cameras, video cameras, fax machines and scanners. In the sphere of *digital imaging*, the CCD is a circuit of variable size, measured in inches, inside which a grid of semiconductors (*photodiodes*) accumulates electrical charge and records impulses that are differentiated in terms of the luminosity identifying every point of the surface to be captured. An external A/D converter then converts the impulses into digital data, thus producing the image.

The quality of a digital photograph largely depends on the quality of the sensor in terms both of size – which determines a greater or lesser degree of pixel density and thus affects the level of detail – and of the electrical potential of each photodiode, which can cause the adverse effect of noise on the surface photographed in the case of high ISO speeds (a phenomenon similar to the graininess of film in analogical cameras).

Digital photography

The acquisition, conversion and recording of images through optical devices (lenses) that act on electronic photodetectors (CCD) in a process that simulates the capture of light on photographic film.

The image produced by interpolation of the set of data thus gathered has to be transferred to a computer through conversion into a legible format, most common being *jpg* and *raw*. In the latter, as the name suggests, the data undergo no alteration whatsoever in the conversion phase, which ensures the maximum yield of digital reflex.

Once downloaded, the file produced can be viewed, processed with special software, reproduced, stored, and printed.

This form of *digital imaging* originated in the 1970s, when the need in the astronomical sphere to transmit visual data over immense distances prompted Kodak engineer Steve Sasson to build the first digital camera in history. Technological developments made rapid progress possible in this sector, and devices were effectively launched on the market in the 1990s.

The success of the digital photography, the superstar of the 2000s, is partly due to practical reasons such as markedly lower costs – film being replaced by a potentially limitless virtual memory (usually a *flash memory*) – and production times, but also to other factors of social nature, such as the incorporation of cameras in mobile devices, and the advent of social networks fostering its dissemination.

Flickr

A popular image and video hosting site (http://www.flickr.com/) launched in 2004 by the Canadian company Ludicorp, which became known all over the world the following year on being bought by the American concern *Yahoo!*

In addition to serving as a container, Flickr constitutes an authentic online community whose users, both amateur and professional photographers, can consult the profiles of others and comment on their content, present their own work, create sets and galleries of images, make use of a geographic location service, participate in discussion forums and join a variety of thematic groups in accordance with their personal interests. Registration can be free of charge, which entitles the user to one terabyte of space, or through two forms of paid subscription, Ad Free and Doublr. The site is freely accessible. As regards privacy, it is the user that sets the parameters of visibility for each image posted.

The numerous institutions and above all museums that use the site to make their holdings known to the public include the US Library of Congress, the Smithsonian Institution, and the George Eastman House. Flickr has also managed over the years to establish important partnerships with sites of stock photographs like Getty Images – users are free to indicate their willingness to sell their images – and others connected with

the printing of merchandising products (business cards, stationery and personalised albums).

Giclée printing

A particular type of digital inkjet printing on high quality paper or canvas making it possible to obtain prints of large size and high definition. These printers generally use more highly developed versions of the CMYK (cyan, magenta, yellow, black) process, which can range from CcMmYK to increasingly precise nine-colour systems. The variety of channels and the use of inks containing particles of pigment as against the normal coloured solutions ensure fluid and homogeneous chromatic transition, very bright tonalities and great detail.

High quality and durability justifies the frequent use of this technology in the production of artworks.

Inkjet printing

This process of computer printing propels droplets of ink through nozzles onto a surface, usually of paper or plastic. The heads containing the nozzles are mounted on a mobile carriage, which covers all of the surface to be printed. The ink required is contained in interchangeable cartridges, which can hold one or more colours depending on the model of printer.

The most common processes are of the *drop-on-demand* type, divided in turn into two different kinds. The first, developed by Canon, is a

thermal process characterised by the presence of heaters, which cause a rise in temperature through electrical impulses. Contact with the ink then produces a bubble that is immediately ejected onto the support. The heating of the ink, which includes an element of water in this case, necessitates a cooling period for drying on the surface. The second type employs a piezoelectric crystal, which changes shape elastically when subjected to electrical impulses, thus causing an increase in the pressure of the ink inside the head that propels the liquid onto the material at high speed. Epson peripherals use this technology. Finally, the *continuous* process used on a far greater scale in industry and commerce involves a constant flow of ink at high frequency and makes printing possible at very high speeds.

Launched on the market in the 1980s by firms like Canon, Epson, and Hewlett-Packard, inkjet printers are those most commonly used and are available in a wide variety of models and price ranges to meet the most varied requirements, professional and otherwise.

Instagram

With over 130 million registered users, Instagram is the most popular online photo-sharing service currently in existence. Created and launched by Kevin Systrom and Michel Krieger in 2010, it is free and can be downloaded from Apple App Store and Google Play.

Mobile device cameras (iPhone and Android) can be used to take unlimited photographs in the characteristic square format of analogical Polaroid and Kodak Instamatic images, and to shoot short videos. Users can then apply coloured filters and add comments and details of location as well as *hashtags* and *tags*, labels that respectively identify the content of an image so as to facilitate searching and the friends (*followers*) present in it, who are immediately notified in turn. Finally, the images can be shared instantaneously on the users' pages as well as other social networks like Facebook (the owner of Instagram since April 2012), Twitter, Tumblr, Flickr, and Foursquare.

The website (http://instagram.com) allows users to post their personal profiles and contains a blog with constant updates on the app as well as thematic galleries of users' photographs. Instagram is widely used by companies and brands for advertising purposes, and also by celebrities, who offer fans glimpses of their private lives. Finally, there are numerous collateral services that enable users to access personal statistics on "likes" and the number of followers, to add further filters and special effects to their photographs, to print stickers and posters, and so on.

Lambda

A photochemical technology of digital printing launched by Durst in 1995 as an evolved form of the classic chromogenic printing method developed by Kodak back in the 1950s and always the most commonly used for analogical colour prints. The process is very close to what happens in the darkroom.

Light-sensitive photographic paper (baryta or resin-coated) is exposed to a laser beam, which serves as an enlarger, divided for the three channels of the RGB system and controlled by computer inside a hermetically sealed exposure chamber. This does not result, however, in a printed image. The paper must be chemically bathed in the respective chromatic components for the colour to be fixed on the surface exposed. The support is then dried.

Lambda printing offers considerable advantages. As the colour is absorbed into the paper rather than present in a superficial layer, the results are far superior to those of inkjet printers in terms of depth and saturation. The lines due to the movements of the carriage in normal inkjet printers are also eliminated.

Photoshop

For over twenty years now, Photoshop has been the world's most advanced and widely-used software for the manipulation of digital images, extensively employed by professionals in the sector of visual communication as well as amateurs.

Developed in the late 1980s by the American brothers Thomas and John Knoll, the program appeared in its first version (1.0) in 1990, produced by Adobe Systems and available only on Macintosh. The current version is the CS6, where CS stands for the Creative Suite, a package of fundamental graphics editing tools produced by Adobe Systems.

The potential of the program, designed from the outset to reproduce techniques previously used in the darkroom digitally, is boundless. Basic image-processing tools are accompanied by corollary accessories like artistic filters, plug-ins, paintbrushes, patterns, sets of actions, and a lot more besides. A log of the actions performed and the structuring of the work in separate levels makes it easy to handle even the most complex files.

Pixel

Term derived from *picture element* and used in computer graphics for the elementary particle of a raster image or bitmap. Unlike vector graphics, defined by mathematical curves, this form of representation has a matrix structure whereby every coordinate (x,y) corresponds to a square or rectangular element, namely the pixel, containing information about brightness (in the case of monochromatic photographs) and colour.

The array of pixels, a grid of rows and columns, produces a homogeneous image whose individual components prove indistinguishable due to a system of interpolation that

intuitively approximates the data on colour, and ensures the fluidity of the passage from one point to another (*anti-aliasing*). The quantity of pixels in a photograph is indicated by the size of the CCD of every digital camera, where they are arranged on a single plane (e.g., a camera with a sensor of 2000 x 3000 pixels will produce 6-megapixel images).

Together with many other factors such as the optical characteristics of the camera, what determines the quality of a raster image is the *density* of its constituent points as measured in *ppi*, or pixels per inch. Correctly known as resolution, this assumes different values in relation to the support used, which can be a computer monitor or a file for printing on paper.

Scanner

Like the digital camera, characterised by an optical system and a sensor, the scanner is an instrument that makes it possible to capture a physical surface and then convert it into a raster image. (Documents can also be turned into text files by means of OCR/optical character recognition.) A scanner is usually equipped with its own conversion software as well as basic tools of image processing in some cases.

There are two main types. The flatbed scanner uses a CCD sensor of linear matrix (a rectangular or square grid on which the individual elements are arranged). A white tungsten light is shone on the object placed on the appropriate surface, and the information regarding every point of the image, in the quantity determined by the sensor's grid, is recorded and transformed by A/D converters. Good results depend on the quality of the peripheral components and the degree of detail attainable in terms of colour and resolution.

The drum scanner, which is earlier than the flatbed but generally offers higher performance, instead uses a system of three photomultiplier tubes (PMT), one for each channel of the RGB system (red, green, and blue). In this case, the light strikes very small portions of the object being scanned and a system of mirrors bounces and amplifies the electrons containing information on luminosity, which are then recorded by the associated photomultiplier tube and converted in turn. Images produced with this system prove superior in precision and reliability to the results of medium-range flatbed scanners.

Timeline

	Culture and arts	History and society	Photography
1981	• Jean Baudrillard publishes *Simulacra and Simulation* • Picasso's masterpiece *Guernica* returns to Spain • *The Blues Brothers*, directed by John Landis, appears in cinemas • Launch of the MTV network • Death of Bob Marley	• François Mitterrand wins the presidential elections in France • Ronald Reagan becomes president of the United States and then survives an assassination attempt in March • Attempt to assassinate Pope John Paul II • Israel annexes the Golan Heights • Fundamentalist extremists assassinate President Sadat of Egypt • First launch of the space shuttle	• Gabriele Basilico publishes *Milano ritratti di fabbriche* • Sony Corporation launches the Mavica, the first commercial digital camera
1982	• Isabel Allende publishes her novel *The House of the Spirits* • Publication of Achille Bonito Oliva's art-critical essay *Transavanguardia Italiana* identifying the movement subsequently known by that name • Documenta 7, Kassel, curator Rudi Fuchs • Ridley Scott's *Blade Runner* and Steven Spielberg's *E.T.* appear in cinemas • The chamber opera *The Photographer* composed by Philip Glass • Michael Jackson releases *Thriller*, his sixth album	• Falklands War between Argentina and Britain • Israel invades Lebanon. • Fall of the military government in Argentina • Helmut Kohl becomes chancellor of West Germany • The first artificial heart transplant is performed	• Publication of Stephen Shore's *Uncommon Places* • The Soviet satellite *Venera 13* sends the first colour image of the surface of Venus to Earth

	Culture and arts	History and society	Photography
1983	• Richard Serra creates the large installation *Clara-Clara* in the Place de la Concorde, Paris • Woody Allen's *Zelig*, Brian De Palma's *Scarface*, and David Cronenberg's *Videodrome* appear in cinemas	• Anti-Soviet guerrilla warfare in Afghanistan • Ronald Reagan announces the "Star Wars" Strategic Defense Initiative and the United States invades Grenada • Discovery of the AIDS virus • The compact disc is launched on the market	• Christer Strömholm publishes *Les Amies de Place Blanche* in Stockholm • Publication of Robert Mapplethorpe's *Lady, Lisa Lyon*
1984	• First edition of the Turner Prize, won by Malcolm Morley • Frederic Jameson publishes *Postmodernism, or, the Cultural Logic of Late Capitalism* • Milan Kundera publishes his novel *The Unbearable Lightness of Being*	• The Soviet Union boycotts the Los Angeles Olympic Games • Indira Gandhi is assassinated in India • Apple presents the first Macintosh computer • The countries in the Horn of Africa are hit by famine and the "civilized" world comes to their aid	• Jeff Wall's solo show "Transparencies" is held at the Institute of Contemporary Arts in London • Opening of the show "Viaggio in Italia" at the Pinacoteca Provinciale in Bari • "Britain in 1984" is held at the Photographer's Gallery in London • Joel Sternfeld publishes *American Prospects*
1985	• The New York Museum of Modern Art (MoMA) reopens after renovation and enlargement • The *Live Aid* mega concert held to combat famine in Ethiopia	• President Reagan begins his second term of office • Mikhail Gorbachev comes to power in USSR and initiates reform • The United States and the EEC impose economic sanctions against apartheid in South Africa • Reagan and Gorbachev meet for the first time to negotiate the limitation of nuclear arsenals • Members of the PLO hijack the *Achille Lauro* cruise ship	• The results of the Mission Photographique de la DATAR, involving 28 photographers from different countries, are exhibited at the Palais de Tokyo in Paris • Opening of the Musée de l'Elysée in Lausanne
1986	• Opening of the Musée d'Orsay in Paris	• Gorbachev announces perestroika • Catastrophic nuclear accident at the Chernobyl power plant in Ukraine • Outbreak of the Irangate scandal in the United States • US planes bomb Tripoli	• Nan Goldin publishes *The Ballad of Sexual Dependency* • Paul Graham publishes *Beyond Caring* • Martin Parr publishes *The Last Resort* • Sebastião Salgado publishes *Otras Americas*, his first book

	Culture and arts	History and society	Photography
1987	• Documenta 8, Kassel, curator Manfred Schneckenburger • Second edition of the Skulptur Projekte Münster • Death of Andy Warhol • U2 release *The Joshua Tree* • Bernardo Bertolucci's *The Last Emperor* and Stanley Kubrick's *Full Metal Jacket* appear in cinemas • *Who's That Girl*, Madonna's first world tour	• The USA and USSR sign a treaty to reduce their nuclear arsenals • Outbreat of the Palestinian Intifada uprising against Israeli occupation • World-wide stock market collapse and the start of a global financial crisis • Gorbachev launches glasnost to reform the party's internal structures	
1988	• Premature death of Jean-Michel Basquiat • Salman Rushdie's book *The Satanic Verses* accused of blasphemy by Muslims	• George H.W. Bush is elected president of the United States • A massive earthquake in Armenia kills around 30,000 people • Cessation of hostilities between Iran and Iraq • A Pan Am flight is destroyed by a bomb over Lockerbie, Scotland, and Britain holds Libya responsible	
1989	• Inauguration of the exhibition "Les Magiciens de la terre" in Paris • "China/Avant-Garde Exhibition" held at the National Gallery, Beijing • Opening of the Vitra Design Museum at Weil am Rhein, Germany • Launch of the Nintendo Game Boy • Oliver Stone's *Born on the Fourth of July* and Krzysztof Kieslowski's *The Decalogue* appear in cinemas	• Fall of the Berlin Wall on 9 November. East and West Germany commence reunification. All the communist governments of East Europe are toppled • Student protests concentrated in the Tiananmen square in Beijing are brutally crushed by the Chinese authorities • Military intervention by the United States in Panama to arrest General Noriega • Popular uprising in Romania and execution of Nicolae and Elena Ceaučescu	• Publication of *Photo-Kunst: Arbeiten aus 150 Jahren. Du XXeme au XIX siècle, aller et retour*, ed. J.F. Chevrier • Bill Gates founds the Corbis photography agency
1990	• Premature death of Keith Haring • Opening of the first Biennial of Contemporary African Art in Dakar	• Iraq invades Kuwait, thus triggering the Gulf War • East and West Germany sign a unification treaty • Gorbachev is awarded the Nobel Peace Prize	• The first version of Photoshop appears

	Culture and arts	History and society	Photography
1991	• Opening of the new Museum für Moderne Kunst designed by Hans Hollein in Frankfurt • Inauguration of the exhibition "Broken English" at the Serpentine Gallery, London, with work by members of the nascent Young British Art movement • First issue of the art magazine *Revue Noire* • Music for the film *Prospero's Books* composed by Michael Nyman • Zhang Yimou's *Raise the Red Lantern* appears in cinemas	• Start of Operation Desert Storm bringing the Gulf War to a close • Eritrea gains independence and civil war breaks out in Rwanda • Abolition of the racial laws in South Africa and the end of apartheid • Severe ethnic and political tension between Serbs and Croats lead to the outbreak of civil war in Yugoslavia • Latvia, Estonia, and Lithuania gain their independence • Gorbachev resigns, and the Community of Independent States comes into being • The problem of the melting of glaciers worsens • Discovery of Ötzi, a natural mummy, on the Similaun glacier between Austria and Italy	• "Aus der Distanz" at the Kunstmuseum in Düsseldorf featuring the work of the "Becher School" • Boris Mikhailov publishes *By the Ground*
1992	• Inauguration of the Museo Nacional Centro de Arte Reina Sofía and the Museo Thyssen-Bornemisza in Madrid • Creation of the huge steel sculpture *Puppy* by Jeff Koons to coincide with documenta 9 • Opening of the exhibition "Post Human", curator Jeffrey Deitch, at the FAE Musée d'Art Contemporaine, Pully/Lausanne • Rehabilitation of Galileo by the Catholic Church • *The Silence of the Lambs* wins the Oscar for best film	• Bill Clinton is elected president of the United States • Serbia is placed under investigation for violations of human rights • Launch of Operation Restore Hope for humanitarian operations in Somalia • Closure of the Soviet newspaper *Pravda*	• Andres Serrano produces the series entitled *The Morgue* • "Photography in Contemporary German Art:1960 to the Present" is held at the Walker Art Center, Minneapolis • Premature death of Luigi Ghirri
1993	• Inauguration of the Louvre Pyramid of glass and metal by I.M. Pei • Jonathan Demme's *Philadelphia* and Steven Spielberg's *Schindler's List* appear in cinemas	• Birth of the Czech Republic and of Slovakia • Braer oil spill in the Shetlands • The Treaty of Maastricht comes into effect marking the birth of the European Union • Letters of mutual recognition signed by Israel and the PLO (Palestine Liberation Organisation)	• Craigie Horsfield begins his *Barcelona Project* • Founding of the Winterthur Fotomuseum

	Culture and arts	History and society	Photography
1994	• Opening of the Andy Warhol Museum in Pittsburgh • Death of the Italian artist Alighiero Boetti • Suicide of Kurt Cobain, leader of the band Nirvana • Quentin Tarantino's *Pulp Fiction*, Oliver Stone's *Natural Born Killers*, and Robert Zemeckis's *Forrest Gump* appear in cinemas	• The IRA announces the cessation of military operations • Uprising in Chechnya and harsh repressive measures by Russia • The peace treaty signed by Rabin and King Hussein puts an official end to the conflict between Israel and Jordan • Genocide in Rwanda • Opening of the Channel Tunnel between Britain and France • Constantly growing use of the Internet all over the world	• The first of the "Rencontres de la photographie africaine" is held in Bamako, Mali • Hans-Peter Feldmann publishes *Voyeur*
1995	• Daniel Pennac publishes *Monsieur Malaussène* • Centenary edition of the Venice Biennale, entitled "Identity and Otherness", curator Jean Clair • First recorded use of the term "Net Art" • Opening of the exhibition "Beyond Belief: Fast Central European Contemporary Art" at the Chicago Museum of Contemporary Art • Damien Hirst wins the Turner Prize for work including *Mother and Child Divided* • Emir Kusturica's *Underground* appears in cinemas • Philip Glass completes his third symphony	• New massacres in Sarajevo • Peace agreement reached between Serbs, Croats, and Bosnians • New peace treaty signed in Jerusalem by the Israeli prime minister Shimon Peres and the Palestinian leader Yasser Arafat • France carries out nuclear weapon testing at Muroroa in Polynesia	• Corbis purchases the Bettmann archives of some 11 million photographs, including those of the United Press agency
1996	• First edition of Manifesta, a touring European biennial of international contemporary art, held in Rotterdam • Opening of the Ars Electronica Center (AEC), a multimedia centre for electronic and digital art, in Linz • *Trainspotting*, directed by Danny Boyle, appears in cinemas	• Terrorist attacks in Jerusalem and Tel Aviv • Embargo on British beef due to the spreading of mad cow disease • Kabul falls to the Taliban movement of Islamic fundamentalists • The sheep Dolly is the first mammal born by cloning a cell	• "In/Sight: African Photographers, 1940 to the Present" is held at the Guggenheim Museum in New York • The Maison Européenne de la Photographie opens in Paris • "Photography after Photography: Memory and Representation in the Digital Age" is held in Munich

	Culture and arts	History and society	Photography
1997	• Opening of the Guggenheim Museum Bilbao, designed by the architect Frank O. Gehry • Inauguration of the exhibition "Sensation" at the Royal Academy, London, with many works of Young British Art from the Charles Saatchi Collection • Don Delillo publishes his novel *Underworld* • Radiohead release *OK Computer*, their third album • James Cameron's *Titanic* appears in cinemas • Start of the literary phenomenon of fantasy novels like the Harry Potter series	• Riots in Albania • Death of the Chinese leader Deng Xiao-Ping • Resurgence of terrorism in Algeria • The Democratic Republic of the Congo is proclaimed in Zaire	• Geoffrey Batchen publishes *Burning with Desire: The Conception of Photography* • The Citibank Photography Prize is founded in London; it became the Deutsche Börse Prize in 2005 • The first edition of *Kurdistan* by Susan Meiselas appears
1998	• Touring exhibition of work by video artist Bill Viola in various museums all over the world • Peter Weir's *The Truman Show* and the Coen brothers' *The Big Lebowski* appear in cinemas	• New attempts to foster the Arab-Israeli peace process • Peace agreements between Catholics and Protestants in Northern Ireland • The European Parliament approves the introduction of the euro as its single currency • Severe financial crisis in Russia and various Asian countries • John Paul II visits Cuba • Creation of a United Nations tribunal for crimes against humanity • The birth of Google	• Birth of the Photo España festival in Madrid
1999	• No fewer than twenty Chinese artists featured at the Venice Biennale • Opening of "After the Wall", an exhibition of work from countries of the former Soviet bloc, at the Moderna Museet, Stockholm • The restoration of Leonardo da Vinci's *Last Supper* is completed • *Eyes Wide Shut*, Stanley Kubrick's last film, appears in cinemas • Maurizio Cattelan's sculpture *La Nona Ora* (*The Ninth Hour*) shows Pope John Paul II struck down by a meteorite	• Clashes in Kossovo and intervention by NATO aircraft • Milosevic indicted by the Hague Tribunal for war crimes • Protests in Seattle against the WTO summit • Growing concern about the so-called Millennium Bug	• Walid Raad founds the Atlas Group • Boris Mikhailov publishes *Case History* • Paris Photo, the first art fair devoted exclusively to the photography, opens in Paris • Corbis buys the Sygma photography agency

	Culture and arts	History and society	Photography
2000	• Opening of Tate Modern, designed by the architects Jacques Herzog and Pierre De Meuron, in a disused power station in London • The CD format loses ground to MP3	• The former German chancellor Helmut Kohl is involved in a scandal over slush funds • Vladimir Putin is elected president of Russia • Vojislav Koštunica is elected president of the Federal Republic of Yugoslavia • George W. Bush is elected president of the United States • The war in Chechnya continues	• Wolfgang Tillmans is the first photographer to win the Turner Prize.
2001	• 49th Venice Biennale, entitled "Plateau of Humankind" • Birth of Wikipedia	• September 11: attack on the Twin Towers of the World Trade Center in New York and the Pentagon in Washington, D.C. The Afghan Taliban and the Al Qaeda terrorist organisation are held responsible. Bush declares war on Afghanistan and launches Operation Enduring Freedom • Israeli military offensive in the Palestinian territories	
2002	• Opening of the MART museum of modern and contemporary art in Rovereto, designed by Mario Botta • Documenta 11, Kassel, artistic director Okwui Enwezor • Reopening of the library of Alexandria, Egypt	• Israeli forces besiege the Church of the Nativity in Bethlehem • Armed clashes between North Korea and South Korea • Jacques Chirac is elected president of the French Republic for the second time • The Kyoto Protocol is signed at the UN meeting on sustainable development • Luiz Inácio Lula da Silva is elected president of Brazil • The euro is introduced in twelve member countries of the European Union	• Publication of *Here is New York: A Democracy of Photographs*

	Culture and arts	History and society	Photography
2003	• Reopening of the La Fenice theatre in Venice after closure and restoration due to a fire • The Turbine Hall of the Tate Modern, London, hosts *The Weather Project*, an installation by Olafur Eliasson using monofrequency lights	• World-wide epidemic of severe acute respiratory syndrome (SARS) • US military attack on the regime of Saddam Hussein in Iraq • Demonstrations in many European and American cities against the war in Iraq • A severe earthquake in Iran kills over 40,000 • Saddam Hussein is captured	• Helmut Newton donates his archives to Berlin, the city of his birth • Clément Chéroux publishes *Fautographie. Petite histoire de l'erreur photographique* • Susan Sontag publishes *Regarding the Pain of Others*
2004	• Reopening of the MoMA in New York after two years of refurbishment and enlargement by Yoshio Taniguchi • *Art Since 1900. Modernism, Antimodernism, Postmodernism* gives rise to controversy with its approach to the history of twentieth-century art • The British Library makes 93 copies of 21 works by Shakespeare drawn from texts of the period available online	• Terrorist attacks cause a massacre in Madrid; a group linked to Al Qaeda claims responsibility • Vladimir Putin is re-elected president of Russia • George W. Bush is re-elected president of the United States • Death of Yasser Arafat in Paris • Birth of Facebook • The Spirit space probe transmits images of Mars to Earth • Rebuilding of the old Mostar bridge is completed in Bosnia and Herzegovina	• Deaths of Helmut Newton, Henri Cartier-Bresson, and Richard Avedon • "Between Past and Future ICP: New Photography and Video from China" is held in New York • Alec Soth publishes *Sleeping by the Mississippi* • Birth of the Flickr photo-sharing site
2005	• Opening of the Memorial to the Murdered Jews of Europe in Berlin • The Palazzo Grassi in Venice is bought by François Pinault to host his collection of contemporary art after refurbishing by Tadao Ando	• Approval of the European Constitution • The Kyoto Protocol to limit emissions of "greenhouse gases" comes into effect • Death of Pope John Paul II and election of Pope Benedict XVI • Islamic terroristic attacks in Cairo, Sharm el-Sheikh, and London • Angela Merkel becomes chancellor of Germany	• The Durst company presents the Lambda digital print

	Culture and arts	History and society	Photography
2006	• Inauguration of Anish Kapoor's outdoor public reflecting sculpture *Cloud Gate* in Chicago • Orhan Pamuk wins the Nobel Prize for literature	• Iran resumes nuclear research • Saddam Hussein is executed in Iraq • Hugo Chávez is re-elected president of Venezuela • Protests and rioting in the Muslim world over the publication of satirical cartoons of Mohammed in a Danish newspaper • Murder of the Russian journalist Anna Politkovskaya, known for her outspoken criticism of the Kremlin	• "Snap Judgements: New Positions in Contemporary African Photography" is held at the ICP in New York
2007	• Documenta 12, Kassel • Inauguration of the new wing of the Prado in Madrid • Death of the art dealer Ileana Sonnabend • Official abolition of limbo by the Vatican • Death of Jean Baudrillard	• Bulgaria and Romania join the European Union • Private property is formally recognised in China • Gordon Brown takes over from Tony Blair as British prime minister	• Malick Sidibé wins the Golden Lion at the Venice Biennale • Andreas Gursky's photograph *99 Cents* is auctioned for the record price of $3.3 million • Taryn Simon publishes *An American Index of the Hidden and Unfamiliar*
2008	• Danny Boyle's *Slumdog Millionaire* appears in cinemas • The first experiments with the Large Hadron Collider (LHC) at the CERN in Geneva, soon interrupted due to an accident • Discovery of water on Mars	• Fidel Castro resigns after fifty years as president of Cuba; his brother Raúl takes over • Kosovo declares independence • Barack Obama is elected 44th president of the United States • Bankruptcy of Lehman Brothers, one of major banks operating on the market for US Treasury securities	• Polaroid announces the closure of its plants in the United States and Mexico • Publication of *Why Photography Matters as Art as Never Before* by M. Fried
2009	• James Cameron's *Avatar* appears in cinemas • Premature death of Michael Jackson	• Outbreak of the Gaza War • US troops leave cities in Iraq under the control of the local authorities • North Korea carries out testing of nuclear weapons • Barack Obama announces reform of the American health system	• Fred Ritchin publishes *After Photography* • Kodak ceases production of Kodachrome film

	Culture and arts	History and society	Photography
2010	• Opening of the MAXXI museum in Rome	• The US president and Russian prime minister Dmitry Medvedev sign the new START treaty to reduce their nuclear arsenals • The dialogue between Benjamin Netanyahu and Abu Mazen resumes in the presence of Barack Obama • Greece is on the verge of bankruptcy • The dust cloud from a volcanic eruption in Iceland prevents air traffic for days • Haiti is devastated by an earthquake	• Birth of Instagram
2011		• Popular uprisings begin in North Africa and the Middle East, first in Tunisia and then Libya, Egypt, and Algeria • China becomes the world's second greatest economic power • Violent earthquake in Japan and nuclear catastrophe at the Fukushima plant • Civil war breaks out in Syria • Crash of the European stock markets	
Since 2012	• Existence of the Higgs boson discovered by scientists at the CERN, Geneva • After 244 years of publication, the Encyclopaedia Britannica becomes available only online	• Vladimir Putin is re-elected in Russia • Barack Obama is re-elected president of the United States • Palestine becomes an observer non-member state of the United Nations • Pope Benedict XVI resigns; his successor Jorge Mario Bergoglio takes the name of Francis I • Violent protests erupt in Turkey • Coup d'état in Egypt; President Mohamed Morsi is arrested by the Egyptian army; clashes take place in many cities across the country	• Peter Galassi resigns as director of the MoMA Department of Photography, and his place is taken by Quentin Bajac • Urs Stahel, one of the founders of the Fotomuseum Winterthur, resigns his post of director

Bibliography

Encyclopaedias and Dictionaries

• Auer, M. *Photographers Encyclopedia International*. Neuchâtel: Ides et Calendes, 1997.
• D'Autilia, G., and R. Lenman. *Dizionario della fotografia*. Turin: Einaudi, 2008.
• *Dictionnaire mondial de la photographie, des origines à nos jours*. Paris: Larousse, 1994 (Italian ed. *Dizionario di fotografia*. Rome: Rizzoli/Contrasto, 2001).
• Eskin, A.H., and G. Drake (eds.). *Index to American Photographic Collection*. New York: G.K. Hall, 1996.
• Govignon, B. (ed.). *The Abrams Encyclopedia of Photography*. New York: Harry N. Abrams Inc., 2004.
• Hannavy, J. *Encyclopedia of Nineteenth-Century Photography*. New York: Routledge, 2007.
• Koetrle, H.M. (ed.). *Photographers A–Z*. Cologne: Taschen, 2011.
• Lambrechts, E., and L. Salu. *Photography and Literature: An International Bibliography of Monographs*. London: Mansell, 1992.
• Lenman, R. (ed.). *The Oxford Companion to the Photograph*. New York: Oxford University Press, 2005.
• Marien, M.W. *100 Ideas that Changed Photography*. London: Laurence King Publishers, 2012.
• McDarrah, G.S., and F.W. McDarrah. *The Photography Encyclopedia*. New York: Schirmer Books, 1999.
• Nadeau, L. *Encyclopedia of Printing. Photographic and Photomechanical Processes*. Fredericton: Luis Nadeau, 1989.
• *Nihon no shashinka / Biographic Dictionary of Japanese Photography*. Tokyo: Nichigai Associates, 2005.
• Pandey, A. *Dictionary of Photography*. Delhi: Isha Books, Isha Foundation, 2005.
• Peres, M.R. *The Focal Encyclopedia of Photography*. New York: Focal Press, 1997.
• Roosens, L., and L. Salu. *History of Photography: A Bibliography of Books*. London and New York: Mansell, 1989–96.
• VV.AA. *MacMillan Biographical Encyclopedia of Photographic Artists and Innovators*. New York: MacMillan Publishers, 1983.
• ———. *International Center of Photography. Encyclopedia of Photography*. New York: Crown Publishers Inc., 1984.
• Warren, L. (ed) *Encyclopedia of Twentieth-Century Photography*. London and New York: Routledge, 2006.

Histories, Issues, and Movements

• Alberro, A., and B. Stimson. *Conceptual Art: A Critical Anthology*. Cambridge: Blake Stimson, 1999.
• ———. *Institutional Critique: An Anthology of Artists' Writings*. Cambridge, MA: MIT Press, 2011.
• Badger, G. *The Genius of Photography*. London: Quadrille Publishing Ltd, 2011.
• Badger, G., and M. Parr. *The Photobook: A History*. London: Phaidon, 2004 (1st vol.); 2006 (2nd vol.).
• Bajac, Q., and A. de Gouvion Saint-Cyr. *Dans le champ des étoiles. Les photographes et le ciel 1850–2000*. Paris: Réunion des Musées Nationaux, 2000.
• Baqué, D. *Photographie plasticienne. L'extrême contemporain*. Paris: Regard, 2004.
• ———. *Pour un nouvel art politique. De l'art contemporain au documentaire*. Paris: Flammarion, 2004.
• Bauret, G. *Color Photography*. New York: Assouline, 2001.
• Benson, R. *The Printed Picture*. New York: The Museum of Modern Art, 2008.
• Bright, S. *Art Photography Now*. New York: Aperture, 2005.
• Bright, S. (ed.). *Autofocus – The Self-Portrait in Contemporary Photography*. London and New York: Thames and Hudson, 2010 (Italian ed. *Autofocus – L'autoritratto nella fotografia contemporanea*. Rome: Contrasto, 2010).
• Brittain, D. (ed.). *Creative Camera: Thirty Years of Writing*. Manchester: Manchester University Press, 2000.
• Brothers, C. *War and Photography: A Cultural History*. London: Routledge, 1997.
• Campany, D. *Art and Photography*. London: Phaidon, 2003.
• Bush, K., and M. Sladen (eds.). *In the Face of History*. London: Black Dog Publishing, 2006.
• Chéroux, C., and U. Eskildsen (eds.). *La Photographie timbrée: l'inventivité visuelle de la carte timbrée photographique*. Paris: Steidl/Jeu de Paume, 2008.
• Chevrier, J.F. *Photo-Kunst – Arbeiten aus 150 Jahren du XVieme au XIXeme Siècle, Aller et Retour*. Ostfildern: Hatje Cantz, 1989.
• Chevrier, J.F., and J. Lingwood (eds.). *Un'altra obiettività / Another Objectivity*. Milan: Idea Books, 1989.
• Choinière, F., and M. Thériault. *Point & Shoot: Performance and Photography*. Montréal: Dazibao, 2005.
• Clark, G. *The Photograph: A Visual and Cultural History*. New York: Oxford University Press, 1997 (Italian ed. *La fotografia. Una storia culturale e visuale*. Turin: Einaudi, 2009).
• Costello, D., and M. Iversen. *Photography After Conceptual Art*. Oxford: Wiley-Blackwell, 2010.
• Cotton, C. *Imperfect Beauty. The Making of Contemporary Fashion Photographs*. London: Victoria and Albert Museum, 2001.
• ———. *The Photograph as Contemporary Art*. London and New York: Thames and Hudson, 2004 (Italian ed. *La fotografia come arte contemporanea*. Turin: Einaudi, 2010).
• De Chassey, É. *Platitudes: une histoire de la photographie plate*. Paris: Gallimard, 2006.
• Demos, T.J., et alii. *Vitamin Ph: New Perspectives in Photography*. London: Phaidon, 2006.
• Dexter, E., and T. Weski (eds.). *Cruel and Tender – The Real in the Twentieth-Century*

Photograph. London: Tate Publishing, 2003.
• Doy, G. *Picturing the Self: Changing Views of the Subject in Visual Culture.* London: I.B. Tauris & Co. Ltd., 2005.
• Edwards, K.A. *Acting Out: Invented Melodrama in Contemporary Photography.* Iowa City: University of Iowa Museum of Art, 2005.
• Enwezor, O. (ed.). *Archive Fever: Uses of the Document in Contemporary Art.* New York: ICP/Steidl, 2006.
• Ewing, W.A. *The Body – Photographs of the Human Form.* London and New York: Thames and Hudson, 1994.
• Ewing, W.A., and N. Herschdorfer. *Face: The New Photographic Portrait.* London and New York: Thames and Hudson, 2008 (Italian ed. *Faccia a faccia. Il nuovo ritratto fotografico.* Rome: Contrasto, 2011).
• ———. *reGeneration. 50 Photographers of Tomorrow.* New York: Aperture, 2006 (1st vol.); 2010 (2nd vol.).
• Fischer, H. (ed.). *Covering the Real – Art and the Press Picture from Warhol to Tillmans.* Basel: Kunstmuseum, 2005.
• Freidus M., J.Lingwood, and R. Slemmons. *Typologies: Nine Contemporary Photographers.* New York: Rizzoli, 1991.
• Frizot, M. (ed.). *A New History of Photography.* Cologne: Könemann, 1994.
• Gagliardi, M.L. *La misura dello spazio.* Rome: Contrasto, 2010.
• Gierstberg, F., M. Verhoeven, M. van den Heuvel, and H. Scholten (eds.). *Documentary*

Now! Contemporary Strategies in Photography, Film and the Visual Arts. Rotterdam: NAi Publishers, 2005.
• Gilardi, A. *Storia sociale della fotografia.* Milan: Feltrinelli, 1976.
• Gilson, M. *The Last Picture Show: Artists Using Photography, 1960–1982.* Minneapolis: Walker Art Center, 2003.
• Grosenick, U., and T. Seelig. *Photo Art: The New World of Photography.* New York: Aperture, 2008.
• Guadagnini, W. *Una storia della fotografia del XX e del XXI secolo.* Bologna: Zanichelli, 2010.
• Gunthert, A., and A. Poivert. *L'art de la photographie.* Paris: Citadelles & Mazenod, 2007 (Italian ed. *Storia della fotografia.* Milan: Mondadori/Electa, 2008).
• Haworth-Booth, M. *Photography: An Independent Art. Photographs from the Victoria and Albert Museum 1839–1996.* Princeton: Princeton University Press, 1997.
• Heiferman, M., L. Phillips, and J.G. Hanhardt (eds.). *Image World: Art and Media Culture.* New York: Whitney Museum of American Art, 1989.
• Heiferman, M. *Photography Changes Everything.* New York: Aperture / Smithsonian Institute, 2012 (Italian ed. *La fotografia cambia tutto.* Rome: Contrasto, 2013).
• Hoy, A.H. *Fabrications. Staged, Altered and Appropriated Photographs.* New York: Abbeville Press Publishers, 1987.

• Jeffrey, I. *Revisions: An Alternative History of Photography.* Bradford: National Museum of Photography, Film and Television, 1999.
• Kismaric, S., and E. Respini. *Fashioning Fiction in Photography Since 1990.* New York: The Museum of Modern Art, 2004.
• Köhler, M. *Das Konstruierte Bild.* Schaffhausen: Edition Stemmle, 1989.
• Kozloff, M. *Lone Visions – Crowded Frames.* Albuquerque: University of New Mexico Press, 1994.
• ———. *The Theatre of the Face. Portrait Photography Since 1900.* London: Phaidon, 2007.
• Krauss, R. *Le photographique. Pour une Theorie des Écarts.* Paris: Macula, 1990 (Italian ed. *Teoria e storia della fotografia.* Milan: Mondadori, 1996).
• Kwon, M. *One Place after Another. Site Specific Art and Location Identity.* Cambridge, MA: MIT Press, 2002.
• Lemagny, J.C., and A. Rouillé. *A History of Photography.* Cambridge: Cambridge University Press, 1987 (Italian ed. *Storia della fotografia.* Florence: Sansoni, 1988).
• Lipkin, J. *Photography Reborn: Image Making in the Digital Era.* New York: H.N. Abrams, 2005.
• Mah, S. (ed.). *Lugares comprometidos. Topografia y actualidad.* Madrid: La Fábrica, 2008.
• Marien, M.W. *Photography: A Cultural History.* London: Laurence King Publishing, 2002.

• Millet, B., and J. Fontcuberta. *Réels. Fictions. Virtuel.* Arles: Actes Sud, 1996.
• Mitchell, W.J.T. *What do Pictures Want? The Lives and Loves of Images.* Chicago and London: University of Chicago Press, 2005.
• Muzzarelli, F. *Formato tessera. Storia, arte e idee in photomatic.* Milan: Mondadori, 2003.
• Nickel, D. *Snapshots: The Photography of Everyday Life, 1988 to the present.* San Francisco: San Francisco Museum of Art, 1998.
• Paul, C. *Digital Art.* London: Thames and Hudson, 2003.
• Phillips, S., et alii. *Exposed: Voyeurism, Surveillance and the Camera.* London: Tate Publishing, 2010.
• Poivert, M. *La photographie contemporaine.* Paris: Flammarion, 2002/2010 (Italian ed. *La fotografia contemporanea.* Turin: Einaudi, 2011).
• Pontbriand, C. *Mutations. Perspectives on Photography.* Göttingen-Paris: Steidl & Partners, 2011.
• Putnam, J. *Art & Artifact: The Museum as Medium.* London: Thames and Hudson, 2009.
• Ribalta, J., and A. Jiménez Jorquera (eds.). *Universal Archive: the Condition of the Document and the Modern Photographic Utopia.* Barcelona: Museu d'Art Contemporani de Barcelona, 2008.
• Romano, G. *Artscape. Panorama dell'arte in rete.* Ancona and Milan: Costa/Nolan, 2000.

• Rosenblum, N. *A History of Women Photographers*. New York: Abbeville Press, 1994.
• ————. *A World History of Photography*. New York: Abbeville Press, 1989.
• Rouillé, A. *La Photographie. Entre document et art contemporain*. Paris: Gallimard, 2005.
• Schaffner, I., M. Winzen, and G. Batchen (eds.). *Deep Storage: Collecting, Storing and Archiving in Art*. Munich: Prestel, 1998.
• Schmidt, M. *Fotografien in Museen, Archiven und Sammlungen. Konservieren, Archivieren. Präsentieren*. Munich: Weltkunst Verlag, 1994.
• Schube, I., and T. Weski. *Photography Calling!*. Göttingen: Steidl, 2012.
• Seelig, T., and U. Stahel (eds.). *The Ecstasy of Things – From the Functional Object to the Fetish In 20th Century Photographs*. Göttingen: Steidl, 2004.
• Stahel, U. (ed.). *Darkside I – Photographic Desire and Sexuality Photographed*. Göttingen: Steidl, 2008.
• ————. *Darkside II – Photographic Power and Photographed Violence, Disease and Death*. Göttingen: Steidl, 2009.
• Steacy, W. (ed.). *Photographs Not Taken*. Hillsborough, NC: Daylight Books, 2012.
• Szarkowski, J., and R.E. Oldenburg. *Photography Until Now*. Cleveland: Little Brown & Co., 1992.
• Thomas, A. *Beauty of Another Order – Photography in Science*. New Haven: Yale University Press, 1997.
• Thompson, M. *The Anxiety of Photography*. Aspen: Aspen Art Press, 2011.
• VV.AA. *Blink. 100 Photographers, 10 Curators, 10 Writers*. London: Phaidon, 2002.
• ————. *Editat, exposat – La Fotografia, del Llibre al Museu*. Barcelona: Museu Nacional d'Art de Catalunya, 2005.
• ————. *Landschaft ohne Horizon / Landscape without Horizon*. Nuremberg: Museum Schloss Moyland, Verlag für Moderne Kunst, 2010.
• ————. *L'Événement, les images comme acteurs de l'histoire*. Paris: Hazan, 2007.
• ————. *Picturing Eden*. Göttingen-London: Steidl / George Eastman House, 2008.
• ————. *Public Information. Desire, Disaster, Document*. San Francisco: San Francisco Museum of Modern Art, 1994.
• ————. *Strangers: The First ICP Triennial of Photography and Video*. New York: ICP/Steidl, 2008.
• Valtorta, R. (ed.). *Fotografia e committenza pubblica. Esperienze storiche e contemporanee*. Milan: Museo di Fotografia Contemporanea/Lupetti, 2010.
• Van Gelder, H., and H.W. Westgeest. *Photography Theory in Historical Perspective*. Oxford: Wiley-Blackwell, 2011.
• Walther, T. *Other Pictures. Anonymous Photographs from the Walther Collection*. New York: Metropolitan Museum of Art, 2000.
• Weiermair, P. *Prospect. Photography in Contemporary Art*. Zurich: Editions Stemmle, 1996.
• Welchman, J.C. *Art After Appropriation. Essays on Art in the 1990s*. New York: Routledge, 2013.
• Weski, T., and J.F. Chevrier. *Click Doubleclick*. Cologne: Walther König, 2006.
• Weski, T., and H. Liesbrock. *How You Look at It. Fotografien des 20. Jahrhunderts*. Cologne: Oktagon, 2000.
• Willis, D. *Reflections in Black: A History of Black Photographers 1840 to the Present*. New York: W.W. Norton & Co., 2000.
• Zannier, I. *Storia e tecnica della fotografia*. Milan: Hoepli, 2009.
• Zanot, F. *Il momento anticipato*. Florence: Edizioni della Meridiana, 2005.

National and Regional Studies
• Benton-Harris, J., and G. Badger. *Through the Looking Glass: Photographic Art in Britain, 1945–1989*. London: Barbican, 1989.
• Bright, S., and V. Williams (eds.). *How we are. Photographing Britain*. London: Tate Publishing, 2007.
• Choroschilow, P. (ed.). *Berlin/Moskva / Moskau Berlin 1950–2000*. Berlin: Nicolai, 2003.
• Cooke, L., and D. Crimp (eds.). *Mixed Use, Manhattan: Photography and Related Practices, 1970s to the Present*. Cambridge, MA: MIT Press, 2010.
• Eklund, D. *The Pictures Generation, 1974-1984*.

New Haven: Yale University Press, 2009.
• Elliott, D., and B. Pejic (eds.). *After the Wall: Art and Culture in Post-Communist Europe*. Stockholm: Moderna Museet, 1999.
• Enwezor, O. *Snap Judgements: New Positions in Contemporary African Photography*. New York: ICP/Steidl, 2006.
• Enwezor, O., and O. Oguibe. *In/Sight. African Photographers, 1940 to the Present*. New York: Guggenheim Museum, 1996.
• Fernandez, H. *The Latin American Photobook*. New York: Aperture, 2011.
• Finney, G. *Visual Culture in Twentieth-Century Germany: Text as Spectacle*. Bloomington: Indiana University Press, 2006.
• Fraser, K.M. *Photography and Japan*. London: Reaktion Books, 2011.
• Gadihoke, S., G. Kapur, and C. Pinney. *Where Three Dreams Cross. 150 Years of Photography from India, Pakistan and Bangladesh*. Göttingen: Steidl, 2010.
• Garb, T. (ed.). *Figures & Fictions: Contemporary South African Photography*. Göttingen and London: Steidl / Victoria and Albert Museum, 2013.
• Garrels, G. *Photography in Contemporary German Art: 1960 to the Present*. Minneapolis: Walker Art Center, 1992.
• Gierstberg, F., and R. Suermondt. *The Dutch Photobook: A Thematic Selection from 1945 Onwards*. New York: Aperture, 2012.

• Gronert, S. *Die Düsseldorfer Photoschule*. Munich: Schirmer/Mosel, 2009 (Italian ed. *La Scuola di Düsseldorf*. Monza: Johan & Levi, 2009).
• Guerrieri, W., et alii (eds.). *Luoghi come paesaggi. Fotografia e committenza pubblica in Europa negli anni Novanta*. Rubiera: Linea di Confine per la Fotografia Contemporanea, 2000.
• Gupta, S., and R. Singh. *Click! Contemporary Photography in India*. New Delhi: Vadehra Art Gallery, 2010.
• Hall, S., and M. Sealy. *Different: A Historical Context*. London: Phaidon, 2001.
• Haworth-Booth, M. (ed.). *British Photography: Towards a Bigger Picture*. New York: Aperture, 1989.
• Holborn, M. *Black Sun: The Eyes of Four. Roots and Innovation in Japanese Photography*. New York: Aperture, 1986.
• Hung, W., and C. Phillips. *Between Past and Future: New Photography and Video from China*. New York: ICP/Steidl, 2004.
• Kismaric, S. *British Photography from the Thatcher Years*. New York: Museum of Modern Art, 1990.
• Maggia, F. (ed.). *Asian Dub Photography. Fotografia contemporanea dall'Estremo Oriente*. Milan: Skira, 2009.
• ———. *Breaking News. Fotografia contemporanea da Medio Oriente e Africa*. Milan: Skira, 2011.
• ———. *Storia, memoria e identità. Fotografia contemporanea dall'Est Europa*. Milan: Skira, 2009.
• Meccarelli, M., and A. Flamminii. *Storia della fotografia in Cina*. Aprilia: Nova Logos, 2011.
• Melo Carvalho, M.L. (ed.). *Contemporary Brazilian Photography*. New York and London: Verso Books, 1996.
• Neumaier, D. (ed.). *Beyond Memory: Soviet Nonconformist Photography and Photo-related Works of Art*. New Brunswick, NJ: Jane Vorhees Zimmerli Art Museum/Rutgers University Press, 2004.
• Pellizzari, M.A. *Percorsi della fotografia in Italia*. Rome: Contrasto, 2011.
• Pohlmann, U., and R. Scheutle. *Industriezeit 1845–2010*. Tübingen: Wasmuth Verlag, 2011.
• Pinney, C., and N. Peterson. *Photography's Other Histories*. Durham: Duke University Press Books, 2003.
• Sarje, K. (ed.). *Erosion: Soviet Conceptual Art and Photography of the 1980s: the Pekka Halonen Collection*. Helsinki: Amos Anderson, 1990.
• Stafford, A. *Photo-texts: Contemporary French Writing of the Photographic Image*. Liverpool: Liverpool University Press, 2010.
• Tucker, A.W. *The History of Japanese Photography*. New Haven: Yale Unversity Press, 2003.
• Tupitsyn, V. *The Museological Unconscious: Communal (Post)Modernism in Russia*. Cambridge, MA: MIT Press, 2012.
• VV.AA. *La fotografia in Italia. A che punto siamo?*. Rome: Contrasto, 2011.
• ———. *Swiss Photobooks from 1927 to the Present: A Different History of Photography*. Zurich: Lars Muller, 2011.
• ———. *The History of Japanese Photography*. New Haven: Yale University Press, 2003.
• Valtorta, R. *Racconti dal paesaggio. 1984–2004 A vent'anni da Viaggio in Italia*. Milan: Museo di Fotografia Contemporanea/Lupetti, 2007.
• Vanhaecke, F. *A Useful Dream: African Photography 1960_2010*. Cinisello Balsamo (Milan): Silvana Editoriale, 2010.
• Walker, J., and C. Ursitti (eds.). *Photo Manifesto: Contemporary Photography in the USSR*. New York: Stewart Tabori & Chang, 1991.
• Weiss, M. *Light from the Middle East: New Photography*. Göttingen and London: Steidl / Victoria and Albert Museum, 2013.
• Wolf, S. *Visions from America: Photographs from the Whitney Museum of American Art 1940–2001*. New York: Whitney Museum of American Art/Prestel, 2002.
• Yapelli, T. *Zooming into Focus: Contemporary Chinese Photography and Video from the Haudenschild Collection*. Shangai: Shangart, 2005.

Theory and Criticism of Photography
• Adams, R. *Along Some Rivers*. New York: Aperture, 2006 (Italian ed. *Lungo i fiumi. Fotografie e conversazioni*. Castel Bolognese: Itacalibri/Ultreya, 2008).
• ———. *Beauty in Photography: Essays in Defense of Traditional Values*. New York: Aperture, 1981 (Italian ed. *La bellezza in fotografia. Saggi in difesa dei valori tradizionali*. Turin: Bollati Boringhieri, 1995).
• ———. *Why People Photograph. Selected Essays and Reviews*. New York: Aperture, 1994.
• Arnheim, R. *Art and Visual Perception. A Psychology of the Creative Eye*. Berkeley and Los Angeles: University of California Press, 1954 (Italian ed. *Arte e percezione visiva*. Milan: Feltrinelli, 1962).
• Badger, G. *The Pleasures of Good Photographs*. New York: Aperture, 2010.
• Baetens, J., and H. van Gelder. *Critical Realism in Contemporary Art*. Leuven: Leuven University Press, 2007.
• Bajac, Q. *Après la photographie?*. Paris: Découvertes Gallimard, 2010 (Italian ed. *Dopo la fotografia*. Rome: Contrasto, 2011).
• Baltz, L. *Texts*. Göttingen: Steidl, 2012.
• Barret, T. *Criticizing Photographs: An Introduction to Understanding Images*. New York: McGraw-Hill, 1990.
• Barthes, R. *La chambre claire*. Paris: Gallimard, 1980 (Italian ed. *La camera chiara*. Turin: Einaudi, 1980).
• ———. *Mythologies*. Paris: Editions du Seuil, 1957 (Italian ed. *Mitologie*. Parma: Pratiche, 1986).

• Batchen, G. *Burning with Desire: The Conception of Photography*. Cambridge, MA: MIT Press, 1999.
• ————. *Each Wild Idea: Writing, Photography, History*. Cambridge, MA: MIT Press, 2002.
• Belting, H. *Bild-Anthropologie. Entwürfe für eine Bildwissenschaft*. Munich: Fink, 2001 (Italian ed. *Antropologia delle immagini*. Rome: Carocci, 2011).
• Benjamin, W. "Das Kunstwerk im Zeitalter seiner technischen Reproduzierbarkeit", in *Zeitschrift für Sozialforschung*. Paris: Félix Alcan, 1936 (Italian ed. *L'opera d'arte nell'epoca della sua riproducibilità tecnica*. Turin: Einaudi, 1966).
• Berger, J. *About Looking*. London: Writers and Readers Cooperative, 1980 (Italian ed. *Sul guardare*. Milan: Bruno Mondadori, 2003).
• Bolton, R. (ed.). *The Contest of Meaning: Critical Histories of Photography*. Cambridge, MA: MIT Press, 1989.
• Bull, S. *Photography*. London-New York: Routledge, 2009.
• Burgin, V. *Components of a Practice*. Milan: Skira, 2008.
• ————. *The End of Art Theory: Criticism and Postmodernity*. Basingstoke: Palgrave Macmillan, 1986.
• Ceserani, R. *L'occhio della Medusa. Fotografia e letteratura*. Turin: Bollati Boringhieri, 2011.
• Chéroux, C. *Fautographie. Petite histoire de l'erreur photographique*. Crisnée: Yellow Now, 2003 (Italian ed.

L'errore fotografico. Turin: Einaudi, 2009).
• Coleman, A.D. *Depth of Field: Essays on Photography, Mass Media, and Lens Culture*. Albuquerque: University of New Mexico Press, 1998.
• Didi-Hubermann, G. *Images malgré tout*. Paris: Minuit, 2004 (Italian ed. *Immagini malgrado tutto*. Milan: Raffaello Cortina, 2005).
• Dubois, P. *L'acte photographique*. Bruxelles: Labor, 1983 (Italian ed. *L'atto fotografico*. Urbino: Quattro Venti, 1996).
• Edwards, E. *Photographs Objects Histories: On the Materiality of Images*. New York: Routledge, 2004.
• ————. *Raw Histories. Photographs, Anthropology and Museums*. Oxford and New York: Berg, 2001.
• Elkins, J. (ed.). *Photography Theory*. New York and London: New Ed, 2007.
• ————. *The Object Stares Back: On the Nature of Seeing*. Boston: Mariner Books, 1997.
• Featherstone, D. *Observations: Essays on Documentary Photography*. Carmel: Friends of Photography, 1984.
• Flusser, V. *Für eine Philosophe der Photographie*. Göttingen: European Photography, 1983 (Italian ed. *Per una filosofia della fotografia*. Milan: Bruno Mondadori, 2006).
• Fontcuberta, J. *La cámara de Pandora. La fotografi@ después de la fotografia*. Barcelona: Gustavo Gili, 2010 (Italian ed. *La (foto)camera di Pandora.*

La fotografia dopo la fotografia. Rome: Contrasto DUE, 2012).
• ————. *Le baiser de Judas. Photographie et verité*. Arles: Actes Sud, 1996 (Italian ed. *Il bacio di Giuda. Fotografia e verità*. Rome: EdUP, 2010).
• Fried, M. *Art and Objecthood: Essays and Reviews*. Chicago and London: University of Chicago Press, 1998.
• ————. *Why Photography Matters as Art as Never Before*. New Haven: Yale University Press, 2008.
• Gervais, T., and G. Morel. *La photographie*. Paris: Larousse, 2008.
• Ghirri, L. *Lezioni di fotografia*. Macerata: Quodlibet, 2010.
• Giusti, S. *La caverna chiara. Fotografia e campo immaginario ai tempi della tecnologia digitale*. Milan: Museo di Fotografia Contemporanea/Lupetti, 2005.
• Goldberg, V. *Light Matters: Writings on Photography*. New York: Aperture, 2005.
• ————. *Photography in Print: Writings from 1816 to the Present*. Albuquerque: University of New Mexico Press, 1988.
• Grundberg, A. *Crisis of the real. Writings on Photography 1974–1989*. New York: Aperture, 1990.
• Howarth, S. (ed.). *Singular Images: Essays on Remarkable Photographs*. London: Tate Publishing, 2005.
• Jaeger, A.C. *Image Makers Image Takers*. London and New York: Thames and Hudson, 2007.
• Johnson, B. *Photography Speaks – 150 Photographers on*

their Art. New York: Aperture, 2005.
• Klein, A. (ed.). *Words Without Pictures*. Los Angeles: LACMA, 2009.
• Levi Strauss, D. *Between the Eyes: Essays on Photography and Politics*. New York: Aperture, 2005 (Italian ed. *Politica della fotografia*. Milan: Postmediabooks, 2007).
• Linfield, S. *The Cruel Radiance: Photography and Political Radiance*. Chicago: University of Chicago Press, 2011 (Italian ed. *La luce crudele*. Rome: Contrasto, 2013).
• Marcenaro, G. *Fotografia come letteratura*. Milan: Mondadori, 2004.
• Marra, C. *Forse in una fotografia. Teorie e poetiche fino al digitale*. Bologna: Clueb, 2002.
• Michaels, W.B. *The Shape of the Signifier: 1967 to the End of History*. Princeton and Oxford: Princeton University Press, 2004.
• Mignemi, A. *Lo sguardo e l'immagine. La fotografia come documento storico*. Turin: Bollati Boringhieri, 2003.
• Mitchell, W.J.T. *Picture Theory: Essays on Verbal and Visuel Representation*. Chicago: University of Chicago Press, 1995.
• ————. *The Reconfigured Eye: Visual Truth in the Post-photographic Era*. Cambridge, MA: MIT Press, 1992.
• Newman, M. (ed.). *Jeff Wall: Works and Collected Writings*. Barcelona: Poligrafa, 2007 (Italian ed. S. Graziani (ed.). *Gestus: Scritti sull'arte e la fotografia*. Macerata: Quodlibet, 2013).

• Papageorge, T. *Core Curriculum: Writings on Photography*. New York: Aperture, 2011.
• Ritchin, F. *After Photography*. New York: W.W. Norton & Co., 2008 (Italian ed. *Dopo la fotografia*. Turin: Einaudi, 2012).
• ———. *Bending the Frame: Photojournalism, Documentary, and the Citizen*. New York: Aperture, 2013.
• Schaeffer, J.M. *L'image précaire*. Paris: Le Seuil, 1987 (Italian ed. *L'immagine precaria. Sul dispositivo fotografico*. Bologna: Clueb, 2006).
• Shore, S. *The Nature of Photographs*. London: Phaidon, 2007 (Italian ed. *Lezione di fotografia*. London: Phaidon, 2009).
• Solomon-Godeau, A. *Photography at the Dock*. Minneapolis: University of Minnesota Press, 1991.
• Sontag, S. *On Photography*. New York: Farrar, Straus and Giroux, 1977 (Italian ed. *Sulla fotografia*. Turin: Einaudi, 1978).
• ———. *Regarding the Pain of Others*. New York: Farrar, Straus and Giroux, 2003 (Italian ed. *Davanti al dolore degli altri*. Milan: Mondadori, 2006).
• Soth, A., and F. Zanot. *Ping Pong Conversations*. Rome: Contrasto, 2013 (Italian ed. *Conversazioni intorno a un tavolo*. Rome: Contrasto, 2013).
• Trachtenberg, A. (ed.). *Classic Essays on Photography*. Chicago: Leete's Island Books, 1980.
• Vaccari, F. *Fotografia e inconscio tecnologico*. Modena: Punto e Virgola, 1979.

• Valtorta, R. *Il pensiero dei fotografi*. Milan: Bruno Mondadori, 2008.
• ———. *Volti della fotografia. Scritti sulle trasformazioni di un'arte contemporanea*. Milan: Skira, 2005.
• Wells, L. (ed.). *Photography: A Critical Introduction*. London-New York: Routledge, 1997.
• ———. *The Photography Reader*. New York: Routledge, 2003.
• Westgeest, H., and H. Van Gelder. *Photography between Poetry and Politics: The Critical Position of the Photographic Medium in Contemporary Art*. Leuven: Leuven University Press, 2008.

Magazines
• *Aperture*, San Francisco, 1952–, four-monthly.
• *Artforum,* New York, 1962–, periodical.
• *Art on Paper*, New York, 1996–2009, two-monthly.
• *Études photographiques*, Paris, 1996–, four-monthly.
• *European Photography*, Berlin, 1980-2010, two-yearly.
• *Eyemazing*, Amsterdam, 2003–, four-monthly.
• *Fantom*, Milan, 2009–, four-monthly.
• *Foam Magazine*, Amsterdam, 2001–, four-monthly.
• *Genis Aci*, Istanbul, 2005–, two-monthly.
• *History of photography*, London, 1977–, three-monthly.
• *Hotshoe*, London, 1974–, two-monthly.
• *Source*, Belfast, 1991–, four-monthly.

• *The British Journal of Photography*, London, 1854–, monthly.
• *Yishu, Journal of Contemporary Chinese Art*, Vancouver, 2002–, two-monthly.
• *Zum*, Istituto Moreira Salles, São Paulo, 2011–, six-monthly.

Webography
• Badger, G. *Hard Memories – Anders Petersen's and J.H. Engström's From Back Home*. Bradford: National Media Museum, 2010, http://www.gerrybadger.com/hard-memories-anders-petersens-and-j-h-engstroms-from-back-home/.
• Barthes, R., G. Kubler, and S. Sontag. *Three Essays*, in *Aspen 5+6*, http://www.ubu.com/aspen/aspen5and6/threeEssays.html#barthes.
• Batchen, G. *Les Snapshots*, in *Études Photographiques*, no. 22, http://etudesphotographiques.revues.org/999 (September 2008).
• Bordignon, E. *Viaggio in Italia*, in *Flash Art Online*, http://www.flashartonline.it/interno.php?pagina=articolo_det&id_art=125&det=ok&articolo=VIAGGIO-IN-ITALIA.
• Brittain, D. *This is British Photography*, in *Source Photographic Review*, no. 31, http://www.source.ie/archive/issue31/is31feature_David_Brittain_07_15_26_16-02-12.php (summer 2002).
• Broomberg, A., and O. Chanarin. *Unconcerned but not indifferent*, in *Foto8*, http://www.broombergchanarin.com/unconcerned-but-not-indifferent-text/ (2008).

• Burbridge, B. *Why Photography May Not Matter As Art As Never Before*, in *Photoworks*, http://photoworks.org.uk/why-photography-may-not-matter-as-art-as-never-befor/ (12/07/11).
• Campany, D. *'Colorless Green Ideas Sleep Furiously'*, in *Source Photographic Review*, no. 36, http://www.source.ie/archive/issue36/is36feature_David_Campany_06_57_19_26-02-12.php (autumn 2003).
• Colberg, J. *Towards the 21st Century: The Full Collection*, in *Conscentious*, http://jmcolberg.com/weblog/2012/09/towards_the_21st_century_the_full_collection/ (22/09/12).
• Eklund, D. *Art and Photography: The 1980s; Art and Photography: 1990s–Present*, in *Heilbrunn Timeline of Art History*. New York: MoMA, 2000, http://www.metmuseum.org/toah/hd/ap80/hd_ap80.htm; http://www.metmuseum.org/toah/hd/ap90/hd_ap90.htm (October 2004).
• ———. *Photography in Düsseldorf*, in *Heilbrunn Timeline of Art History*, New York: MoMA, http://www.americansuburbx.com/2010/12/theory-photography-in-dusseldorf.html (2010).
• ———. *The Pictures Generation*, in *Heilbrunn Timeline of Art History*, New York: MoMA, http://www.metmuseum.org/toah/hd/pcgn/hd_pcgn.htm (October 2004).
• Graham, P. *Photography is Easy, Photography is Difficult*;

The Unreasonable Apple, http://www.paulgrahamarchive. com/writings_by.html (February 2009; february 2010).
● Grigg, J. *Collecting The Indefinable*, in *Source Photographic Review*, no. 23, http://www.source.ie/archive/is sue23/is23feature_Jennifer_Gri gg_05_41_36_20-02-12.php (summer 2000).
● Gunthert, A. *L'image partagée*, in *Études Photographiques*, no. 24, http://etudesphotographiques.r evues.org/2832 (November 2009).
● Lavoie, V. *Guerre et i-Phone. Les nouveaux fronts du fotojournalisme*, in *Études Photographiques*, no. 29, http://etudesphotographiques.r evues.org/3294 (2012).
● Lugon, O. *Avant la «forme tableau»*, in *Études Photographiques*, no. 25, http://etudesphotographiques.r evues.org/3039 (May 2010).
● Molon, D. *A Pulse Within the System: Wolfgang Tilmans and Photoconceptualism*, in *Wolfgang Tillmans*. New Haven and London: MCA Chicago / Hammer Museum LA, Yale University Press, 2006, http://tillmans.co.uk/images/stor ies/pdf/molon_essay.pdf.
● Morel, G. *Esthétique de l'auteur*, in *Études Photographiques*, no. 20, http://etudesphotographiques.r evues.org/1202 (June 2007).
● O'Hagan, S. *How Photographers joined the self-publishing revolution*, in *The Observer*, http://www.guardian.co.uk/artan ddesign/2013/apr/14/photograp hy-self-publishing-afronauts- space (14/04/13).
● ————. *Photography: an ever-evolving art form*, in *The Observer*, http://www.guardian.co.uk/artan ddesign/2012/nov/16/sean- ohagan-photography-art-form (16/11/12).
● Parr, M. *Too Much Photography*, http://www.martinparr.com/201 2/too-much-photography/ (April 2012).
● Stallabrass, J. *Jeff Wall, Museum Photography and Museum Prose*, http://www.courtauld.ac.uk/peo ple/stallabrass_julian/2011- additions/Wall.pdf.
● Tillmans, W. *Royal Academy School Annual Lecture*. London: Royal Academy of Arts, http://tillmans.co.uk/images/stor ies/pdf/2011_Lecture_Tillmans_ Royal_Academy_english.pdf (22/02/11).
● *What is Conceptual Photography?*, in *Source Photographic Review*, n. 71, three-part documentary, http://www.source.ie/feature/w hat_is_conceptual.html (summer 2012).

Index of names

A

Aarsman, Hans: 254, *260*
Acconci, Vito: 189
Adams, Andy: 168
Adams, Robert: 19
Agee, James: 27
Al-Ani, Jananne: 229, 231
Ameisenhaufen, Peter: 225
Angeletti, Marie: 166, *167*
Antonioni, Michelangelo: 72
Arbus, Diane: 25, 146
Armstrong, David: 25, 72
Arnold, Eve: 189, 228–229
Asher, Michael: 188
Atget, Eugène: 20, 223
Attìa, Kader: *227*, 229
August, Bille: 37

B

Baader-Meinhof (terrorist gang): 106n
Badger, Gerry: 196, 242n
Baldessari, John: 47
Baltz, Lewis: 19
Barber, Tim: 167
Barbieri, Olivo: 18–19, 65, *68*
Barents, Els: 80, 82
Barthes, Roland: 46, 254
Basilico, Gabriele: 18–19, 65, *70*
Bataille, Georges: 188
Batniji, Taysir: 229, 231, *232*
Battistella, Giannantonio: 65
Baudrillard, Jean: 11
Baumgarten, Lothar: 189
Bayer, Herbert: 162-163
Becher, Bernd (Bernhard): 15, *16*, 17, 20, 33n, 103, 110
Becher, Bernd e Hilla: 22–25, 110-112, 124
Becher, Hilla: 15, *16*, 17, 20, 33n, 103, 110

Beckman, Jen: 168
Begg, Zanny: 239
Belli D'Elia, Pina: 64
Benjamin, Walter: 94, 230, 242n
Berges, Laurenz: 111
Beshty, Walead: *155*, 160
Bielicky, Michael: 239
Biemann, Ursula: 239
Blalock, Lucas: 169
Bloom, Barbara: 189
Blossfeldt, Karl: 124
Bohr, Marco: 168
Boltanski, Christian: 89, 95, 99–100, *100*, 101, *101*, 107n, 124, 189, *192*
Boot, Chris: 205
Botticelli, Sandro (Sandro di Mariano Filipepi, also known as): 146
Bowes-Lyon, Elizabeth (Queen Mother): 125
Brauntuch, Troy: 46
Brecht, Bertolt: 30, 32, 73, 242n, 262–263
Breton, André: 36
Broodthaers, Marcel: 95, 124, 189
Broomberg, Adam: 229, *229*, 231, 242n, 262–264, *265–269*
Buchloh, Benjamin: 97–98
Buñuel, Luis: 72
Buren, Daniel: 188
Burgin, Victor: 242n
Buschmann, Rholand: *257*
Byrne, Gerard: 222–223, *223*, 224, 241n

C

Caillebotte, Gustave: 82
Calle, Sophie: 190, *194*

Campany, David: 228–229
Capa, Robert: 204, 228
Cardiff, Janet: 188
Cartier-Bresson, Henri: 189, 204, 212
Casebere, James: 31, 242n
Castella, Vincenzo: 65, *69*
Castelli, Leo: 46
Castro, Fidel (Fidel Alejandro Castro Ruz): 219, 222, *222*, 223
Cavazzuti, Andrea: 65
Caviezel, Kurt: 254, *259*
Celati, Gianni: 65
Ceschel, Bruno: 167
Chanarin, Oliver: 229, *229*, 231, 242n, 262–264, *265–269*
Chatwin, Bruce: 57–58
Chéroux, Clément: 253–254, *255*
Chevrier, Jean-François: 28–29, 32
Chiaramonte, Giovanni: 65
Christian, Christer *see* Strömholm, Christer
Christo (Christo Javachev): 190
Claerbout, David: 221, *221*, 222
Clark, Larry: 73
Clark, Timothy James: 80
Clergue, Lucien: 252
Colberg, Joerg: 168
Cooke, Lynne: 99
Cornell, Joseph: 189
Cotton, Charlotte: 12, 112, 242n
Cresci, Mario: 65
Crimp, Douglas: 46, 106n

D

Daguerre, Louis: 17
Dahlbäck, Bengt: 242n

Dali, Zhang: 213
David, Jacques-Louis: 205
Dawidsson, Björn: 37
Debord, Guy: 46
Degas, Edgar: 190, *194*
Delacroix, Eugène: 80–81, *83*
Delahaye, Luc: 28, *29*, 204–206, *207–211*
Demand, Thomas: 31, *32*, 242n
de Mooij, Emmeline: 161, *162*
Derrida, Jacques: 90, 99
Descamps, Bernard: 138, 140
Deschenes, Liz: 162–163, *163*, 164
Dibbets, Jan: 190
diCorcia, Philip-Lorca: 25, *25*, 73
Dijkstra, Rineke: 30, *30*, 146–147, *148-153*
Dion, Mark: 188-189
Distel, Herbert: 189
Djeddi, Diana: 239
Douglas, Stan: *92*, 95, 242n
Duchamp, Marcel: 189, *191*, 222, 253
Duchenne de Boulogne, Guillaume-Benjamin-Amand: 262
Dumas, Charlotte: 167

E

Eakins, Thomas: 57
Eaton, Jessica: 160, *161*
Ebner, Shannon: 164, *164*
Edgerton, Harold: 125, 220
Eggleston, William: 19, 24, 172
Ehrenberg, Johan: 36
Ekman, Agneta: 37
Enwezor, Okwui: 12, 139
Erwitt, Elliott: 189
Esser, Elger: 111
Ethridge, Roe: 33n, 166, *166*

Evans, Jason: *156*, 158
Evans, Walker: 16, 19–20, 27, 33n, 64, 105, 205, 212, 223
Ezekiel (prophet): 264

F

Fakhouri, Fadl: 246–247
Fani-Kayode, Rotimi: 139–140, *145*
Feldmann, Hans-Peter: 96, *96*, 97, *97*, 99, 106n, 124–125, *127–131*
Fellig, Arthur (Usher) *see* Weegee
Fellini, Federico: 72
Fenton, Roger: 189
Feustel, Marc: 168
Fink, Larry: 190
Finkeldey, Bernd: 111
Fletcher, Suzanne: 73
Flinck, Govert: 190, *194*
Fluxus (group): 189
Fontcuberta, Joan: *224*, 231, *234*, 253, *255*
Formiguera, Pere: 225
Fossati, Vittore: 65
Fosso, Samuel: 139, *143*
Foster, Hal: 89, 95
Foucault, Michel: 46, 91–92
Frank, Robert: 19, 197, 212
Fried, Michael: 205–206
Friedlander, Lee: 17, 19
Frisinghelli, Christine: 18
Frith, Francis: 263
Fudong, Yang: 214
Fulford, Jason: 167

G

Gao Brothers (Zhen and Qiang Gao): *212*, 213
Garzia, Carlo: 65

Gbré, François-Xavier: 229
General Idea (Felix Partz, Jorge Zontal, AA Bronson [Michael Tims]): 189
Genzken, Isa: 160
George, Alice Rose: 252
Géricault, Théodore: 205
Ghirri, Luigi: 18, 64–65, *67*
Ghirri, Paola: 64
Giacomelli, Mario: 125
Gill, Stephen: 167
Godard, Jean-Luc: 72
Goertz, Ralph: 33n
Goldin, Barbara Holly: 72
Goldin, Nan (Nancy): 24–25, 72–74, *75–79*, 172
Goldstein, Jack: 46
Goller, Bruno: 124
Gorbachev, Mikhail: 183
Gordon, Daniel: 168, *169*
Gordon, Jenny: 140
Görlich, Ulrich: 20
Graham, Dan: 80
Graham, Paul: 27, *27*, 28, 118–119, *120–123*, 157–158
Grünewald, Isaac: 36
Guidi, Guido: 18–19, 65
Gursky, Andreas: *15*, 17, 20, 29, 33n, 103, 111–112, *113*

H

Haacke, Hans: 189
Hamilton, Richard: 190
Hampl, Patricia: 197
Hao, Hong: 213
Harvey, Michael: 47
Heartfield, John: 242n
Hébel, François: 252
Heiferman, Marvin: 73
Heinecken, Robert: 160
Hill, Shelley: 65

Hiller, Susan: 189
Hirsch, Walter: 37
Hirschhorn, Thomas: 95, 102, *102*
Hirst, Alex: 140
Höfer, Candida: 17, 20, 23, 103, 111–112, *117*, 189
Holborn, Mark: 73
Holland Day, Fred: 57
Hongzhong, Gu: 213
Honnef, Klaus: 20–21
Hoyningen-Huene, George: 57
Hudson, Ingrid: 140
Huguier, Françoise: 138, 140
Hung, Wu: 212
Hütte, Axel: 17, 20, 111–112, *114*

J

Jaar, Alfredo: *94*, 95, 234, 236–237, *237*, 243n
Jinsong, Wang: 213
Jodice, Francesco: 229, *238*, 239
Jodice, Mimmo (Domenico): 65, *70*
Jones, Edwin: 263
Joreige, Lamia: 95
Joselit, David: 242n

K

Kabakov, Ilya: 182
Kalman, Tibor: 262
Kaplan, J.A.: 247
Kardon, Janet: 56
Kasten, Barbara: 159
Katz, Leslie George: 33n
Kawauchi, Rinko: 166
Keïta, Seydou: 138–139, *140*
Kellein, Thomas: 132
Kelm, Annette: *32*, 33n

Kennedy, John Fitzgerald: 47
Kessels, Erik: 234, *235*, 237, 253, *255*, *257*
Killip, Chris: 26
Klapheck, Konrad: 124
Klein, William: 36
Koenig, Wilmar: 20
König, Walther: 246
Komar & Melamid (group): 190
Kristeva, Julia: 46
Kruger, Barbara: 48

L

Ladd, Jeff: 168
Lassry, Elad: 166, *166*
La Touche, Gaston: 81
Lavalette, Shane: 167
Lawler, Louise: 188–189
Lawson, Thomas: 47
Lê, An-My: *226*, 229
Leavitt, William: 47
Lebel, Robert: 188
Le Corbusier (pseudonym of Charles-Édouard Jeanneret): 36
Léger, Fernand: 36
Le Gray, Gustave: 189
Leirner, Jac: 189
Lemberg, Ulla: 37
Leone, Gianni: 64–65
Les Liens Invisibles (Clemente Pestelli and Gionatan Quintini): 239
Levine, Sherrie: 46–47, *52*, 105, 190
Lincoln, Abraham: 47
Longo, Robert: 46
Lütgens, Annelie: 173–174
Lyon, Lisa: 56–58, *59*, *61*, *63*

M

Magnin, André: 138
Mailaender, Thomas: 253, *261*
Manet, Édouard: 80–81, *84*,
 190, *194*, 220
Man Ray (pseudonym of
 Emmanuel Radinski): 36, 159
Mao (Mao Zedong): 213
Mapplethorpe, Robert: 56–57,
 59–63, 174
Mayer, Hansjörg: 132
McCullin, Don: 228
McLuhan, Marshall: 239
McQueen, Steve: 95–96
McShine, Kynaston: 188
Meiselas, Susan: *240*, 241
Menschel, Joyce: *52*, *117*
Menschel, Robert: *52*, *117*
Meyerowitz, Joel: 19
Mikhailov, Boris: 31, *31*,
 182–183, *184-187*
Milošević, Slobodan: 205
Mitchell, William J. Thomas: 94
Mofokeng, Santu: 140, *144*
Moholy-Nagy, László: 159
Molesworth, Helen: 173–174
Morrisroe, Mark: 25, 73
Morrissey, Paul: 72
Mosse, Richard: 231–232, *233*,
 242n
Mull, Carter: 164, *165*
Müller, Maria: 111
Mullican, Matt: 48
Munch, Edvard: 262
Muniz, Vik: 189, *195*

N

Nana: 36
Nares, James: 158
Niedermayr, Walter: 19, *20*
Niépce, Joseph Nicéfore: 17

Nieweg, Simone: 111
Nori, Claude: 65
Nori, Franziska: 241n, 243n

O

Odulf, Tor-Ivan: 37
Oldenburg, Claes: 189
Ophir, Adi: 264
Oppenheim, Dennis: 190,
 192
Orozco, Gabriel: 95

P

Paglen, Trevor: 164–165, 229
Parr, George: 196
Parr, Martin: 26, *26*, 27, 118,
 196–197, *198*, *200*, 253, *255*
Patterson, Christian: 33n
Peale, Charles Willson: 189
Peress, Gilles: 239, 252
Petersen, Anders: 37, *38–39*,
 41, 44
Phillips, Christopher: 212,
 214
Pickering, Sarah: 229
Pierson, Jack: 25
Pigozzi, Jean: 138
Platt Lynes, George: 57
Pohlen, Annelie: 105
Pohlmann, Ulrich: 242n
Polidori, Robert: 242n
Prince, Richard: 47–48, *52*,
 95
Prus, Timothy: 263

Q

Quarantelli, Ezio: 65
Quingsong, Wang: 213, *216*
Quinlan, Eileen: *159*, 160
Quintavalle, Arturo Carlo:
 65

R

Raad, Walid (The Atlas Group):
 91, 95, 231–232, 246–247,
 248–251
Ractliffe, Jo: 229
Reiring, Janelle: 46
Rembrandt, Harmenszoon van
 Rijn: 190, *194*
Ressler, Oliver: 239
Richter, Gerhard: 95, 97–98, *98*,
 99, 104, 110, 124, 172
Rickard, Doug: 254, *258*
Riebesehl, Heinrich: 20
Ristelhueber, Sophie: *228*, 229
Ritchin, Fred: 11, 239, 243n
Robeson, Paul: 96
Rong Rong: 213, *215*
Roquette, Jean-Maurice: 252
Rosler, Martha: 242n
Ruff, Thomas: 17, 23, *23*, 33n,
 95–96, 103–104, *104*, 105,
 105, 106, 111–112, *117*
Ruscha, Ed (Edward Joseph IV):
 124, 190

S

Salgado, Sebastião: 125
Sander, August: 20, 124, 147,
 223
Sarkissian, Hrair: *227*, 229
Sartorello, Umberto: 65
Sasse, Jörg: 111
Schmid, Joachim: 253, *255*
Schmidt, Michael: 18, 20–21,
 21
Schneckenburger, Manfred: 17
Schorr, Collier: 174
Schuman, Aaron: 168
Schürmann, Wilhelm: 20
Schwitters, Kurt: 172
Sekula, Alan: 242n

Serralongue, Bruno: 229, *230*,
 233
Seymour, David: 189
Shafran, Nigel: 167
Shearer, Norma: *136*
Sherman, Cindy: 20, 31, 47, *51*,
 95, 212
Shibli, Ahlam: 229, *231*
Shore, Stephen: 17, 19,
 118
Shulan, Michael: 252
Sidibé, Malick: 139, *142*
Simmons, Laurie: 47, *49*
Simon, Taryn: 229
Simpson, Lorna: 95
Singh, Dayanita: 95
Sköld, Otte: 36
Smith, Patti (Patricia Lee
 Smith): 56
Smith, Philip: 46
Smithson, Robert: 190
Smoliansky, Gunnar: 37
Sontag, Susan: 233
Soth, Alec: 167, 197–198, *200*,
 203
Stahel, Urs: 119
Steinert, Otto: 36
Stella, Frank: 225
Sternfeld, Joel: 118
Stieglitz, Alfred: 189
Strömholm, Christer: 36–37, *41*,
 43–44
Struth, Thomas: 17, 20, 23–24,
 24, 103, 111–112, *115*,
 189
Stryker, John L.: *78*
Sugimoto, Hiroshi: 132–134,
 135–137, 189, 222, *222*,
 223
Svanberg, Lasse: 37
Szeemann, Harald: 17

T

Talbot, William Henry Fox: 17
Thatcher, Margaret: 26-27, 118
The Atlas Group *see* Raad, Walid
Thomson, David: 263
Thurston Thompson, Charles: 189
Tillmans, Wolfgang: 21, *22*, 172–174, *175-181*
Tinelli, Mario: 65
Toscani, Oliviero: 262
Tournier, Michel: 252
Traub, Charles: 252
Truffaut, François: 72
Tuliozi, Ernesto: 65
Tupitsyn, Victor: 182

V

Valtorta, Roberta: 19
VanDerBeek, Sara: 161, *162*
Van der Elsken, Ed (Eduard): 36
Van Winkiel, Camiel: 242n
Velati, Enzo: 64
Ventura, Fulvio: 65
Vermeer, Jan: 190, *194*
Vierkant, Artie: *168*, 169
Vionnet, Corinne: 254, *261*
Visser, Hripsimé: 146
Vitali, Massimo: *18*, 19
von Gloeden, Wilhelm: 57
von Kubert, Hans: 225

W

Waldberg, Isabelle: 188
Wall, Jeff: 20, 30, 80–82, *83-87*, 103, 189, 219, *219*, 220–222, 233, 241n–242n
Warhol, Andy (pseudonym of Andrew Warhola Jr.): 72, 95, 233

Washington, George: 47
Weegee (pseudonym of Arthur Fellig): 196
Weems, Carrie Mae: 95
Weill, Kurt: 73
Weiwei, Ai: 240
Welling, James: 47–48, *50*, 159
Weski, Thomas: 12
Weston, Edward: 57
White, Cuchi: 65
Wilkes Tucker, Anne: 197
Williams, Christopher: 189
Willmann, Manfred: 18
Wilson, Fred: 189
Winer, Helene: 46
Winogrand, Garry: 28, 190
Wolf, Michael: 229
Wunderlich, Petra: 111

Y

Yongjin, Luo: 213

Z

Zanot, Francesco: 13, 242n
Zappa, Frank: 73